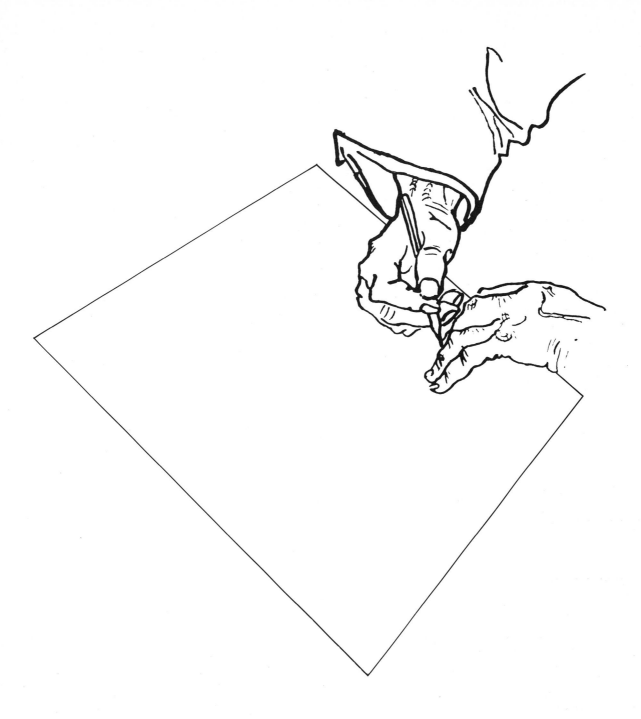

D1385146

# LEARNING TO SEE AND DRAW

Studying the techniques of the old masters for working methods and a personal style.

by GASPARE DE FIORE

Translated from Italian
by Joachim Neugroschel

*The Drawing Course, Volume One*

*WATSON-GUPTILL PUBLICATIONS/NEW YORK*

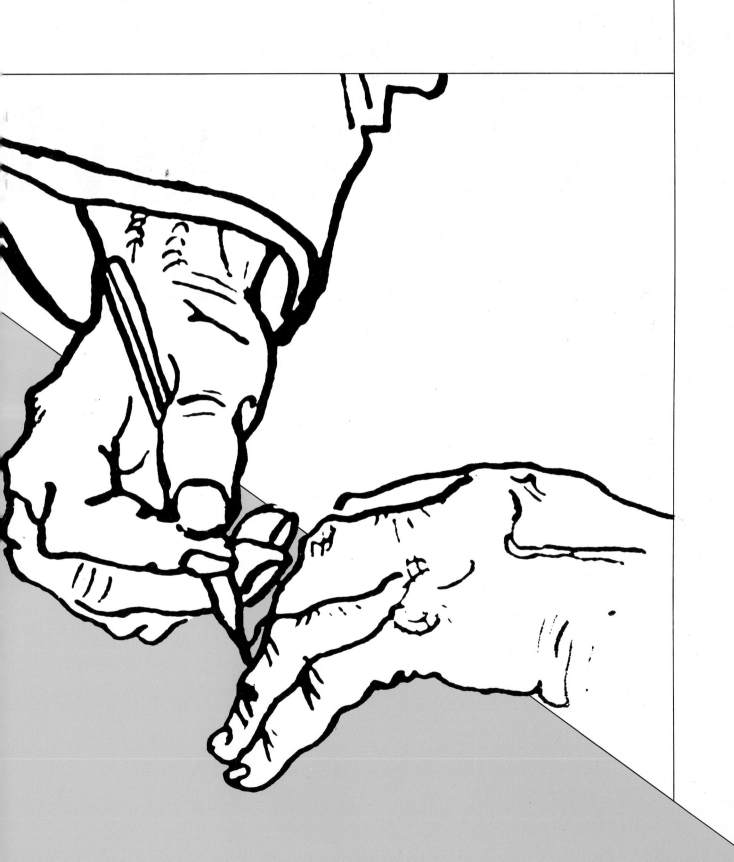

g 741.2
D 361 l

Copyright © 1983 by Gruppo Editoriale Fabbri, S.p.A.,
Milano

Published 1983 in Italy by Gruppo Editoriale Fabbri
S.p.A., Milano

First published 1984 in the United States and Canada
by Watson-Guptill Publications, a division of Billboard
Publications, Inc., 1515 Broadway, New York, N.Y.
10036.

Library of Congress Catalog
Card Number: 84–40291

ISBN 0-8230-1357-X

All rights reserved. No part of this publication may be
reproduced or used in any form or by any means—
graphic, electronic, or mechanical, including
photocopying, recording, taping, or information storage
and retrieval systems—without written permission of
the publisher.

Manufactured in Italy

First Printing, 1984

# Introduction to The Drawing Course Series

I am convinced that drawing cannot be taught but that it *can* be learned in the sense that drawing comes naturally to people and only needs to be brought out, refined, and valued. Basically each of us knows how to draw because drawing is at the base of our awareness. If we look at something, an actual image is formed on the retina of our eye that we perceive through a mysterious process in our brains. If we think about something a mental image forms that we perceive through our imagination. In either case, whether real or imagined, the image of something seen or thought is a drawing which is formed in our head. It only needs method and materials to transfer it to a sheet of paper.

But drawing does not just mean transferring an idea or image to a sheet of paper. Precisely because it succeeds in expressing images of reality and fantasy through shape and color, drawing becomes an expression of the rapport between us and the outside world as well as our internal world.

If we are able to understand what and how much drawing can mean above and beyond its value as a pretty picture—that is, understand it as a means of seeing, recognizing, participating—then in the pages collected in our album, in the sketches on the wall in our room, in the thousands of images that surround us we will find a fantastic world, the world of drawing. When we draw, the moment we trace a line down the page, our participation is direct. But we also participate indirectly when we interpret the drawing, completing the form, light and shadows, and color with our imagination. The old Chinese artist was right when he said, "The suggestion of an empty cup is not inferior to that of a full one," alluding to the importance of white spaces, the parts left blank, and therefore also to the role of the observer who himself becomes a creator. Thus a drawing, like poetry, music, dance, painting, and sculpture, becomes a part of life in which we can all participate, interpreting images from the real world and creating imagines from our fantasies.

# Contents of The Drawing Course Series

The drawing course is developed through sixteen basic phases of drawing, each further divided into five parts. The result is a rich, as well as practical and enjoyable framework for the teaching of drawing. In each section, the ideas, teachings, experiences, and works of the great masters, analyzed through different stages of their development, are used to illustrate the basic techniques taught in the course.

The lessons are developed through a method which takes into account the need to individualize the diverse procedures of drawing but never loses sight of the search for a true synthesis of the vision, image, and actual portrayal of the subject. At the same time that it teaches the need for scientific and objective procedures, it emphasizes each person's personality and interpretation.

The course focuses on the techniques of drawing, from the moment of "seeing" to the interpretation of color. It also gives specific information about materials, such as the various kinds of .pencils and crayons available, and how to use them. There is also information on the various applications for drawings—from sketches to technical drawings. The series concludes with an introduction to painting.

This first volume covers the first three subjects. The entire course—a total of six volumes—is described below:

## 1 Learning to See

*The course begins by stressing the need to learn to see. Observing in order to portray an object, the definition of form and chiaroscuro, the analysis of form and color, images of reality and images of ideas all represent fundamental steps in learning to draw, phases which are picked up and developed throughout the course in their most diverse applications.*

## 2 Drawing From Life

*We learn to know the world around us better through drawing, and present it in a personal way. Drawing from real objects, notes from travels (in a sketch book that we will take with us when we go out to help us see and remember), anatomy studies, and perspective of objects and backgrounds that interest us will all be covered, using the drawings of the masters as a laboratory of experience and technique.*

## 3 Seeing Shape

*The first lesson in the learning process is the analysis and representation of form. As we read about shape, we will discover the geometric structures that are the key to the construction or basis for the drawing, along with the relationship of the various elements and the search for balance and proportion. We'll see that even when a shape is represented by a single line, that line can suggest emotion, sensation, light and shadow.*

## 4 Light and Shadow

*A line can suggest light and shadow but it is chiaroscuro that interprets and expresses it fully through the wise use of black and white, reflections and tinted shadows, thereby creating a third dimension of volume and depth.*

## 5 The Development of a Drawing

*A drawing begins with a sketch of the initial idea or impression; then the search begins for the right arrangement, point of view, development of foreground and background and its position on the paper. Chosen with awareness, this series of elements will contribute to the synthesis of the composition.*

## 6 Composition

*Composition, which is the basic structure of drawing, finds harmony and balance in the discipline of geometry, even in free sketching. An axial composition is based on one of the axes or on two perpendicular axes. It can also be diagonal, triangular, square, circular or something even more complex such as mixed where geometric figures vary or are superimposed on each other.*

## 7 Color Theory

*Drawing is seeing and interpreting the world around us, a world in color. Light is color; all colors are created from the basic three, red, blue and yellow. Besides the abstraction and stimulus of a black and white drawing, color theory is developed in order to understand and portray new compositions and spatiality.*

## 8 Color and Personality

*Beyond objective color theory there is the world of color in each of us, full of contrasts, variations, harmonies, and subjective agreement for the portrayal of ideas and impressions. Color thus becomes a means of self-expression.*

## 9 Sketching

*Sketching is the first step in a drawing; notes are born from ideas or observations, whether real or from fantasy, made up or actually seen. In the sketch book, images and impressions multiply that can become drawings themselves or parts of another project.*

*A few lines on a page sometimes say more than a complicated drawing. More than other drawings they succeed in expressing personality and feeling and developing our fantasy.*

## 10 Fantasy Drawing

*Fantasy drawing is inventive drawing that can be applied to daily life, in fashion, decoration, jewelry, household objects, furnishings. In drawing, we can freely express our fantasies clarifying ideas that can then be carried out.*

## 11 Language

*Drawing is communication. With lines on paper we can speak even to those whose language we don't know. We can draw to explain something, to show how something is made, to recall an event, to play and even to dream. One needs only a line to suggest something to enrich and complete with imagination.*

## 12 Illustration

*In mass media, drawing plays a protagonist's role, working hand in hand with texts, even substituting for them at times, and competing with photographs. There are scientific drawings, humorous ones, such as caricature and political satire, illustrations in books and magazines, and the still young field of comics and animated cartoons. But even with this wide range, there are fixed rules on which every drawing is based.*

## 13 Geometric Drawing

*The methods of geometric representation give us rules for drawing three-dimensional objects. The concept behind each method, however, is unique: The drawing, as a projection on a surface (paper) seen from a single point of view.*

*With perspective, an actual point of view is projected, while orthogonal projects such as maps and diagrams are infinite. In each case the geometric drawing is a fundamental tool for the representation of architecture, objects, machines and land.*

## 14 Design

*This section looks at the vast world of graphics as used in designing books, covers, signs, publicity and brochures as well as in the industrial world where it becomes a blueprint for the production of models and products.*

15  Preliminary Sketches

*A drawing starts with the preliminary sketch; it is also the basis of paintings, sculpture, architecture, scene paintings and engravings. It is the link between the idea and the finished work, letting us understand the beginnings and history of the process of invention and its realization.*

16  Invitation to Painting

*In the long process toward the discovery of drawing, color is often brought into play. Now that we know something about drawing, we can turn to the fascinating world of painting where color triumphs, with a greater awareness and consciousness, enriching our images, visions, and ideas with color.*

# Learning to See and Draw

The world of drawing isn't filled with just great master studies and drawings collected in museums and galleries or jealously guarded in private collections. It also includes the world around us—the world we draw—with its infinite images that amuse, confuse, influence, and communicate to us. It is also the world we'd *like* to draw, the one we'd like to know or invent.

And so the world of drawing belongs not only to the great artists, but to the rest of us who draw what we see with fantasy and imagination or who solve practical ideas and projects every day with our drawings. It belongs to writers like Victor Hugo, who enriched his novels with his own charming images; and to film directors like Federico Fellini, who jotted down ideas for lighting, costumes, and scenery for his films on hundreds of colored sheets of paper and hung them around his studio. The world of drawing is also the world of adventure we find in the comic strips of our daily newspapers and in animated cartoons on television, and it includes everything from blueprints for cars and motorcycles, furniture and buildings…to designing the colors and shapes of a jigsaw puzzle, a deck of cards, record album, or a film poster.

How many times have you drawn something—or at least wished you could? Perhaps you needed to sketch an outfit you wanted to buy, or make up the plan of a house you wanted built to show it to the architect. When we draw, we reproduce the physical world about us. But we also reproduce our own inner world, too. And so while drawing allows us to get to know the universe in which we live, at the same time it gives a chance to explore our deepest selves.

But how can we find the right kind of drawing to express ourselves? How can we learn how to draw? I think there's no more productive and exciting way to learn than by reading the words, advice, experiences, and teachings of the masters, past and present; seeing what they have written about drawing and problems they've encountered, hear them analyzing their work, revisiting them, and discovering in their drawings the manner, methods, and tools they have used.

This book is an invitation to look at the drawings of the masters as though we were looking over their shoulders as they drew, watching them as they traced a line down the page, looking at their models and how they interpreted them, seeing them first sketch an idea and then develop it. What we really would like to do is try to understand those drawings without relying on theory but by letting the artist speak and explain for himself the history, reasoning, meaning, and development of a project from its birth as an idea to the last stroke of pencil on paper.

Every time we can see a work with the eyes of the artist and understand the creative process behind it, we face the problems he faced and prepare ourselves to resolve them as he has. With this in mind, I have chosen a few drawings from the many in the history of art and I have imagined being able to ask the artists about each drawing and through a sort of imaginary interview—or lesson—to get each one to tell his motivation, his aesthetic and technical problems, his artistic solutions and his inventions.

We will do this by looking at—or better yet, by interpreting—each drawing and composition carefully and critically so that we can go beyond our own interpretations of the work to unravel the threads of the artistic process to reach the artist himself.

Gaspare de Fiore

# CONTENTS

# LEARNING TO SEE

L et your hand draw what you see, what you think. Drawing is fascinating. It arouses and stimulates the imagination. In preparing our course, we have tried to pinpoint and explain the various functions and aspects of drawing. We wanted to find a logical series of steps toward developing a personal approach. The first step is: awareness. Drawing is a method for learning how to see, observe, understand, confront, and get to know.

Let's take an example. We go to work, to school, to the store every day. Who knows how often we pass an important building, a church, or a particularly interesting house. Now if we were asked about their facades, about their proportions, their planes, the features of their doors and windows, or some other detail, our answers would be vague or empty. Why? Because we are so *used* to these places that we have never truly *seen* them.

Similarly, if we tried to record the details of the face of a person we spend a lot of time with, we would have a problem. But if, for once, we try to *draw* his face—just try, nothing more—we will be forced to find the characteristic shapes, the eyebrow lines, the attachment of the ear lobe, the curve of the nostrils, the profile. Then we will truly *see* him.

We can say, therefore, that drawing is a unique method of *learning how to see.*

In this first section, we analyze several fundamental themes and aspects of drawing: (1) depiction or rendering; (2) shape and chiaroscuro (light and shade); (3) the real image and the idea; (4) the link between details and essence.

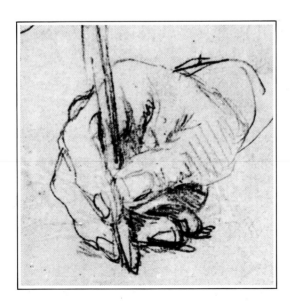

*Hans Holbein the younger (1497-1548):* Studies of Hands *(detail). Black pencil on gray paper. Louvre, Cabinet des Dessins, Paris.*

# Drawing a Tree

Among the many possible subjects to start with, let's try a tree. Why a tree? Because its structure develops the way a drawing ought to develop; from the main trunk to the secondary branches. Look around and find a tree with a form that strikes you as interesting enough for you to draw it.

Before starting to draw, we have to define the **framework** of the drawing. Select the frame, that is, the totality of the elements that you want to draw. This may be difficult, especially for a landscape or environment that contains many diverse elements. You will have an easier time by using a type of viewfinder called a "crossframe." A crossframe is a rectangular device which you can construct yourself from a sheet of transparent plastic. It is divided into four equal parts by two perpendicular lines marking the vertical and the horizontal axis. What does it do?

- It helps you to select the best **framework** for the subject.
- It isolates the chief **motif,** eliminating the accessory or secondary elements or pushing them into second place.
- It defines the **totality** of the drawing and the place occupied by each object or group of objects in the drawing.
- It makes it easier to pinpoint the **angles** of the lines and directions in the composition.

The prime advantage of using the crossframe is the ease with which you can overcome the obvious disproportion between the broad view of the real picture and the small size of the drawing paper. No matter how vast the environment, the crossframe presents it in a handy and proportionate size.

Hold the crossframe in front of your eyes and shift it up, down, right, left, so you can vary the framework. If you move it away from your eyes, you will have a smaller view. If you move it closer to your face, you will have a larger view.

Once you have chosen the framework, find the exact point on the drawing paper on which the tree will be located, by referring to the sides of the crossframe and the axes that divide the scene into equal parts.

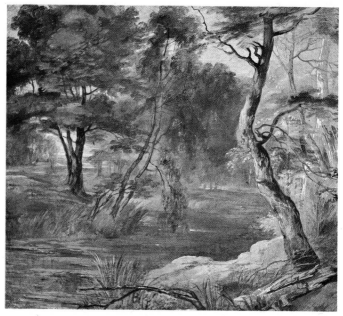

*Jacques Fouquières (1590/91-1659):* Stream Flowing through a Forest. *Watercolor and gouache, 381 × 377 mm. Louvre, Cabinet des Dessins, Paris.*

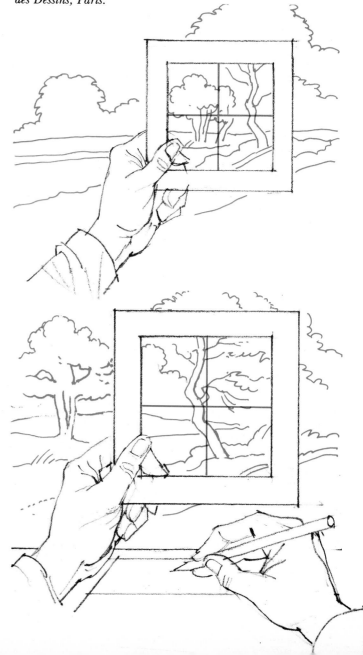

## The Sign of the Tree

Chinese teachers, we hear, tell their pupils the following: "When you draw a tree, you have to feel as if you are rising with it, starting from the bottom, growing together with the tree." In the drawing of a tree, the composition has to emerge, unfold, and articulate itself like the construction of the tree: from the trunk to the main branches, from these to the secondary branches and twigs, and so forth. The image thus completes its natural development, and so does the tree. Perhaps it is this extraordinary correspondence that has always made the tree a subject for every artist, painter, sculptor, architect. The Italian sculptor, Emilio Greco, writes: "I also did drawings of trees and landscapes. There are some olive trees that look like human figures, dramatic, desperate figures with raised arms. There are olive trunks that arouse my deepest emotions…. They have a compositional law that adjusts, unchanged, to all external factors: the

The tree can be at the center of the paper or on one side, depending on the shape of the foliage and the branches. The best location is toward the bottom, which allows more space for the sky.

Once you have selected the framework and defined the layout, you are ready to start drawing. Where should you begin? The **procedure** is based on information provided by the great masters, and we ought to "read" their drawings.

The French painter Henri Mattisse offered simple advice culled from his experience: We must shift attention from the tree as a shape, to the background, in order to set the tree against the empty spaces of the background. Draw these empty spaces, the ones inside the tree, and those in between the branches. This helps us to *see* the form of the tree. It is a device, a mental mechanism that liberates us from our conventional image of the tree. We are learning to "read" and "discover" the particular tree in front of us.

The following example is a drawing by the French painter Corot. His drawing is characterized by the lines of the two large trees in the foreground. Let's try to see the spaces cut out in the sky by the long branches, so that we too, like the artist, can participate in the landscape and in nature. For Corot, the tree is a lot more than just a fascinating object. It is his favorite theme. It is the element that can link the earth (by the roots) to the sky (by the branches).

It will help you to repeat this mental exercise several times with various subjects. Little by little, you will get used to reading the shapes of these subjects.

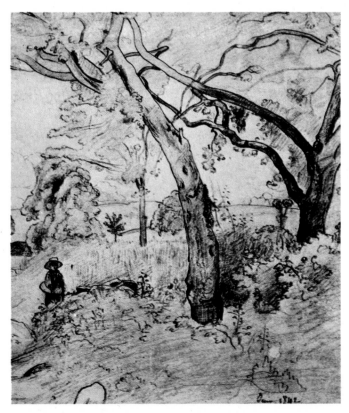

*Jean-Baptiste-Camille Corot (1796-1875):* Landscape *(detail). Pen and ink and black pencil. Louvre, Cabinet des Dessins, Paris.*

*The same Corot drawing, but reworked to show the empty spaces between the branches.*

wind, the rain, the seasons. These trees change shape according to their environment. In a windy zone, pine trees are all bent and twisted, and they become even more beautiful. Each object has, in its own nature, its own way of existing and changing in terms of surrounding conditions and external factors. There is nothing random or arbitrary about this; on the contrary, there is a precise logic."

When the French painter Henri Matisse thought and wrote about art, he often focused on the problem of drawing a tree: "Didn't I show you the drawings I'm now doing in order to learn how to depict a tree, all trees? As though I had never seen, never drawn a tree. I can see one from my window. I must patiently come to understand the construction of the overall mass of the tree, then the tree itself, the trunk, the branches, the leaves; above all, the branches that are symmetrically arranged on a single level. Then, the way the branches encircle the tree, and pass in front of it. Don't misunderstand

Now that we have recognized our tree, let's try to see its makeup. That is, let's try to understand its structure: the dynamics of the trunk and the branches, the way these elements relate to one another, the volume of the foliage. Let's try to see not only the shape, but the development of the shape.

A drawing does not necessarily develop from the top left of the sheet of paper to the bottom right, as if we were writing a letter. It grows organically from the main elements to the secondary elements.

Thus, in the case of the tree, we have to start by drawing the trunk, which is the chief element in the foreground. Next, we draw the major and then the minor branches. Finally, we draw the whole middle ground, the background, and the skyline.

The drawing that we will now analyze is by the French painter Nicolas Poussin. In this Roman landscape, the composition is worked out in all three planes. In the foreground: two tree trunks on the right, leaning slightly, cut off by the framework. In the middle ground, on the left: a large tree, with its leaves agitated by the wind, connected to the two right-hand tree trunks by the outline of the grassy terrain. In the background: the hilly countryside spreads out with a bridge at center.

In these diagrams of the drawing, we have followed the successive stages of execution with conventional colors:

- Red for the first elements to be drawn.
- Blue for the second.
- Green for the remainder.

In these schematic renderings, we have established the axes of the drawing which corresponds to the axes of the crossframe and help us get used to observing the proportions of the parts.

*Nicolas Poussin (1599-1655):* Ponte Mollo in Rome. *Metal-tip pen and brush with brown ink, and brown pencil, 187 × 256 mm. Graphische Sammlung Albertina, Vienna.*

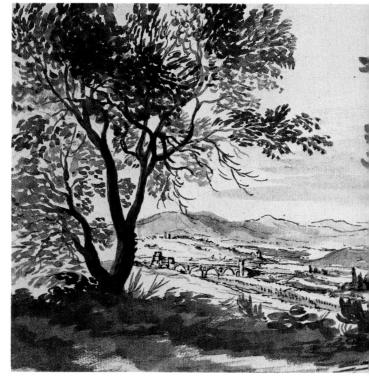

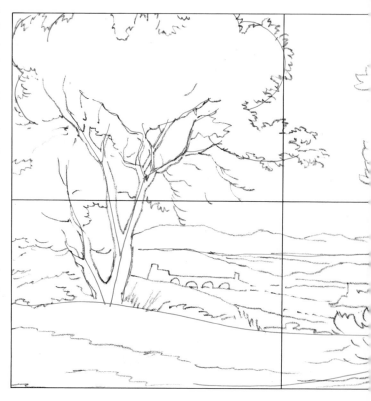

me: I don't mean that in seeing the tree from my window I am working to copy it. The tree is also the sum of the effect it produces in me. I will by no means draw the tree as I see it now. I have before me an object that operates upon my mind not only as a tree, but also in relation to all sorts of other feelings. I would not free myself of my emotion if I copied the tree precisely and drew the leaves one by one in the current language. First, I must identify with the tree. I have to create an object that resembles the tree, symbol of the tree.... I feel the interrelationship between the objects of my enchantment while drawing the olive tree I see from my bed.... When the inspiration has left the object, we ought to observe the empty spaces between the branches. That's how we get away from the habitual image of the drawn object, the stereotypical 'olive tree.' At the same time, we identify with the object." (*Jazz*, 1948).

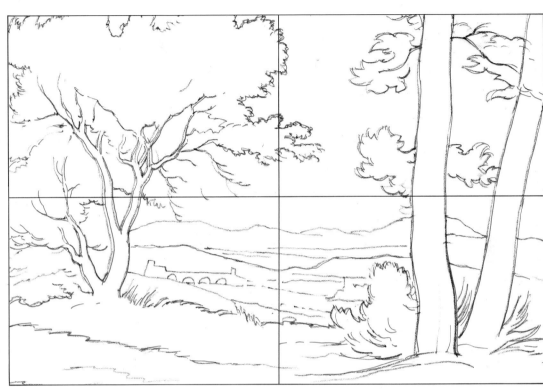

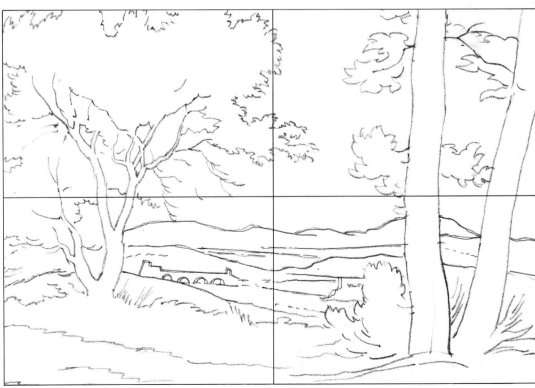

In establishing the drawing of the tree (or any drawing, for that matter), we have to pinpoint the **angles** of the basic lines, that is, the lines of the trunk and the group of primary and secondary branches.

Once you find the framework and establish the layout, that is, the position of the framework on the paper, you can start to draw. Work from the main trunks to the secondary trunks.

How can you locate and define the angles of these elements?

As usual, the secret is to observe attentively. It is easier to see the angles if we view them in terms of a vertical or horizontal direction.

To do so, hold the pencil in a horizontal or vertical position in front of the drawing. Half close your eyes. Now you've got a precise and simple reference for reading the structure, and you can single out the **angles** of the trunks and branches, both as a totality and individually. Let's take as an example, a drawing by Peter Paul Rubens, the greatest Flemish painter of the 17th century.

The poetry of the image is fascinating—the transparency of the colors, the simplicity of the composition. After giving in to its spell for a moment, let's examine the composition. A group of almost vertical trees stands out at the left, in the middle ground. Beyond the footbridge, a tree trunk leans toward the right, like the other trees that close off the framework.

The angles of the trunks can be established more easily if, as we have said, we refer it to the vertical line of the pencil (which we hold firmly before our eyes). The flow of the stream is found by positioning the same pencil horizontally.

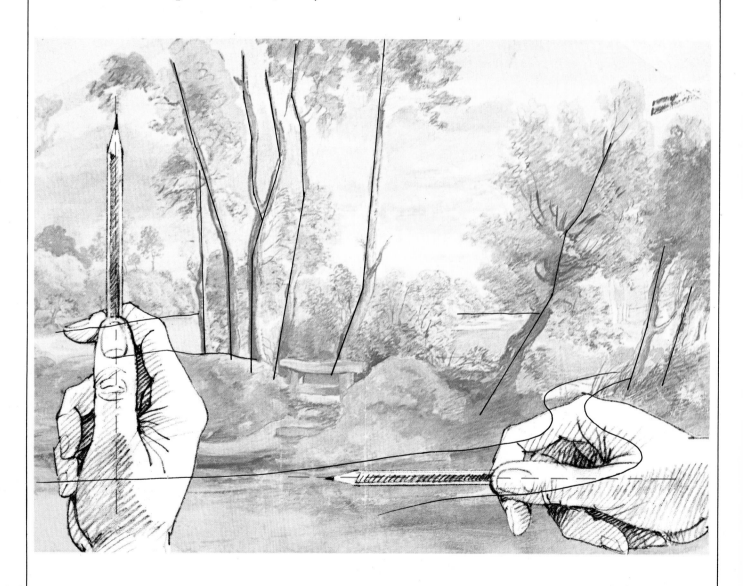

*Peter Paul Rubens (1577-1640):* Landscape with Footbridge. *Gouache on charcoal sketch, 435 × 590 mm. Hermitage, Leningrad.*

# Drawing a Face

Don't be surprised at our second experiment. We are asking you to look into a mirror and draw your face or, if you prefer, your entire upper body down to the waist, including your arms and hands.

Why a self-portrait? Well, art begins at home. And by doing your own portrait, you are dealing with a subject that you often see and that you think you know. You only think so. Actually, everyone is so accustomed to his own image, which he frequently looks at and which, before trying to draw it today, he has never really seen.

What are your eyes like? Are they close together or far apart? And what about your nose, mouth, ears? Drawing your own face is not easy. But it's not impossible, either. Especially if, in this first attempt, we don't try to express everything that we think or see.

The main problem is to get the right proportions, the relationship between the various parts of the face. Where should we begin?

Some artists begin with an eye when they draw a portrait. Others begin with the axis of the face (seen from the front). After they establish the axis they indicate the proportions of the various elements—the lines of the eyes, nostrils, mouth, chin. Still others begin with the horizontal line of the eyes or eyebrows and the sloping line of the nose (if the face is seen in three quarters). On the basis of these lines, they then compose the shape of the face.

In other words, there is no hard and fast rule. Just look into a mirror and take a stab at it.

At the beginning at least, draw with a pencil, and if you want, use the crossframe (I would advise it). Place the frame between you and the mirror at the handiest distance, a point which gives you the framework that you prefer for your face. In any case, the crossframe will be extremely useful because of the references of the axes. More than anything, however, it will help you to *see,* to understand the true form of your eyes, nose, lips, and it will increase your pleasure in *discovering* what they are like.

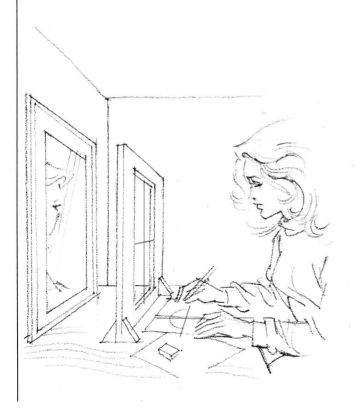
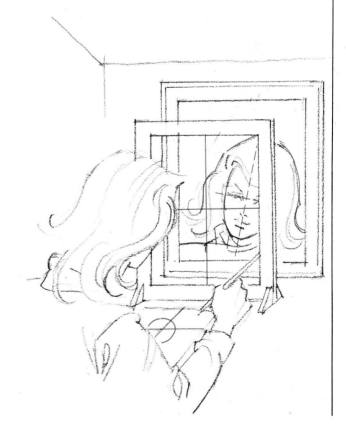

# Van Gogh's Self-Portrait

"And when I write you, 'Become a painter,' it is not because I feel that your present profession does not have a certain fascination. However, I think it is better to be a painter, and I would like you to be able to work in your studio rather than at a desk in an office. That's how it is. I am convinced

To understand how the master draftsmen dealt with this same problem, let's look at the drawing reproduced on this page. It is a self-portrait of Vincent van Gogh, probably done around 1888. It is especially interesting because of the detailed studies: the nose seen from the front, and the left eye. The artist began his drawing with a pencil; the lower sketch is all in pencil. He then used a pen for certain parts: eyes, nose, right cheek, some of the hair. This was no haphazard choice, since the artist's experiments become more precise and accentuated in the eyes and nose. Van Gogh's search, the labor and drama of his struggle to be a painter, are described in his letters to his brother Théo. This correspondence (from which this drawing is taken) went on for eighteen years, from August 1872 until the artist's death on July 27, 1890. No document in the history of painting is as precise, as detailed, and as pitiless in depicting and analyzing what it means to try to paint. As we read the correspondence and plunge deeper and deeper into van Gogh's long and passionate confession, we witness the relentless drama of what it means to be a painter, to try to find oneself in art. Art becomes the "craft of living." And van Gogh desperately set this craft of living over any other kind of work.

Why are van Gogh's letters so thought-provoking? Because they do not illustrate just one side of the author's soul, just one aspect of his life. These letters bare his soul completely, ruthlessly analyzing every detail of his life. His whole inner world, his infinite relationships with the universe, are placed on an anatomical table, and the resulting vivisection is tragically lucid and truly poignant.

*Vincent van Gogh (1853-1890):* Self-Portrait. *Canvas, 65 × 54 cm. Louvre, Jeu de Paume, Paris. (photo: AGRACI).*

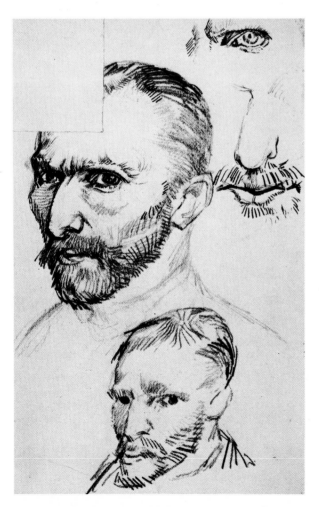

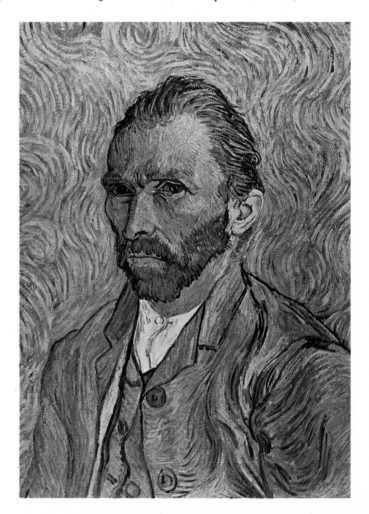

that there, in your studio, something will be aroused in you, something that you do not know now: a great concealed force of work and creation. And once this force is aroused, it will remain forever....

"I can never tell you how happy I am despite the new difficulties that occur and that will keep recurring every day. I can never tell you how happy I am to be drawing again. Drawing from life: figures or landscapes? Why, they're the very same!....

"I keep feeling more and more that figure drawing is a wonderful thing that indirectly and favorably affects landscape drawing. If you draw a willow tree as if it were a living being (and ultimately, that's what it is), everything else will come easily. You only have to concentrate on that single tree, so that you can succeed in imbuing it with life." (Vincent van Gogh: *Letters to His Brother Théo*).

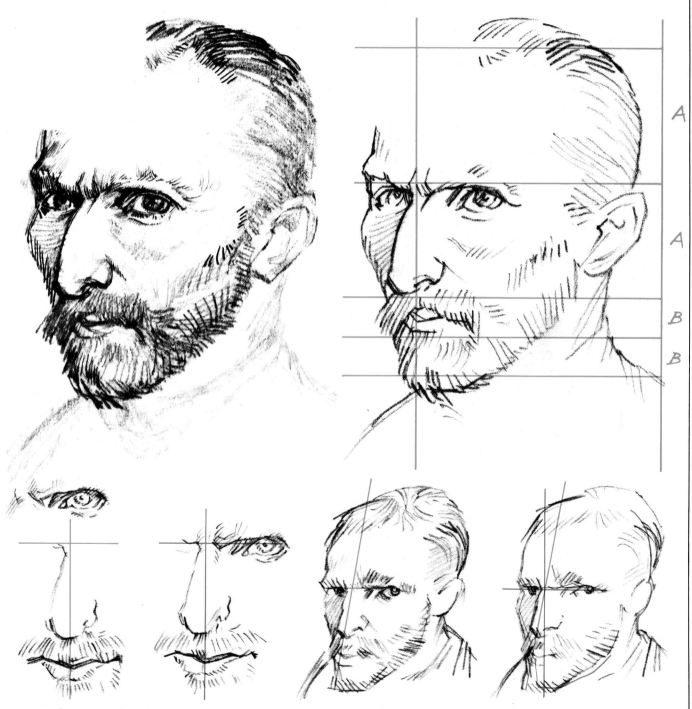

For a better understanding of van Gogh's way of working, look at these schematic representations of his sketches illustrating the painter's efforts to define proportions and alignments. In the pencil sketch (at the bottom of the page) and in the study of the nose and the eye, van Gogh seems to be seeking the shape of his face before drawing the foreshortening. He investigates his nose, his pupil, then his nose seen from the front.

In the sketch of his head, his search for "what is inside" makes him disregard the angles and proportions (which are then made specific in the final drawing).

# Rules and Freedom

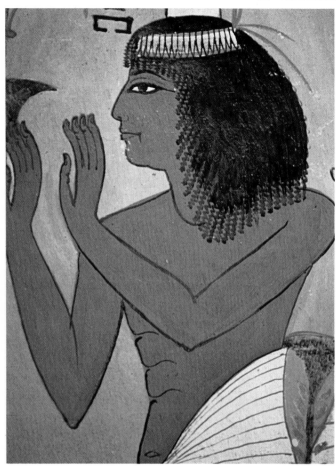

*Detail from a wall painting, 13th century B.C., in the tomb of Sennedjem in Deir-el-Medineh.*

*The Egyptians did not draw what they saw, they drew what they knew. Their figures and portraits follow precise canons, with geometrical and mathematical rules. The Egyptian artists knew that in order to depict the facial features, it is more effective to draw the profile, showing the line of the forehead, nose, chin, and then use the entire shape of the eye in the final drawing. The overall depiction of the figure follows the same principle: the upper part of the body is presented frontally, while the head is reproduced in profile.*

We have to deal with a difficulty that seems insurmountable or very nearly so: verisimilitude or complete likeness—the resemblance to the model.

Each era interprets the human figure according to a style, and each artist, as an interpreter of his era, sees and draws according to his personality.

*Lavinia, in a 13th century miniature from the* Aeneid *of Heinrich von Veldeke, Tübingen, Stiftung Preussischer Kulturbesitz, Depot der Staatsbibliothek.*

*The image of this miniature testifies to the efforts of the Byzantine artists to affirm the intense spirituality and almost magical character of the figures. These artists did not seek verisimilitude in movement or volume. They tended to depict an inner depth of thought in the dilated eyes, the facial pallor; in their magical figurations, the spiritual force seems to increase as the material force decreases.*

However, even before beginning to draw, we must remember that to draw means to know. Drawing is always an attempt to intensify reality, to express a reality that is more alive than the one we normally see. This is true of such varied artworks as the carved drawings of the Egyptians and the many drawings and paintings of Picasso.

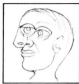

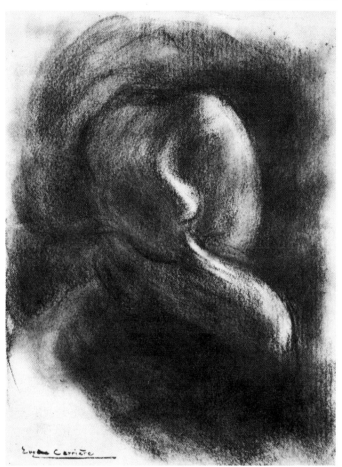

*Eugène Carrière (1849-1906):* Portrait of Woman with Her Face on Her Hand, *Charcoal, 35.1 × 25.4 mm. Louvre, Cabinet des Dessins, Paris.*

*Eugène Carrière confirms that he is a man of his time: using shadow effects, he seeks the variation of shape that the Impressionists tried to achieve with light effects. In addition, we see the poetic spirit and the personal synthesis. There is nothing superfluous here, all accessories vanish, we see only the essential. And the face emerges from the background like a sculpture bathed in penumbra (halftones and soft shadows), with the reflections of both mystery and life.*

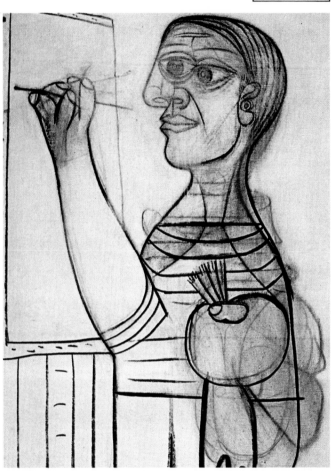

*Pablo Picasso (1881-1973):* Self-Portrait, 1938. Charcoal on canvas, no fixative, life-size.*

*Picasso interprets reality according to the Cubist vision. He overcomes the concept of a fixed, single framework by using multiple viewpoints and overlapping images in a single drawing. Picasso speaks of an inner eye that sees and senses emotionally: "Through this inner eye of the imagination, one can see, understand, and love beyond eyesight in the physical sense; and this inner vision can be all the more intense when the windows to the outer world are closed."*

Now the Egyptian images show human faces in profile, with the visible eye depicted from the front. Yet they are more vivid than reality. Why? Because the human face has two very obvious and significant elements: the "profile" and the eye seen frontally. The spontaneous fusion of these two elements in a drawing produces, not a monster, but a truer, more lifelike human being than we take for granted, than we normally see—or, more precisely, than we look at.

I am not saying that you should draw in one way rather than another. I only want to reaffirm the freedom of conception in drawing, freedom in seeing, thinking, interpreting.

# The Proportions

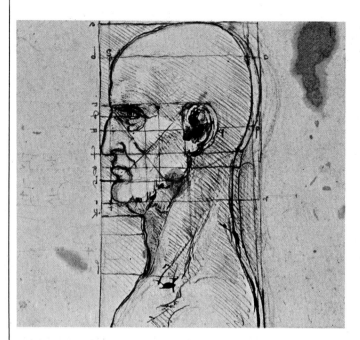

Leonardo da Vinci (1452-1519): Proportions of the Human Face. *Pen and ink, watercolor highlights, 343 × 245 mm. Academy Gallery, Venice.*

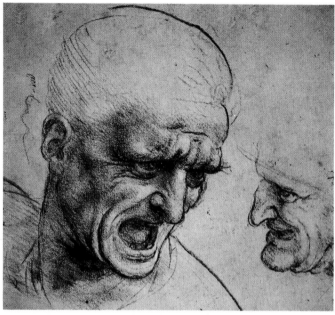

Leonardo da Vinci: Studies of Two Heads of Warriors. *Black pencil and traces of red, 191 × 198 mm. National Museum of Fine Arts, Budapest.*

Naturally, there are also standards for forms and proportions, and many artists have tested and studied them and theorized about them. Leonardo da Vinci did anatomical studies using modules to establish the essential points of the body parts and the various proportions within the body. He was looking for a rule and an ideal proportion. As we can see in the sketch reproduced above, the study of proportions involves placing the head (profile) inside an encompassing rectangle and then superimposing a network of lines and measures from which we can deduce the proportions of the forehead, the nose, the lips, the chin. Here, for instance, the distance from the upper lip to the nose is equal to the distance from the lower lip to the chin. Likewise, the horizontal line of the eyebrows touches the upper part of the ear, and the ear is the same length as the nose.

Da Vinci set down his theories in *Treatise on Painting.* After specifying that the "hump" of the nose can be any of at least eight types, he goes on: "The nose attaches to the eyebrow in two manners, that is, either concave or straight. There are three kinds of forehead: flat, concave, or bulging (that is, sticking out)." He then gives detailed advice to anyone who wants "to remember the shapes of a face. Take a pad and record the various forms of the nose, mouth, and other features, and "when you have glanced at the face of the person you wish to draw, check which nose or mouth resembles his, and make a small mark to remember it at home and then put it all together." After finding more forms of relative beauty in nature (as the German artist Dürer did later on), Da Vinci gives up the myth of the unique and ideal proportion: "The faces of different people can be equally beautiful, but they are never similar in appearance, there are as many different varieties as there are faces."

Da Vinci emphasized the characteristics of faces to the point of caricature or, as in the physiognomies in *The Last Supper,* he looked for types partly on the basis of his astrological knowledge, making each person look like his zodiac sign.

# Form and Chiaroscuro

In his *Treatise on Painting,* Leonardo da Vinci examines contours and chiaroscuro, and offers a simple and precise definition of painting from a scientific point of view. His definition is immediate and clear, like something that we have always known and that we think we are rediscovering: "Take a pane of glass half the size of a sheet of paper and hold it tightly in front of your eyes, between you and the thing you wish to draw. Next, move it far away, with your eye on the aforementioned glass—two thirds of an arm's length. Keep your head in place with an instrument so that you cannot move it at all. Then, shut or cover one eye and, with a brush or lead pencil mark on the glass what appears before you, and then trace it on paper. You can transfer it to good paper, and paint it, if you like, using aerial perspective."

Nothing is simpler for illustrating something that is, in reality, extraordinarily complex. Drawing is nothing other than tracing, with a brush or crayon on glass, the things that we, staying motionless, see through the glass. In scientific terms, this means that drawing is the "eye's projection of the object onto a vertical plane that cuts through the cone of vision. Said another way; at a certain distance from the face we insert the transparent glass on which we draw, thus cutting through the beam of "rays," that start from our eyes, to enwrap the object.

We can trace simply the form of the object, its outline, or using pencil, pen, or color, we can draw shadows, chiaroscuro, and tones as well.

Leonardo da Vinci's glass between the eye and the object (for tracing "what appears before you") was eventually replaced by something else. Leon Battista Alberti substituted the *velo* (Italian for veil), a grid, whose use he described in his treatise *On Painting.* Alberti's *velo* is a wooden frame with horizontal and vertical threads connecting the sides. The result is a network through which we can "sight" the object we want to draw. The object is thus divided and subdivided by a grid. The

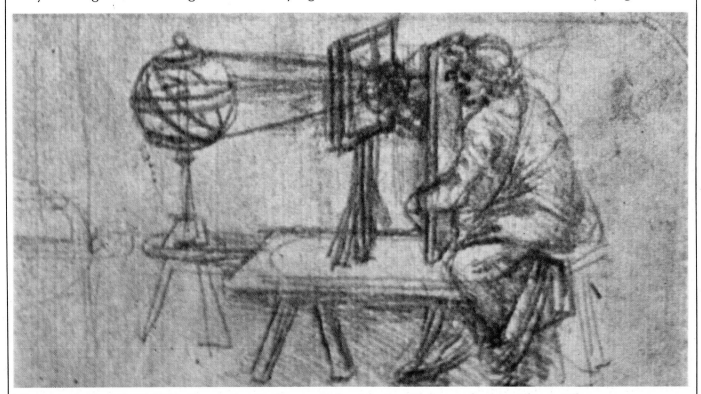

*Leonardo da Vinci (1452-1519):* Perspective Draftsman. *Codice Atlantico, 5th line, Ambrosiana Library, Milan.*

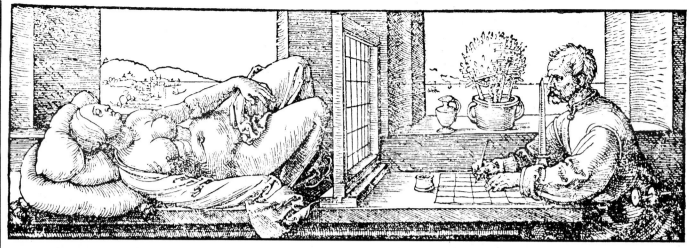

*Albrecht Dürer (1472-1528):* Man Drawing Reclining Woman. *Engraving from* Measuring Instructions, *printed in Nuremberg, 1525. Kupferstichkabinett, Berlin.*

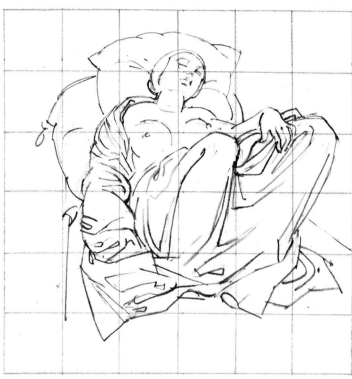

*Drawing of the* Reclining Woman *as probably seen by Dürer through the grid or velo* .

*Above right:*
*Pablo Picasso:* Nude, *1941.*

same grid is marked out on the sheet of graph paper on which we plan to reproduce our subject. The squares on the paper correspond to the squares of the grid *velo*, which, held up before our eyes, "frames" the subject. This makes our task a lot earier.

The German painter Albrecht Dürer (1471-1528) visited Italy hoping to master the laws of perspective. He studied Alberti and da Vinci and illustrated their teachings in four prints. One of these prints, *Man Drawing A Reclining Woman,* shows an instrument used for drawing in perspective. It is a *velo*, a grid attached to a vertical frame. On a sheet of graph paper, the artist is shown tracing the outline of the model in correct proportion. A small obelisk, perched on the table and reaching the observer's eye, guarantees the immo-

bility of the viewpoint.

With Leon Battista Alberti's device, da Vinci's definition, and Dürer's engraving, drawing, and the search for form, seemed defined once and for all—or at least until the Impressionists and then the Cubists shook off the tradition of a concept based on the line and the single, immobile view point in favor of depicting light and movement. What does this mean?

From the 15th to the 19th century, drawing had remained essentially the same. As conceived by da Vinci and illustrated by Dürer, drawing was the "projection" (image) of the object on a two-dimensional surface (glass, grid) from a single, motionless viewpoint. But now, the Impressionists became interested in light and color rather than outlines.

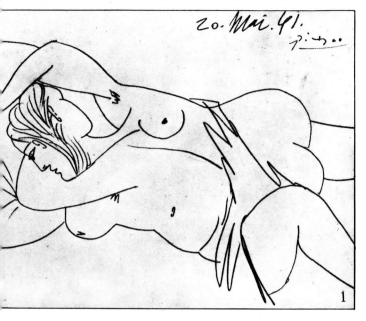

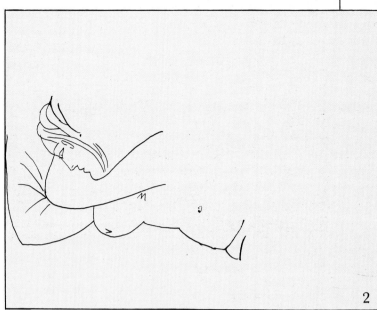

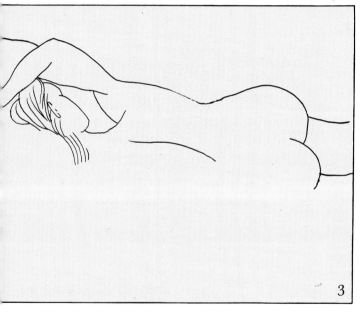

Finally, the Cubists added the fourth dimension, *time*, to the first three dimensions (width, height, and depth). *Time* is the succession of view points. The Cubists also applied a way of *seeing* that involved not only eyesight, but the other senses as well. The Cubists, especially Picasso and Braque, asked themselves the following question: "If I want to draw a reclining woman, why must I look at her from a single, motionless point of view? After all, I can and want to move around her, to see her from several vantage points, to draw the different frameworks simultaneously, and participate in her presence with all my senses—touch her with my hands, listen to her words—and thereby understand her feelings and experience her sensations."

Four centuries after Dürer, Picasso tackled the same theme, a woman lying with her head on cushions (1). If we dissect this drawing we see that Picasso began by drawing the figure in terms of the classic pattern, with her left arm folded under her profile (see Figure 2). Then he changed the viewpoint and, instead of completing the hair, he drew the head in three quarters, from the right and the back, with the arm raised (3), while the side view of the left breast and the right leg (4) intertwines with the view of the back through the barely delineated drapery.

In other words, Picasso moved around his model, looking at her and capturing, in a single drawing, the things he saw in successive moments. His depiction becomes the interpretation of an inner vision that is deeper and more dramatic.

## The Expressive Line

"The first painting was merely a line around a man's shadow created by the sunlight on the walls." These words were written by Leonardo da Vinci in his *Treatise on Painting*. Four centuries later, Delacroix was equally resolute in his *Journal:* "The first and most important thing in painting is the outline. The rest may be overlooked; but if there are outlines, then the painting is firm and finished."

For now, let's just touch upon the problem of drawing outlines (we'll get back to it several times). We'll start by facing the subject and defining the framework and the layout (pay attention to the proportions). We thus construct an overall line that "contains" the subject and designates its shape. Our drawing will develop this shape, re-producing the various elements and confronting them with one another. The elements should be seen, not separately, but in terms of one another.

To define the shape of the subject more effectively, we must not be content to see it directly, We have to draw the shape of the background (or the sky) as cut out by the subject, using the outline for this purpose.

This line will not always remain even and constant. It will "quiver" according to the shape that is drawn, according to the light and the shadow. This line will express not only the subject, but also the personality, way of life, and feelings of the person drawing it.

## The Fascination of the Line

Dürer and Picasso constituted two poles of de-

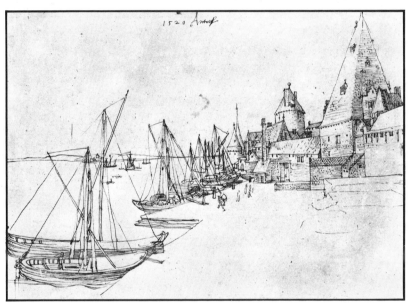

*Albrecht Dürer:* The Harbor of Antwerp. *Pen and ink, 213 × 283 mm. Graphische Sammlung Albertina, Vienna.*

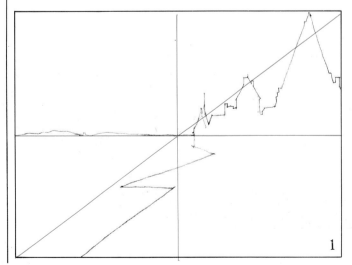

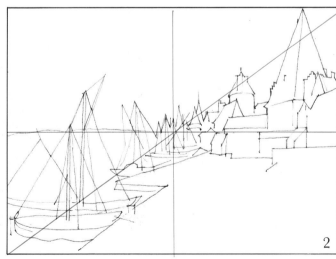

—24—

velopment in the history of drawing. We can analyze their different ways of viewing and drawing in these examples which illustrate the use of the outline alone in a landscape or interior.

In Dürer's drawing, the sharp precise line perfectly defines the boats and the buildings in the background within the context of overall composition. The composition is based on the diagonal line and on the geometrical play of the triangular forms of the boats and roofs (1).

This is a geometrical perspective, achieved by foreshortening the wharf and drawing objects in proportionate constructions. The aerial perspective is suggested by the expressive line, which is sharper in the foreground, and vague and blurry in the background. Dürer's drawing is richly poetic, yet it is constructed rationally, according to the optics and theory of the Renaissance (2).

Looking at Picasso's sketch, it is hard to find a basic geometry within the free composition. But, despite the seeming confusion, it is not hard to locate the plane of the background wall with the central window facing the garden (1). In the foreground, we discern something like a theatrical prop room, filled with studio objects in cheerful disorder (2).

In other words, Picasso moved around his model, looking at her and capturing, in a single drawing, the things he saw in successive moments. His depiction becomes the interpretation of an inner vision that is deeper and more dramatic.

*Pablo Picasso:* Inside the Villa "The California" in Cannes, *1955. Pencil. Collection of the artist.*

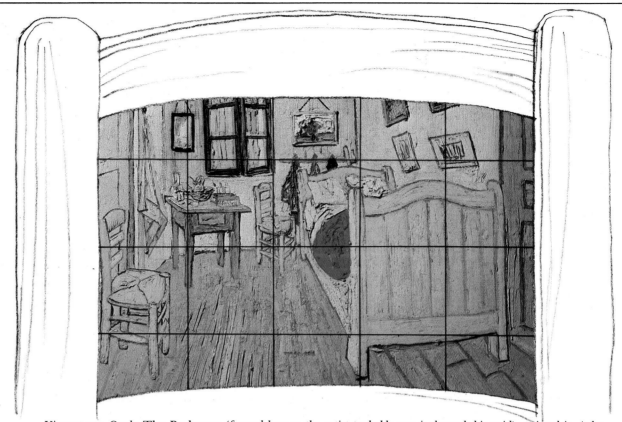

*Vincent van Gogh:* The Bedroom *(framed here as the artist probably saw it through his grid), painted in Arles, 1888. Canvas, 72 × 90 cm. National Vincent van Gogh Museum, Amsterdam.*

## Vincent van Gogh's Grid

At one point in his letters to his brother Théo, Vincent van Gogh refers to Leon Batista Alberti's grid (the grid *velo* designed by Dürer who referred to Alberti's instructions when he drew his famous print *Man Drawing Reclining Woman).* Van Gogh writes:

"Last winter, I spent less on paints than other artists, but I spent more on making an instrument to study proportions and perspective. You can find a description of it in a book by Albrecht Dürer. Even the old Dutch painters used it. This instrument makes it possible to compare the proportions of nearby objects and those in a distant plane, cases in which it is not possible to construct a picture according to the rules of perspective. When you try to work with the naked eye (unless you're one of the experts and one of the top ones at that), the result is always completely wrong. I didn't succeed immediately in building the instrument, but I did eventually after a great deal of effort, and the help of a carpenter. After a great deal of further effort, I can see the possibility of obtaining even better results."

This carpenter built van Gogh an apparatus just like the one suggested by Dürer's engraving. However, van Gogh had already attempted something similar, he had constructed his own grid. Using it, he could sight the object and thus simplify the process of working out the proportions and drawing the shape. This is how he made it: he took an old chair and tied horizontal threads between the two struts of the back and vertical threads between the two strips. This grid was then repeated on the drawing paper and painting.

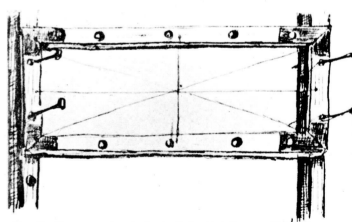

*Van Gogh's perspective device built in Aix, August, 1882. Pen and ink, 55 × 110 mm. Vincent van Gogh Foundation, Amsterdam.*

## Light and Shade (Chiaroscuro)

By using chiaroscuro (light and shade) in a drawing, we interpret the relationship between light and shade in the subject and establish the various degrees of brightness and darkness. Traditionally, painters have distinguished between five levels of intensity in chiaroscuro: light, shade, reflections, halftones, colors. In a black-and-white drawing, the artist achieves light by drawing shade. One of the chief difficulties here is, of course, the network of reflections—the areas that are dark and yet enjoy light sent from a brighter area or light source. How do we achieve chiaroscuro?

For now, let's limit ourselves to a one-color drawing, a monochrome. The gradual passages of tones from light to shade can be achieved in a number of ways. The outline can more or less interweave light and shade. This is known as *sfumato:* you smudge the outline with your finger or your stump. You can also use crosshatching, an interweaving of more or less sloping lines. You can even try brief strokes and dots, often with the aid of the granular quality of the paper, which permits a more interesting passage from the light areas to the dark areas. Finally, you can try halftones or a sharp separation of light and dark areas.

- After defining the shapes of the subject by means of the outline, draw the shapes of the dark zones (shade) and the cast shadows. Emphasize the "shade separator" or "accent"—the ideal line that divides the illuminated area from the dark area.

- Then begin to extend the chiaroscuro from the darkest point, gradating everything else in terms of this point. The darkest places should not be drawn very darkly right away. Instead, shade them in little by little working all the dark areas of the drawing at once. There is thus a gradual deepening of the definition of the dark areas and the reflections.

- The problem of reflections demands particular care, not only in the depiction of the darkness, but also in the realization and the technique. The dark areas (the outlines and the sfumato) have to have the transparency that hints at the effect of reflection.

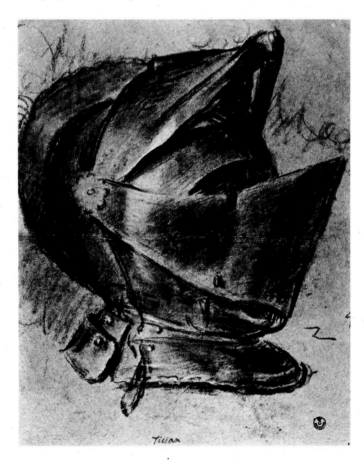

*Titian Vecellio (c. 1487-1576):* Study of a Helmet. *Charcoal and white lead on pale blue paper, 451 × 358 mm. Uffizi, Gabinetto dei Disegni e delle Stampe, Florence.*

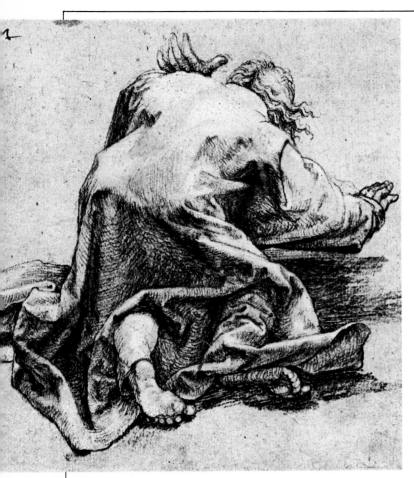

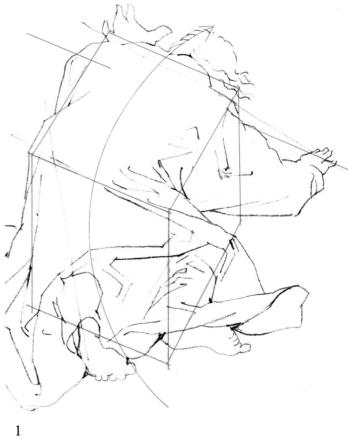

## Chiaroscuro Reveals Form

These two studies, remote in time and conception, are nevertheless revealing in regard to the quest for volume, drapery, and chiaroscuro.

In Grünewald's drawing, the effect of light and shade makes "squares" of the planes of the figure, connecting the plane of the back and the plane of the legs. Yet, there is a precise and attentive definition of the folds in the garment. The apostle seems squeezed into a cube, as demonstrated by the schematization (1). His figure achieves sculptural volume as it crouches on the ground (defined only by his shadow), which is parallel to the plane of his back. The rolling movement has an extraordinary effect. The chiaroscuro, giving weight and volume to the image, is rendered by an open outline. This outline is strengthened by crosshatchings in the darker areas. The technique and sureness of execution are highly instructive. Run your eyes slowly across the drapery of the apostle's coat. Note the details in the schematization at the right. Also, observe the drawing of the creases and their shapes, the balance (tone relationship) of the chiaroscuro, the transparency of the reflections in the dark areas.

*Mathias Gothart Neithart Grünewald (c. 1460-1528):* Studies for an Apostle, *Black pencil on gray watercolor with white-lead highlights, 146 × 208 mm. Staatliche Kunstsammlungen, Kupferstichkabinett, Dresden.*

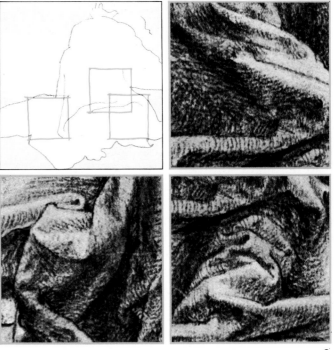

2

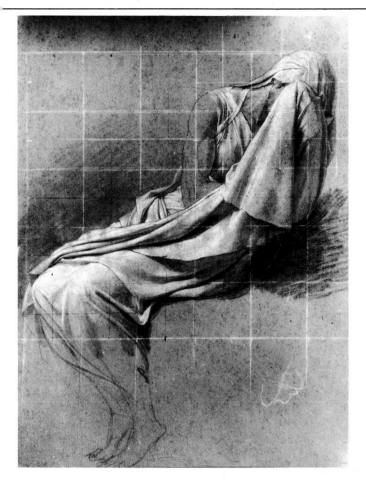

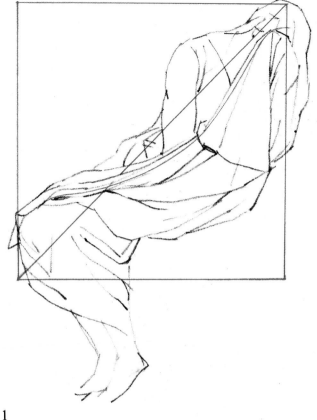

1

There is no substitute for drawing from life. But sometimes, "copying" a drawing like this one can be useful. Try to capture the sureness of the overall structure as well as the style and technique of the chiaroscuro effects. A good exercise is to focus on a few details and enlarge them.

In this study by David, the composition is based on a diagonal (1). Its great strength lies in the effects of light and shade and in the soft material of the cloak. A dramatic sensation is derived from concealing the face in the folds, as the soft line of the drapery leads us to the arm that cradles the head. In the drawing, the figure seems decomposed, or rather, to live only in the long creases that are brought out by the light (2). The white lead highlights on the beige paper accentuate the substance and softness of the cloth. This makes David's study instructive for the student of drawing. In studying the effects of synthesis, we cannot overlook the winding area of the knees, the softness of the drapery that leads to the head, the triangular block of volume that completes the figuration. David's refined technique, with his fusion of pencil and water-colored white lead, is the product of long practice and experience.

*Jacques-Louis David (1748-1825):* Study for Brutus. *Black pencil with white lead highlights on beige paper, pasted on cardboard and gridded in white chalk, 566 × 432 mm. Musée des Beaux-Arts, Tours.*

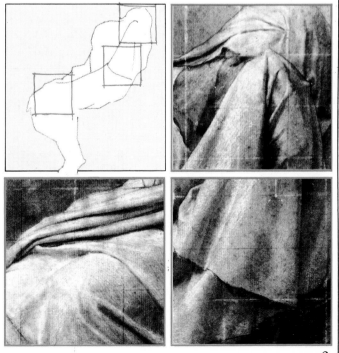

2

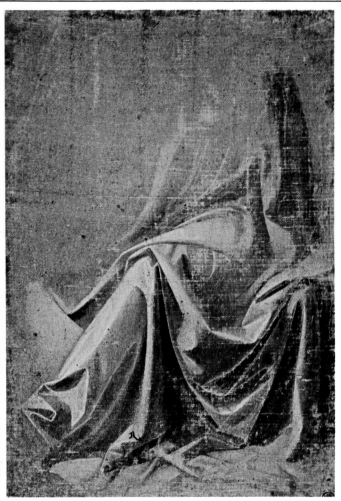

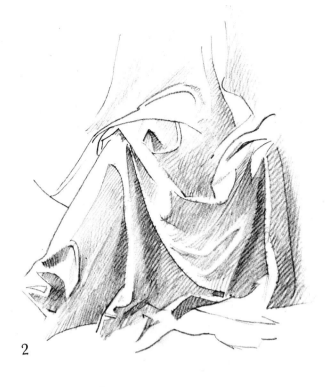

2

3

*Leonardo da Vinci:* Drapery Study. *Gray tempera and white lead on linen canvas, 288 × 204 mm. Uffizi, Gabinetto dei Disegni e delle Stampe, Florence.*

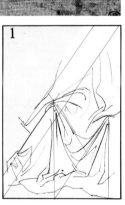

1

## Da Vinci's Shade and Shadows

In analyzing da Vinci's study, we see (1) the overall composition, the geometry of the drapery and the basic lines and angles.

Next (2) we explore the outlines of the drapery and folds, which are drawn with an expressive line that interprets and emphasizes not only the forms, but also the shade and light. Finally (3), we look at the first draft of the chiaroscuro. Starting at the darker points (while eyeing the lighter points), the chiaroscuro is worked out in the drawing of the form with "successive coats," which gradually reenforce it and bring out areas of light and shade.

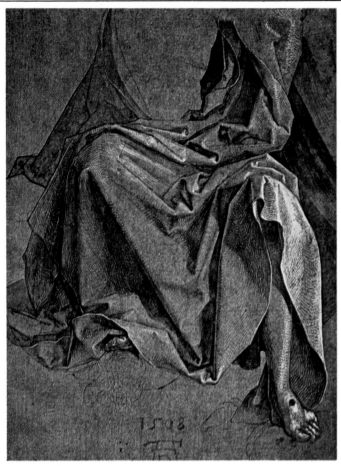

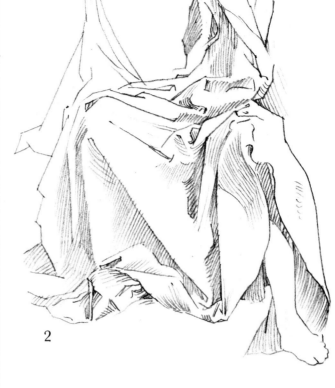

*Albrecht Dürer:* Drapery Study. *Pen and black ink with white lead highlights on prepared green paper, 255 × 190 mm. Louvre, Cabinet des Dessins, Paris.*

## Dürer's Light

Looking at Dürer's drawing, we first analyze the composition, which is based on vertical and diagonal lines (1), by finding and reconstructing the hidden geometry. This deepens our observation and guarantees a correct proportioning.

The second phase of our analysis (2) focuses on the shape, achieved with a sensitive line, which produces a rich network of folds in the drapery and a clear separation of light and shade.

The third part (3) of our analysis points out one of the many phases of drawing the chiaroscuro. These phases are characterized by an equal relationship between the various dark areas; as the chiaroscuro gradates from the darkest point, it progressively strengthens the other points.

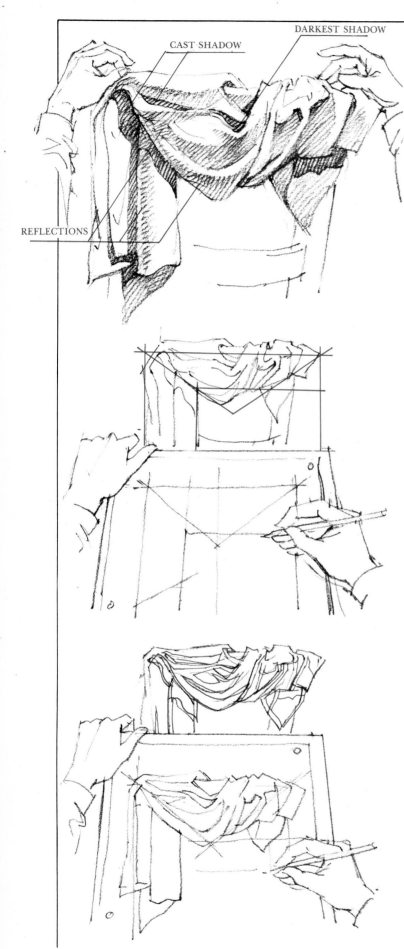

CAST·SHADOW

DARKEST SHADOW

REFLECTIONS

## A Study of Drapery

We can now practice rendering any object we like using outline and chiaroscuro. However, if we wish to learn directly from the masters, drawing drapery (as illustrated in the preceding pages), will help us practice what they taught. We can imitate their ways of seeing and drawing if we too work on drapery after studying the examples illustrated in these pages.

Your model can be any kind of cloth you happen to have at hand. For instance, a towel. Drape it over the back of a chair or put it on a table. Try to bring out the folds suggested by the sketch (on the left), letting it fall on one side and crumpling it together on the other. In this way, you can obtain a large variety of creases, forms, and chiaroscuro.

Once you have arranged your cloth model, start to draw it. Use a soft no. 2 pencil on a sheet of medium-grain paper, neither too smooth nor too rough. First, try to find the structural lines, the direction of the lines of force, which make up this specific composition. You are actually constructing a geometric pattern as a basis for your procedure.

Then continue, attentively observing your subject. You are virtually reading its form. Draw the overall outline and the contours of the folds and creases. Press harder on the line wherever the shade is darker, but lighten your touch in the light areas.

Verify the accuracy of the shapes by constantly checking the various parts. Compare the relative width and length of the overall shape with the individual parts. Next, go on to the chiaroscuro. But first construct the shapes of the shadows, draw the outlines of dark areas and cast shadows by viewing them with your eyes half shut so that you can get an immediate image of synthesis.

Finally, sketch in the dark areas, bearing down and crosshatching wherever the shade is darker. In this way, the first draft of the chiaroscuro will preserve the effect of reflections.

There are no rules to guide us in the difficult rendering of the chiaroscuro. But experience teaches us the following:

- shade and shadow look darker near their edges because of the light reflected onto their inner areas;

- cast shadows are generally darker than shaded areas.

# Shape

In a logical sequence of instruction as in the process of drawing, shape is followed by chiaroscuro, and chiaroscuro by color.

Now what is the relationship between shape and color? We can say that shape is an abstraction, an imaginary line that defines the object in relation to the background. Space is a black outline that we draw on a white surface. On the other hand, color is the luminous substance of the object, the tones that reveal its complexity and volume.

Even in a drawing done in a single color, light and dark are expressed in the same tonality, which is more or less intense.

This too is an abstraction. Obviously, a monochrome drawing does not represent reality. It merely suggests it, indicating balance of light or shade, the brightness and darkness of the object, rather than its colors or their nuances and gradations.

A monochrome can be fascinating. And so is chiaroscuro in black and white. Because it suggests color and volume, it gives greater scope and freer rein to the spectator's imagination and participation. Nevertheless, the image we receive from an object is obviously colored. And if we observe it in order to depict it, we are more often struck by the color than by the shape or form.

For this reason, when we think about color after thinking about shape, we have to plan and interpret colors as *colored shapes* rather than colored light and shade. We have to find the *colored* shapes of the objects, the *colored* shapes of light and dark.

The French painter Eugène Delacroix said the following about the "shape of color":

"We have to carefully distinguish the various planes, circumscribing each one; we have to arrange them in the order in which they present themselves to the light; we have to first pick out and only then paint those that have the same value."

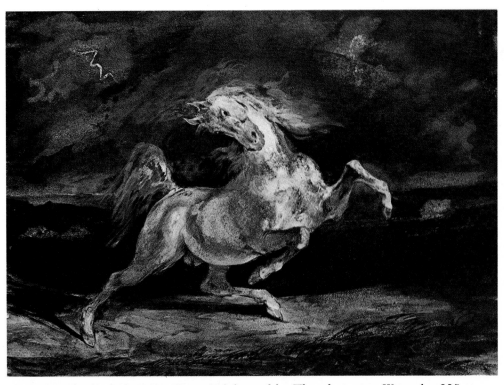

*Eugène Delacroix (1798-1863):* Horse Frightened by Thunderstorm. *Watercolor, 235 × 320 mm. National Museum of Fine Arts, Budapest.*

# The Color Spectrum

A world without colors would be inconceivable. Colors are the constituent elements of light, revealing the soul and spirit of our world.

In 1676, the English physicist Isaac Newton used a triangular prism to demonstrate the formation of colors and to reveal the color spectrum. He let white sunlight pass through a crack and strike a triangular prism. By intercepting this light ray, he obtained a range of colors from red to orange, yellow, green, blue, and finally violet.

If you use a converging lens to recompose this gamut of colors on a different screen, you will once again have white light. Naturally, you can also obtain other results. You can have some of the colors of the spectrum converge separately, for instance red, orange, and yellow on one side, and green, blue, and violet on the other. Then, by fusing these two sets, you can again get white.

The basic colors are red, yellow, and blue. All the other colors are combinations of any of these three. Mixing red and blue produces purple. Blue and yellow will produce green, red and yellow will produce orange. Complementary colors are colors that, when combined, produce white (We are speaking, of course, of the colors of light). Thus, if we isolate one color from the spectrum, for instance, red, and fuse the rest by means of a converging lens, the result will be green; green is the complementary of red, the color we have isolated. If, on the other hand, we isolate yellow, the remaining colors will produce its complement: violet. Every color in the light spectrum is the complement of the color resulting from the blend of all the others. Thus, red is the complement of green (blue + yellow). Blue is the complement of

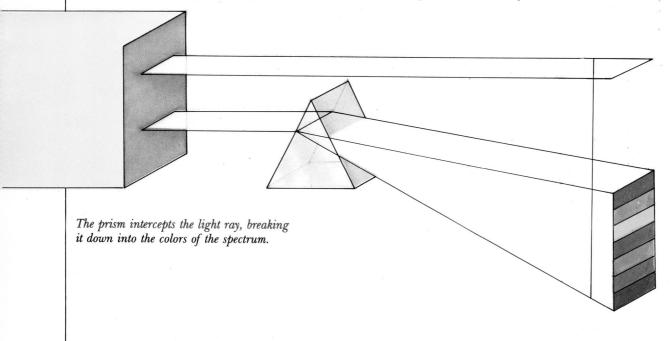

*The prism intercepts the light ray, breaking it down into the colors of the spectrum.*

*The spectrum includes all the colors except purple.*

orange (red + yellow). And yellow is the complementary of violet (blue + red).

## How Colors Are Produced

Colors are produced by light waves, which are a particular type of electromagnetic radiation. We measure wave lengths in *microns*, symbolized by the Greek letter $\mu$. The light waves perceived by our eyes are those between 400 and 700 $\mu$ in length. Hence, there are colors that human beings or animals cannot see because their wavelengths are outside our visible range.

## Why Do Objects Appear Colored?

A green plant looks green because it absorbs all the other colors of the spectrum and reflects only green.
We can confirm this by placing a green filter in front of the color spectrum. The green filter absorbs all the colors but green. No color remains, and the result is black. Thus, when we say a plant is green, we are really saying that the surface of the plant is made up in such a way as to absorb all light rays that are not green. In other words, the plant itself has no color. It is the light that makes it look colored.

## Balance of Colors

Joan Miró said: "I almost always begin with the blacks, I look at them again the next day, and when I am satisfied with the drawing, I then tackle the colors. The colors follow the drawing, and I arrange them in a certain equilibrium. For instance, I put a red next to a black point, a blue next to the red, then green after blue, and yellow after green. I then enrich the whole thing by touching it up a little."

*Joan Mirò (1893):* Nightingale Wing Circled by Gilded Blue Joins the Heart of the Poppy Sleeping on the Prairie Adorned with Diamonds. *Pierre Matisse Gallery, New York.*

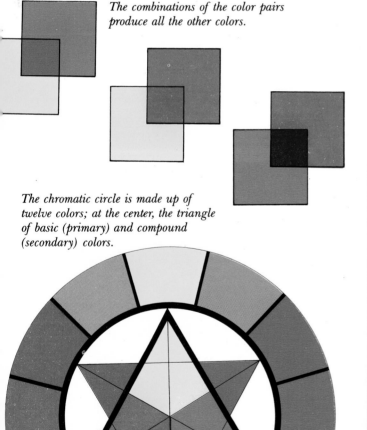

*The combinations of the color pairs produce all the other colors.*

*The chromatic circle is made up of twelve colors; at the center, the triangle of basic (primary) and compound (secondary) colors.*

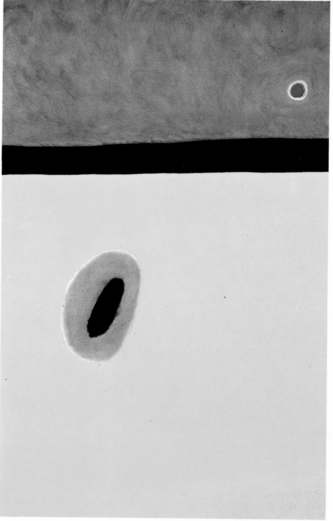

*Giorgio Morandi:* Still Life, *c. 1962. Watercolor and pencil, 323 × 230 mm. Private collection, Milan.*

## Morandi's Imprints

Georgio Morandi is famous above all for his etchings, landscapes, and still lifes. The latter contain glasses, bottles, and jugs in gradated tones, a refined range of grays.

His watercolors reveal the artist's restrained and delicate palette. They condense an extraordinarily deep message with an extreme economy of means. Morandi uses two or three tones of ochre, gray, blue, modulated on the white of the paper, and attuned to the empty spaces of the surface.

It is the *empty spaces* of his watercolors that draw our attention and arouse our imagination. We have to remember and observe these "vacuums" when we try to *see* the shapes of the object we are drawing. In Morandi's watercolors, the synthesis of the shapes (filled spaces) and the background (empty spaces) is carried to the ultimate in his spare, linear imprints.

We know very well that such simplicity, such synthesis and essentiality comes from years of work, experience, and mastery. Still, when we do our own drawings, we can look at Morandi's work and find inspiration in his lean cut-out spaces.

Follow this procedure:

- For your model select a few simple objects: bottles, carafes, boxes, glasses, arranged next to one another.

- Draw them attentively, lovingly. Look closely at the proportions. Examine the outlines etched against the background by half closing your eyes and reading the shapes of the spaces between the objects.

- When you add the colors, fill in the outlines patiently and carefully. This applies to the objects and especially to the background. Use pencils or brushes, pastels or watercolors.

- Observe the real colors of the objects in light. For the moment, forget about the chiaroscuro and the shadows (you can note them on the side). Try to pinpoint the colors of the shadows by picturing their outlines.

- Select an initial color, the lightest or darkest, and then gradate the other colors in terms of this one.

- Half close your eyes in order to filter the colors and reduce them to the main tones, which you will then apply to the paper.

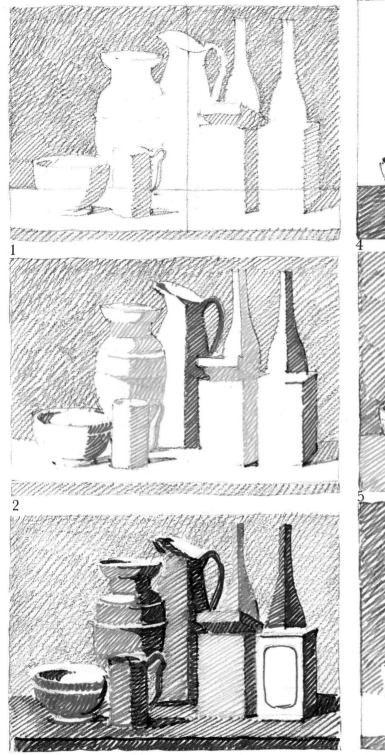

1

2

3

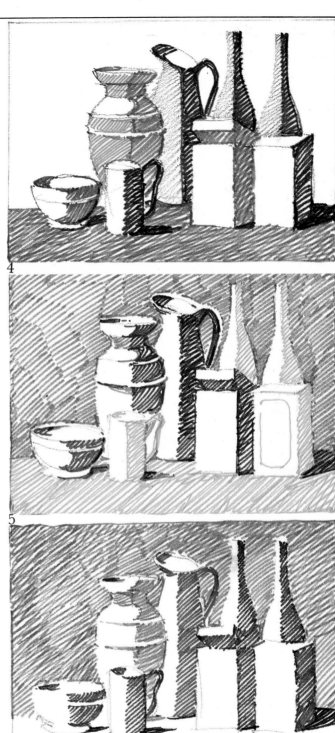

4

5

6

• Don't worry about applying "all" the colors you see. Pick those that strike your fancy. Or make the composition uniform with the predominant color.

The first drawing will probably not work out as you want. Do it over, several times. Make it simpler and more essential each time. In the end, you will have an imaginative drawing that is also true because it is yours.

*Diagrams 1, 2, and 3 illustrate the successive stages in drawing shapes and defining colors and areas of light and shade.*

*Diagrams 4, 5, and 6 exemplify some possibilities of interpreting colors personally, depending on the time and the intention. After closely observing the shapes and colors of the subject, draw it and color it freely without looking at it, in order to reinvent it as an expression of your personality. Limit the colors of your palette to a few tones, especially at the beginning. If you are drawing monochrome or nearly monochrome objects, use a different color for only one.*

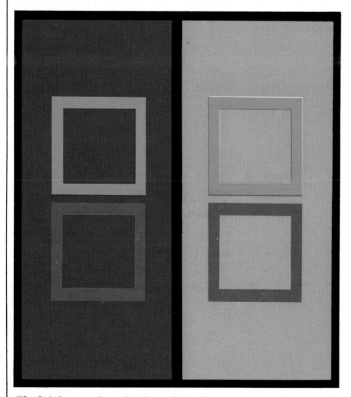

*The same colored form—the gray square—seems to change tone and size against different backgrounds.*

*The brightness of a color depends on the colors surrounding it or beneath it.*

# Color Values

If you wish to obtain a specific effect, it is important to know how to vary the value of a color in terms of the surroundings, that is, in terms of the colors around it. How are colors perceived? The value of a color can be gauged only in relation to the so-called "negative colors" (that is, black, white, gray) and the other colors nearby.

We all know that the chromatic effect of a color changes depending on the adjacent colors. Yellow may look different if it is next to white, or black, or red, or green. Finally, the size of a colored square seems to change depending on whether the background is white or black.

Try the following experiment. Cut two equal squares out of gray paper and put them on larger squares, one red and one blue. You will instantly see that the gray square on the red seems bluish and larger, while the gray square on the blue seems reddish and smaller.

Now cut out two equal-sized square frames from green-yellow paper and two from violet-red paper. Place one square of each color in a vertical position against an ultramarine background and then an orange background. You will instantly see that the green against the blue (at the left) seems lighter, while the violet tends toward red. Conversely, on the right side, the green on orange seems darker, and the violet tends toward blue.

If we then speak of the simultaneous effect of two or more colors, we are dealing with harmony, a subject treated at length in the following chapters. It is difficult to agree on an objective definition of color harmony. In general, we can say that arrangements of adjacent colors are harmonious if they are "pleasing" or "agreeable." These notions are based on personal opinions and feelings.

In his *Theory of Colors*, the German poet Goethe wrote: "If the eye perceives a color, it is instantly made active and it is constrained by its nature to instantly produce another color, which, together with the first, comprises the totality of the chromatic scale. Each single color, by means of a specific sensation, stimulates the eye to strive for the totality. This is the fundamental law of all chromatic harmony."

On the basis of all this and on the basis of personal experience, we may conclude that all pairs of complementary colors are harmonious, as are other arrangements, such as green-orange-violet, or yellow-orange-blue-violet.

# The Meanings of Colors

In all eras, people have been very curious about the meanings of colors. In the past, these meanings were seen as chiefly literary and scholarly. But today, we focus on studying the perception of colors. In the mid 18th century, Cardinal Federico Borromeo noted that "colors are almost words, which, perceived by the eyes, penetrate into the soul, just like voices perceived by the ears." This is why we can classify colors by effects.

We all know that a primary classification of colors puts them into categories of hot, cold, and neutral, depending on the sensations they produce. Red, yellow, and their mixtures are hot. Blue, green, and their combinations are cold. White, black, and gray are neutral. However, if we talk about symbolic meanings and individual perceptions of colors, we find hidden significances. Red, for instance, can excite a person because it is normally associated with blood and fire. Green recalls nature, fields, trees, it induces calm and relaxation.

Goethe divided colors in the following way:

- positive (or active): yellow, reddish yellow (orange), and yellowish red (red lead and cinnabar). These colors induce "an active behavior."

- negative (or passive): blue, reddish blue, bluish red, colors which "conform to a restless, malleable, passionate, and tender frame of mind."

Thus, for Goethe, red contains dignity and serenity, because he feels that it combines all the other colors: a light landscape, observed through red glass strikes "through the atmosphere, which, thus transformed, arouses awe and reverence, reminding us of the diffuse light in the sky and on earth at Judgment Day."

Yellow, says Goethe, is "gay and tenderly attractive." When strengthened by red, it becomes "more powerful and magnificent," and, more than any other color, it "gives us a sense of warmth and delight."

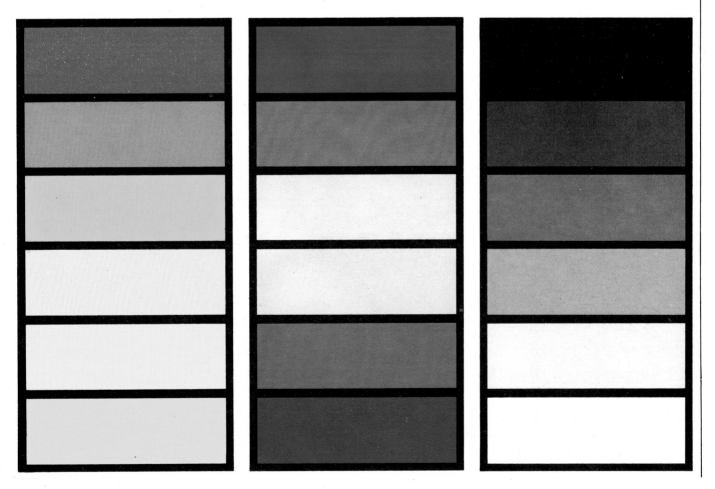

Blue is an "enchanting nothingness." But if it becomes reddish blue, "it makes us restless, nervous, it keeps us inactive."

The French painter Matisse also thought about the effects of colors: "Pure colors can act on our inner feelings more powerfully if they are simple colors. A blue, for instance, accompanied by the irradiation of its complementaries, hits our emotions like an energetic gong stroke. The same applies to yellow and red, and the artist has to manipulate them according to necessity."

Yet this "necessity" now has different and varied applications in everyday life.

For instance, architects are well aware of the meanings of colors in their interior decorations. Yellow might be more fitting for a children's room, while blue-green might be more suitable for a bedroom.

A football coach might have his team's locker room painted blue to create an atmosphere of relaxation during the half-time. On the other hand, he might paint the outer room red in order to create a more arousing background for his pep talks.

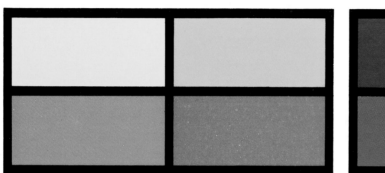 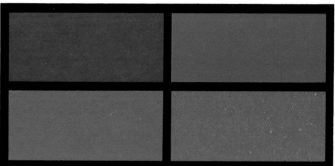

*Johann Wolfgang von Goethe (1749-1832):* The Symbolic Image of the Magnet.
*Watercolor, Forschungs und Gedenkstätten der klassischen deutschen Literatur in Weimar.*

# Drawing With Colors

If you want to draw with colors, you have to observe your subject and find a reference point, that is, one color on which to establish the color of everything else. As usual, we ought to listen to what the masters have to say. Delacroix wrote in his diaries: "It would be good to start working out the scale of values in a painting by choosing a light-colored subject whose tone and value could be copied from life: a handkerchief, a piece of material...."

Remember these words when you find yourself in front of a landscape—a green meadow, for instance. Place a white handkerchief on the grass, and gradate your colors on the basis of that white.

With their big, bright masses of color, Matisse's paintings seem to result from an immediate impact with nature or objects. Actually, before painting a picture, he would first do small sketches of the subject, with precise indications of the choice and distribution of the colors. In other words, before trusting his instinct and sensitivity, he created a compositional color scheme, which he would then take over fully or else modify.

After studying the shapes of the objects and their relationship to the chosen frame, you should indicate the main colors. Next, "cut out" the shapes of the colors and the shadows on the silhouette of the subject itself, according to the contours and the lines separating light and dark. To gain even better insight into the shapes of colors and of (colored) shade, analyze the works of Matisse, delve into their compositions.

The figure of a seated woman is created with blue paper, partially colored by the artist. The still life on the next page is painted in oil pigments that fill well-defined outlines, reducing the chiaroscuro as much as possible and thus emphasizing the pure tones.

And now, let's do it ourselves.

**1.** Pick a theme, a subject for your composition from among the everyday objects you see around you: vases and bottles, flowers and fruits, books and newspapers. For now, select breakfast items: a cup, coffee pot, roll, newspaper. Arrange them on

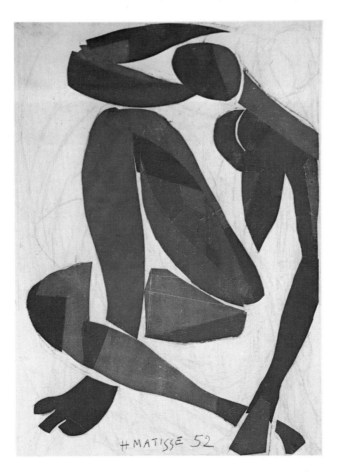

*Henri Matisse (1869-1954):* Blue Nude IV, *1952. Cut-out gouache, 103 × 74 cm.*
*Musée Henri Matisse, Nice. (Jean Matisse Donation).*

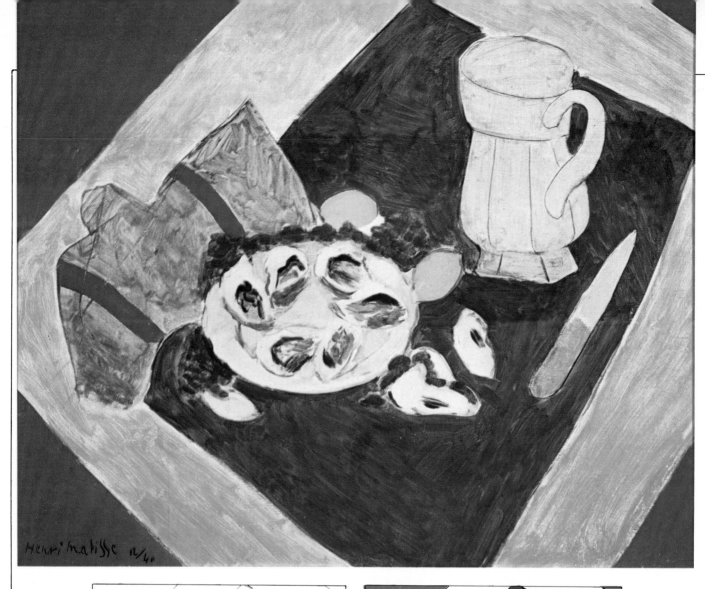

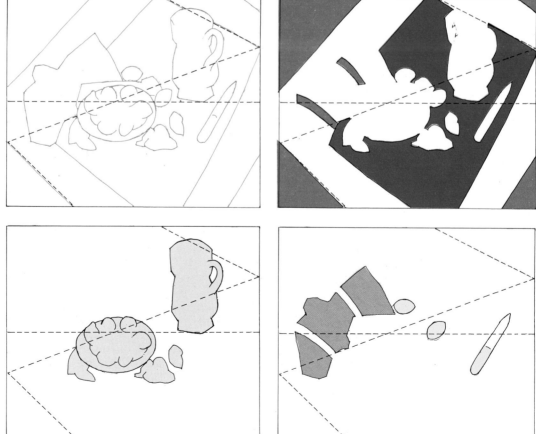

a table corner in accordance with your taste and your sense of order.

**2.** Do one of the following two possibilities:

    a) Draw these objects with your pencil, defining the outlines and then coloring them in with pastels, watercolors, or whatever you prefer. In so doing, simplify the chiaroscuro. You might even separate the light from the shade with an imaginary line with a different color for each area.

    b) Find the colors of the objects in colored paper that you already have at hand or that you can obtain. Take these sheets of colored paper and cut out pieces in the shapes of the objects. This method will help you to see the shapes of the colors.

**3.** Sketch the shapes of the elements in the composition. While you draw the outlines with a pencil, consider the "right color" for each element (for the time being, disregard the chiaroscuro).

**4.** Find the colored paper best suited to render each object. If you can't find the colored paper you want for each element, draw and color them with your own colors.

Matisse, as we have seen, was not content with using colored paper for his *papiers collés* ("pasted papers"). In his collages, he painted the paper himself, and pasted the various pieces on top of one another. In this way he obtained an interplay of tones, often with subtle variations.

When we start our experiments, we can make do with the colored paper that we already have, from notebook leaves to bread wrappers, magazine pages, and newsprint. This too was suggested by the masters: depict an object by using the same material that it is made of. Basically, instead of resorting to a palette of traditional media (pastels, watercolors, tempera), you employ the palette offered by the world around you. Naturally, this "game," which seems so simple, is not really all that way. You have to create balance, harmony, and meaning (beyond a curious effect or even a *trompe-l'oeil*). The artists who expressed themselves in collages called upon the full wealth of their experience in drawing and coloring.

As the diagrams of Matisse's compositions confirm, everything that at first sight looks natural and immediate is actually the result of a complex process. The outlines, filled in with colors, reveal a quest for balance.

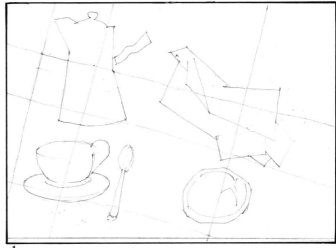

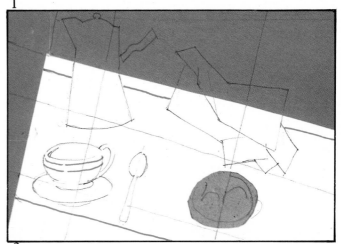

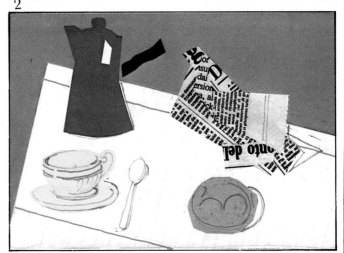

*In this example, the tablecloth is rendered by a piece of lined paper pasted on the background color. On it, two lines are drawn in blue pencil. The cup is cut out of white paper; the roll from beige paper; the coffee pot is made of rust-colored paper (the shimmer is suggested by a piece of white paper pasted on it; while the newspaper is constructed with a page of newsprint, on which other cutouts are pasted in successive layers). The phases of the drawing are indicated in the three schematizations and the "construction" of the composition is based on sloping lines that are perpendicular to one another. In phase 1, the objects are arranged in the corners of a rectangle. In phases 2 and 3 the shapes are balanced with white, rust, gray, and straw-yellow.*

*Top left: Henri Matisse:* Still Life with Oysters; *1940. Oil on canvas. Öffentliches Kunstmuseum, Basel.*

# The Colors of the Mountain

Mont Sainte-Victoire was one of Cézanne's favorite subjects, and he often depicted it in his drawings, watercolors, and oil paintings. Beyond the inspiration of the landscape, this subject fascinated him because the volume of the mountain embodied the geometric principles that formed the basis of his artistic theory and philosophy.

In a letter of 1904, Cézanne wrote to his friend Émile Bernard: "Draw nature in terms of a cylinder, sphere, cone, everything in perspective, so that every line of an object, of a plane runs toward a central point. The lines parallel to the horizon create extension, that is, a section of nature or, if you prefer, of the spectacle that God, the Omnipotent Eternal Father, presents to our eyes. The lines perpendicular to the horizon create depth. Now, for us human beings, nature is more in depth than on the surface; hence the need to introduce light vibrations, which are presented by reds and yellows, a sufficient amount of blues, in order to let us feel the air."

In Cézanne's watercolors, these tones not only render the distant and fascinating mountain, they also demonstrate pictorial problems and offer possibilities for solving them: You have to draw and paint your subject several times. Beyond the meanings suggested by the successive depictions of the mountain, these paintings confirm Cézanne's genius as a painter. Cézanne based his palette on a structure of light and he succeeded in making the luminous quiverings of Impressionism both solid and transparent.

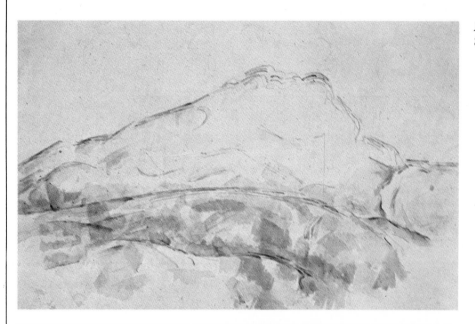

*Paul Cézanne (1839-1906):* Mont Sainte-Victoire, c. 1902. Watercolor, 310 × 480 mm. Private collection, U.S.A.

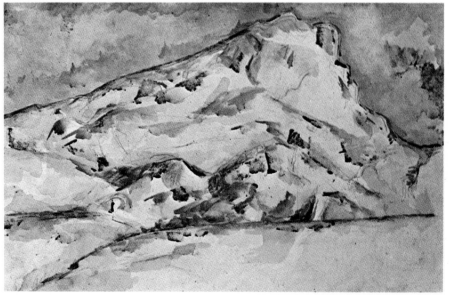

*Paul Cézanne:* Mont Sainte-Victoire, c. 1900. Watercolor with graphic strokes, 311 × 479 mm. Louvre, Paris.

*Mont Sainte-Victoire: its image will haunt Cézanne until the end of his life. It is seen as a huge mass of light, in which tones of orange and green, blue and violet, seem to symbolize the colors and things of this world, while the transitions from dark to light seem to symbolize the passage from the earth to the sky.*

# Real Image Versus Idea

When we look at something the light rays coming from the object enter the pupil, pass through the crystalline lens, and hit the retina, especially the sensitive area containing the nerve cells, where the eye and the brain meet. These cells enable us to perceive what we see. The image of the viewed object then forms on the retina. However, if we think of something, we similarly perceive an image; we *see* it, so to speak, with the mind's eye.

In other words, we can hypothesize that the process is the same for both a real image and an idea. But in the former case, the sensations come from the eye and the retina and are transmitted to the brain. And in the second case, the sensations originate in the brain.

The following basic concept will clarify the points that are of interest to us. There exists a real image of what we see with our eyes, but there also exists an image of what we think; each of these images form a "mental drawing."

Picasso translated this concept in his own way: "It is at the junction of perception and the deepest reasons of the mind that we find an inner metaphysical eye, which sees and feels emotionally. Through this eye of the imagination, we can see, understand, and love even without vision in the physical sense; and this inner eyesight can be all the more intense when the windows to the outer world are closed."

*Odilon Redon (1840-1916):* The Eye as a Bizarre Balloon Moving Toward Infinity. *Lithograph for the volume* Edgar Allan Poe, 1882. 262 × 198 mm. Fischbacher Gallery, Paris.

# The Real Image

## Canaletto and the Camera Obscura

To fully understand the formation of a real image and its depiction, we have reconstructed Canaletto's research. This Italian painter devised an instrument with which he succeeded in "capturing" and seeing the image on a transparent screen in order to draw it. This instrument was called *camera obscura,* literally "dark room."

Giovanni Antonio Canal, nicknamed Canaletto, worked mainly in Venice during the first half of the 18th century. He was renowned for his vistas—splendid panoramic views of the Grand Canal, Piazza San Marco, Piazza delle Mercerie, etc. To execute these paintings, he took a device already in vogue among the Northern European painters and perfected it as the camera obscura. His apparatus is now on display at the Museo Correr in Venice.

The camera obscura is essentially a box. Images of outside objects or, more precisely, the light rays coming from them, enter through a tiny hole and are reflected on a sheet of paper attached to the back of the box. The images form on this paper. This instrument was improved by means of a small lens in a larger hole; this made the image sharper and brighter.

Canaletto added a further improvement. He placed a mirror at a forty-five degree angle on the side opposite the hole. This mirror reflected the image on the box cover, a piece of transparent polished glass. A hoodlike device protected the glass from external light, thus making the reflected image brighter. The artist then placed a sheet of paper upon this screen and traced the image that appeared.

Canaletto used this convenient portable instrument chiefly in order to save time and to improve

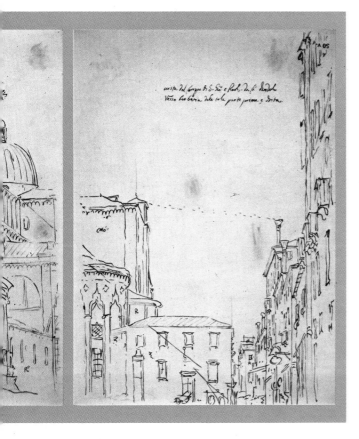

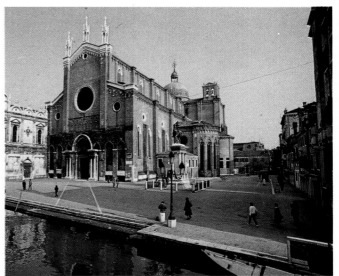

Campo San Giovanni e Paolo, Venice, in a contemporary photograph.

*Canaletto (1697-1768):* Campo San Giovanni e Paolo. *Vista created by lining up four drawings from the artist's notebook (52, 51v, 51, 50v). Gallerie dell'Accademia, Venice.*

the choice and drawing of the framework—a fundamental element in his vistas. He would roam the streets of Venice and wander along the canals, hunting for the most meaningful "cut," selecting perspectives and transparencies. He would then return to these places with his "camera," "shoot" the selected frame, and trace the reflected image on the transparent paper. He would also make notes about the tones, colors, and details, which the monochrome drawing could not render.

After completing his tour, he would go back to his studio in order to "copy" and "sift" those hasty notes in his notebooks, completing them with the help of his memory and experience.

Canaletto used the camera obscura like a real movie camera, "shooting" extraordinarily huge panoramas. He drew adjacent frames in succession from a fixed point by rotating the apparatus around it. Then, placing these contiguous views side by side, he obtained a kind of photomontage, a fundamental aid for his great panoramic paintings.

Canaletto's drawings not only document his creative methods, they also show how an artist can make "his own drawing" from an instrument's diagram, a moment's note, the memory of a sight.

In regard to the "notebook" and the "camera," we may say pedagogically, that the study of the outside world and the depiction of a real image have a specific goal: they teach us how to observe, see, remember, how to find the "reality" and "truth" that are in each one of us.

From a critical point of view, we may logically conclude that precisely because the painter depicts his "own truth," the reality within him, within his head and heart, we believe that we see a "realer" reality if it is the artist's truth.

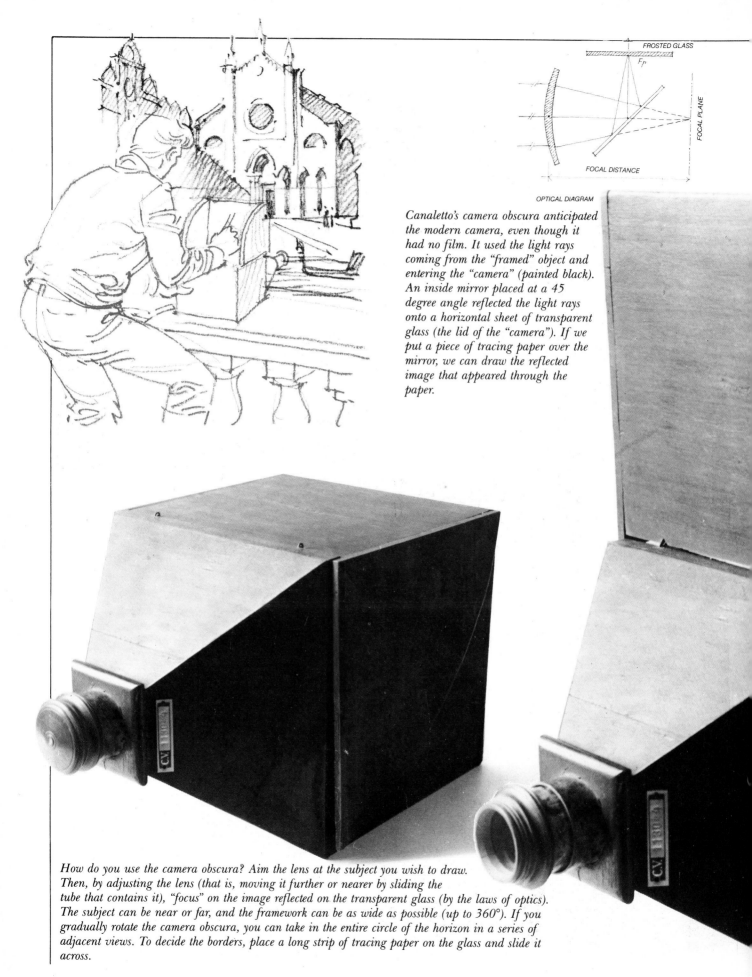

*Canaletto's camera obscura anticipated the modern camera, even though it had no film. It used the light rays coming from the "framed" object and entering the "camera" (painted black). An inside mirror placed at a 45 degree angle reflected the light rays onto a horizontal sheet of transparent glass (the lid of the "camera"). If we put a piece of tracing paper over the mirror, we can draw the reflected image that appeared through the paper.*

*How do you use the camera obscura? Aim the lens at the subject you wish to draw. Then, by adjusting the lens (that is, moving it further or nearer by sliding the tube that contains it), "focus" on the image reflected on the transparent glass (by the laws of optics). The subject can be near or far, and the framework can be as wide as possible (up to 360°). If you gradually rotate the camera obscura, you can take in the entire circle of the horizon in a series of adjacent views. To decide the borders, place a long strip of tracing paper on the glass and slide it across.*

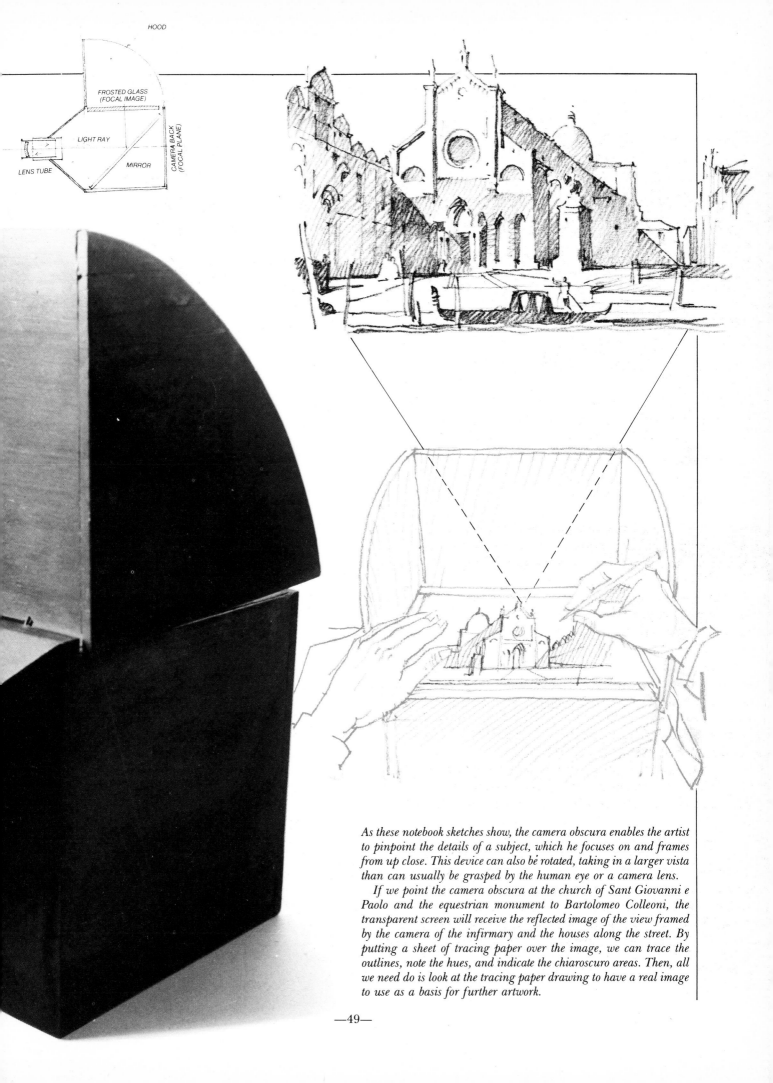

HOOD

FROSTED GLASS
(FOCAL IMAGE)

LIGHT RAY

LENS TUBE

MIRROR

CAMERA BACK
(FOCAL PLANE)

As these notebook sketches show, the camera obscura enables the artist to pinpoint the details of a subject, which he focuses on and frames from up close. This device can also be rotated, taking in a larger vista than can usually be grasped by the human eye or a camera lens.

If we point the camera obscura at the church of Sant Giovanni e Paolo and the equestrian monument to Bartolomeo Colleoni, the transparent screen will receive the reflected image of the view framed by the camera of the infirmary and the houses along the street. By putting a sheet of tracing paper over the image, we can trace the outlines, note the hues, and indicate the chiaroscuro areas. Then, all we need do is look at the tracing paper drawing to have a real image to use as a basis for further artwork.

—49—

# Rendering an Image

### La Piera del Bando

A large number of Canaletto's notebook sketches helped him to complete his marvelous paintings, especially the Windsor series. They also served as references for his engravings, some of which were based on his paintings.

He would line up his sketches in the order in which he had "shot" them, thus creating the overall panorama to guide him for engravings or paintings of vistas. The instrument he used most was his notebook, filled with minute details and jottings, some in color. The practice of seeing and noting the architectural details of Venice enabled Canaletto to make his engravings so precise and detailed. However, it was his nature as a Venetian painter that made him render everything so uniformly, virtually immersing his works in the atmosphere of the lagoon.

The etching *La Piera del Bando* is one of Canaletto's many engravings. (Later on, we will discuss the process of etching, in which the image is printed from a copper or zinc plate engraved with the help of acid.)

1. Trace the framework axes or, even better, use the crossframe, and you will more easily locate the guidelines in the foreshortened facade of the Doge's Palace.
2. Imagine and reconstruct the image in a diagram of rectangles, each one-seventh the width and one-third the height of the whole drawing. This allows us to find the proportions of the various parts of the composition in a ratio that can be checked throughout the execution of the drawing.
3. The diagram will pinpoint the "theatrical space" of the view through the foreshortenings of the "stage." Now draw the teeming square, before the Doge's Palace, its rows of columns, and the "backdrop" of the island of San Giorgio.

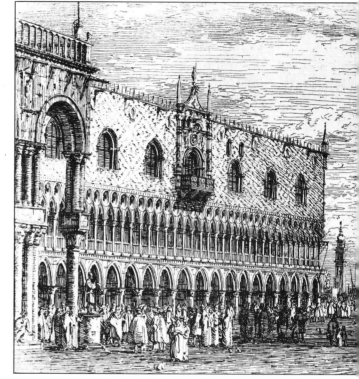

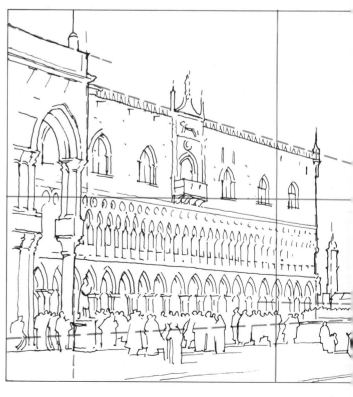

*Above:*
Canaletto: La Piera del Bando. *Etching, Ambrosiana Library, Milan.*

"He went to London and stayed there for four years. He was instantly given a chance by those gentlemen to produce new work with his prolific brush. Returning home, where he still lives, he brought back various sketches of the most remarkable views and sites of that vast city, which he hopes to turn into paintings." (Guarienti, 1753).

"In his early years, Antonio Canal practiced doing theatrical scenery with his father; these exercises were useful in loosening the boy's wrist, awakening his imagination, and forcing him to work swiftly. He did wonderful drawings for stage sets. Because of his annoyance at the indiscretions of the dramatic poets, he 'excommunicated' the theater, as he solemnly put it. The boy then went to Rome and devoted himself entirely to painting natural views. These were beautiful subjects, and he concentrated on Antiquity." (A. M. Zanetti, Jr., 1771).

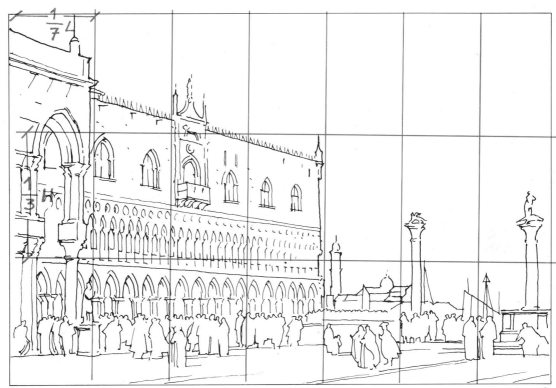

2

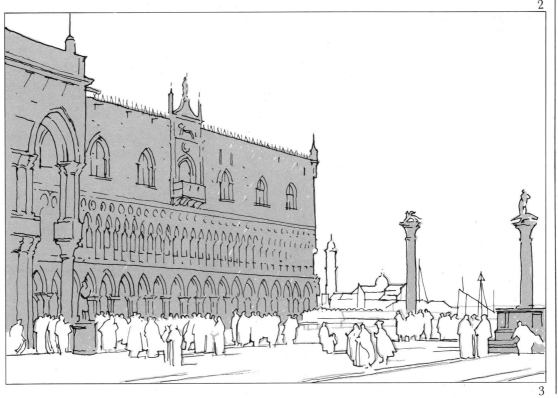

1

3

# From Idea to Image

## Da Vinci's Machines

Every artist's workshop in the Renaissance had a "workshop book." Here, every artist or workman could jot down or even draw his own "ideas." Leonardo da Vinci entered Verrocchio's studio in Florence at the age of thirteen and got into the habit of jotting down his ideas. He continued to do so throughout his life, even after leaving Florence. The pages of his manuscripts reveal an extraordinary and inimitable fusion of art and science. Some of his drawings are complete and highly detailed designs of unique mechanisms; some are quick, tiny sketches squeezed into the blank spaces. Every single drawing expresses an "idea," a sudden inspiration that was first worked out in the artist's mind. His projects range from a flying machine to a bicycle, from dissection tables to musical instruments. These studies and inventions came not in the form of completed plans, but as "ideas," that is, in the immediate language of images. Sketches, jottings, drawings, executed in the moment of conception and yet presented in a perfect composition. They testify, like few other works, to the fascinating relationship, the direct and irreplaceable kinship, between thinking and drawing, between the mental image and the drawn image.

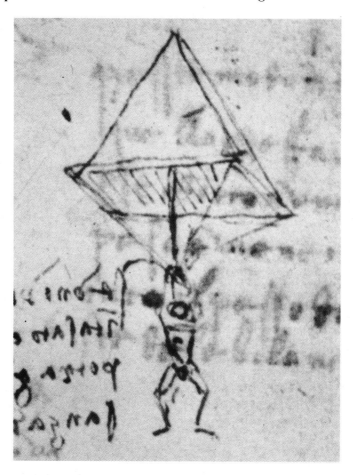

*Leonardo da Vinci:* Study for Instrument of Human Flight: the Parachute. *Codice Atlantico, 1058 v. Ambrosiana Library, Milan.*

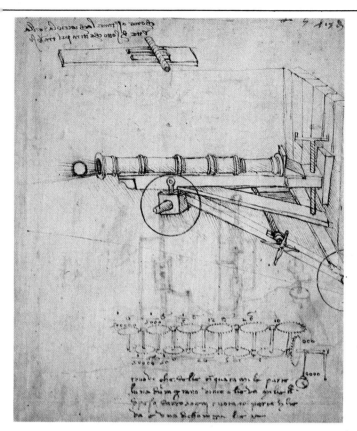

*Leonardo da Vinci:* Mortars without Recoils and Series of Cog Wheels, *Codice Atlantico, 114 v. Ambrosiana Library, Milan.*

*Leonardo da Vinci:* Catapult "with Organs." *Codice Atlantico, 157 r. Ambrosiana Library, Milan.*

## The Birth of the Idea

Da Vinci did hundreds of drawings to illustrate the problem of human flight. Many of these drawings are sketchy, cursory, done in brief strokes, as if to *catch* the idea. Folio 1058 of the Codice Atlantico (Biblioteca Ambrosiana, Milan) contains quick sketches of flying machines steered by pilots who also supply the energy. All at once, in a very tiny drawing, sketched as swiftly as the flash of intuition, we find the idea of the parachute.

Obviously, while immersed in the problem of human flight, Da Vinci suddenly thought of what might happen if the pilot had to abandon ship. So, for a moment, he stopped thinking about flying machines and sketched the "idea" of a pyramidal umbrella "twelve arms high and twelve arms wide," which would enable an endangered pilot to reach the ground safe and sound.

## The Elaborated Idea

When Leonardo Da Vinci petitioned Ludovico il Moro to invite him to his court, one of the arguments used by the artist was his knowledge of mechanics, especially in regard to military devices. In a famous letter of 1482 to Ludovico, Da Vinci wrote: "I also have convenient and easily portable bombardment instruments for hurling small rocks with the force of a tempest and creating smoke to terrify the enemy and cause great confusion. And for a maritime battle, I have many highly active instruments for attacking and defending ships, which can resist any enormous bombardment as well as powder and smoke. I will make covered wagons, secure and unassailable, and which, moving among the enemies and their artillery, can break through any number of soldiers, no matter how many. If necessary, I can make mortars ... and long-range culverins in beautiful and useful forms, beyond common usage. If mortars cannot be operated, I can manufacture catapults, mangles ... and other marvelously effective and highly unusual instruments...."

Among the illustrations of these ideas, there are drawings of besieging machines, gigantic catapults, enormous cannon, mortars "with organs," and even detailed designs of parts of firearms.

# Futurist Images from the Imagination

When you draw what you see in front of you, you sometimes feel as if you are not so much understanding as "redoing" reality, reinterpreting it, transforming it into your personal vision. And this feeling of creativity becomes all the more intense when a drawing successfully expresses an idea.

It seems to me that what distinguishes man from the animals is not only his ability to think, but also his capacity for immediately transferring a thought to a sheet of paper, writing it down or drawing it. Indeed, the drawing of an idea is certainly the most immediate form of expression and often of communication. Thus, many artists always carry a sketchbook in order to record not only interesting images but also any ideas that may come to them in the course of the day, that they may be immediately fixed in a sketch.

The Italian filmmaker Federico Fellini is in the habit of using colored pencils to sketch things that he sees, remembers, or imagines, recording his ideas on paper for future use. Fellini's fantastic world is overflowing with ideas that are crystallized in numerous sketches which he later uses to prepare his movies. Cinema is a world of images—of ideas translated into images. Science fiction, in particular, becomes more fascinating every day, offering extraordinary visions of the most fantastic environments, landscapes, machines, characters.

Thus, in suggesting the "drawing of an idea," we note that few areas offer a vaster and richer panorama of possibilities than science fiction. Why shouldn't *we* try to imagine and depict those extraterrestrials that we have discovered in so many movies, beings that were originally seen, imagined, and drawn by others. We find some are ferocious and dreadful, others tender and vulnerable, some have trunks or tentacles, others look like a Siamese cat with its ears cut off. Since we are free to express our thoughts, dreams, and desires, to work our imaginations, let us, drawing inspiration from the creatures on these pages make a stab at defining our idea of the future by drawing the image of a friend from another world.

*Selenita (inhabitant of the moon) depicted in an apocryphal article by a great astronomer of the 19th century.*

*Inhabitant of Mercury as depicted in the 18th century.*

*Lunar warrior of H.G. Wells.*

*Martian of H.G. Wells.*

*Martian as imagined in the 19th century.*

The Martians Invade Earth, *print, 19th century, from H. G. Wells,* The War of the Worlds.

*A few images from the fantastic world of Mirò.*

## THE GAME OF "EXQUISITE CORPSES"
*Victor Brauner, André Breton, Jacques Hérold, Yves Tanguy: Four "Exquisite Corpses," 1935.*

During the 1920s, the French Surrealist painters invented a game to create fantastic figures. They got the idea from an existing word game in which the players collectively made up a sentence. The first player wrote down a word, then folded the paper over it and passed it on to the next player, who added a word, and did likewise. In French, this word game is known as "The Exquisite Corpse," because the first sentence written by this method was: "The Exquisite Corpse Will Drink the New Wine."

Instead of words, the Surrealists used the parts of a figure: the first player drew the head, the second the chest, the third the legs, and the fourth the feet. Each participant had to indicate on the fold line the points at which the concealed drawing ended. Using this system, the players could draw human beings, animals, and plants as if from another world!

# Fellini: Dreams and Drawings

*A Fellini sketch for a setting in the movie* Casanova. *The drawn idea of a stage with a large bed and a hall with a semicircular table is accompanied by written notes ("straw animals, bear, stag, eagle, monkey, bed, basin, stage building") and an additional sketch showing a new position for the bed, which is now by the grated window.*

Among contemporary filmmakers, Federico Fellini is certainly one of the most inventive and one of the most capable of turning his ideas into the magical images on film. He is able to set these ideas down, for himself and for others, in quick, imaginative drawings. How does Fellini make these drawings?

"When I'm preparing a movie, I sketch and scribble things in order to note some little idea, and to make my explanations and suggestions more practical and convincing. This gives my various coworkers a better notion of what I'm after and how to do the scene or costume or makeup or wig. These sketches serve as a way to start 'envisioning' the film, a method that takes the two-dimensional, to the three-dimensional; a perspective translation of something that has the seductiveness, and vaguess of a fantasy, still existing in some hazy and mysterious dimension like that of the imagination. I therefore find it indispensable and very natural to take my colored pencils from my box and to begin doodling. I have never studied drawing and, I repeat, I do very rough doodles, scribblings; still, I communicate the idea of what I'm after."

And what an idea! These are memories, impressions, but also intentions, dreams, visions.

"For me, drawing is the most direct method of conversing with my collaborators; these sketches are attached to the script and serve as reference points."

Drawing, for Fellini, serves as a vehicle for implementing his ideas. His drawings demonstrate that Fellini's famous "improvization" is actually a continuous and attentive openness to new suggestions within a rational mode of operation, made up of precise calculations, experiences, ideas, plans.

"A film is a voyage into life, and, like life, it is rich in contradictions, unexpected and moving encounters. An artistic operation is a scientific operation of great rigor; however, this rigor should not exclude the unawaited, the unforeseen, rages, passions, muddles. ... Everything is part of this voyage, which tells a certain story. Ultimately even the story of the story makes a valid contribution to the film."

And this contribution is also made by the hundreds of colored drawings that cover his desk and the wall behind his chair: drawn ideas. "These are things that are seen or remembered or imagined; in any case, they are fixed in drawings so that they won't be forgotten."

# The Procedure

The great German poet Johann Wolfgang von Goethe, who certainly did not lack any means of verbal expression, was not content with writing when he visited Italy. He also wanted to learn how to draw. Thus, in his *Voyage through Italy,* he notes: "My most important goal is still to progress far enough in drawing so that I can do something easily, without having to start all over again, or to remain idle for so long as I was, alas, in the most beautiful period of my life. I have to find an excuse: drawing just to draw is like speaking just to speak. If I had nothing to express, and nothing excited me, and I could find a worthy subject only with a great deal of difficulty, what would my spirit of imitation play with?"

With the personal experience of someone dealing with the problems of drawing for the first time, Goethe clarifies the need to have an idea before one sets pen to paper. It's no use drawing if you have nothing to say.

Thus, the process of drawing is not based simply on the composition—the choice of framework, and on the technique, and the definition of shape and color. Ultimately, the fundamental element is the "design of the drawing": the real image we draw from life, the mental image we draw from an idea.

This concept of the idea before the drawing is essential. We cannot look for an idea on white paper, in the hatchwork of strokes, in the confusion of scribblings, if we don't already have an idea in mind. This idea may be well defined or hazy. But however it may appear in your mind, your idea has to guide your hand so it may be defined in your drawing.

This means that we have to capture the image that takes shape in our minds and triggers the fantastic and partly mysterious process of drawing: from the moment we think of it or see it to the moment we implement the idea or image on paper with a pencil, a pen, or watercolors.

Sometimes, you may have an idea in your head, a certain situation you wish to depict. So you seek it out in real life, in order to translate it into a drawing. You may recall a landscape and decide on its most interesting framework. Or you may prefer to draw a figure in a specific pose, so you reconstruct your idea in real life and then depict it.

At other times, you may use a drawing as a point

*Johann Wolfgang von Goethe:* Landscape with Ruins. *Watercolor. Freies Deutsches Hochstift, Frankfurter Goethemuseum, Frankfurt.*

of departure for executing an idea. This is what designs are for. Not only for architects, who carry out their plans on the basis of blueprints, but also for painters, sculptors, set designers, and print-makers. I am referring to the preliminary drawings that precede a final work. These preparatory works enable the artist to clarify his idea for the painting or sculpture, the stage set or etching. In this way, he has a better chance of doing a complete and definitive job on canvas, marble, wood or on copperplate.

On the other hand, some drawings—even some sketches or jottings—are "completed works" with-in themselves. They express themselves com-pletely within themselves. They find their defini-tive meaning within their own compositions and chiaroscuro. These drawings manage to transmit the artist's idea by the magic of their lines. The observer completes them with his own imagina-tion, enriching them with the surrounding space, the atmosphere, the color—everything that the lines and strokes suggest. It is these.elements that . establish the complicity between the artist and the spectator, who is called upon to take part in the act of drawing.

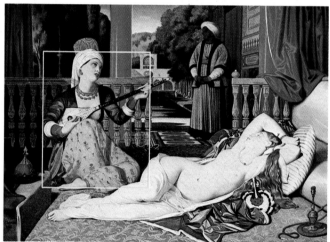

*Jean Auguste Dominique Ingres:* Study for Odalisque. *Black pencil, 234 × 202 mm. Musée Ingres, Montauban.*

*Jean Auguste Dominique Ingres (1780-1867);* Odalisque with Slave, *1842. Canvas. Walters Art Gallery, Baltimore.*

*The yellow square focuses on the figure of the slave playing a guitar. The artist did many preliminary studies for this figure, as for almost all the figures in his paintings.*

## Before the Painting

Ingres' preliminary drawings for the figure of the slave with the guitar, pointedly illustrate the artist's work method.

Ingres intended to place a squatting female figure playing a guitar at the feet of the odalis-que, for the composition of the painting *Odalisque with Slave,* which he organized on the di-agonal of the nude body of the odalisque. The artist then looked for the best position for his figure within the surround-ings, keeping in mind the total picture and the projected col-ors, which he no doubt imag-ined clearly. Knowing how he would dress her, the artist first drew the slave nude so he could study her proportions and de-fine her posture. We thus have this interesting study. Beyond its value as a drawing, it is also highly instructive in demon-strating the process that led to the final painting.

• The lines trace the figure cross-legged on the floor, her arms and hands poised to hold a mu-sical instrument. Is this a study from life or a sketch based on previous experience with many nude studies?

Everything seems to indicate that Ingres "constructed" his model from memory, on the basis of numerous life studies and his knowledge of the female nude. This is an "Ingres nude." Starting with the obser-vation of reality, he trans-formed his female figures into long, soft, languid bodies with luminous flesh tones.

• The first idea—the initial pose—is followed by a fur-ther idea, a choice in posi-tioning the limbs. Ingres superimposed his "research" on the first sketch with an effective suggestion of trans-parency and movement.

• For a more complete aware-ness of his figure, the painter drew her in the nude. This was not the only time he did this, nor was he the only painter to use this method. It is their desire to "create" a new and personal reality that induces artists to construct on the white of the paper. Start-ing with the initial idea, they gradually build up all the ele-ments of this reality, one by one. The process is some-times long and demanding, and the artist has to be very patient. But the outcome is sure.

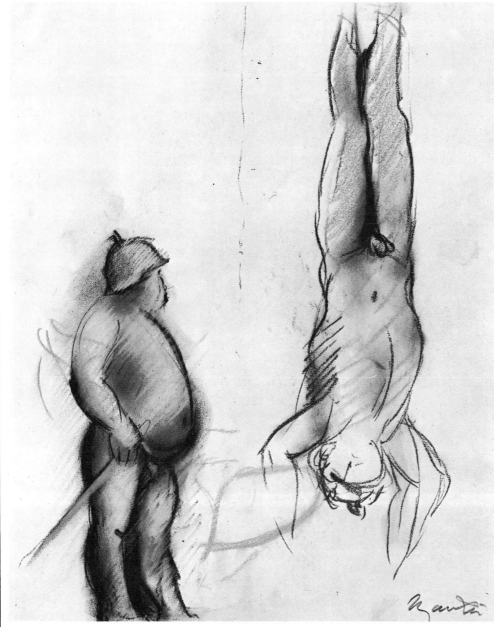

1 *Giacomo Manzù (1908):*
Studies for the Theme of
Christ in Our Humanity:
*1.* Death of a Partisan,
*1961. Pastel, 46 × 38 cm.*
*2.* Death of a Partisan,
*1955/56. Bronze, 70 × 70 cm.*
*3.* Variations on the Theme
of Christ in Our Humanity,
*1955-65. Bronze, 70 × 70
cm. Collection of the artist.*

## Before the Sculpture

Manzù's studies for the bas-reliefs of the cycle *Christ in Our Humanity* takes up motifs that the artist carried in his heart and from his memory.

The tragic image of the partisan hanging upside down was impressed on the artist when he saw it near his home in the village of Bergam one April morning during World War II. Many years later, he used this image in one of the lower panels of the Gate of Saint Peter, dedicated to Pope John XXIII. In a new dimension of human sacredness, the figure of the partisan is transmuted into that of Christ, passing through Manzù's deep and instinctive religiosity, from the direct to the indirect theme, from the "profane" to the "sacred." Manzù's pastel sketch illustrates the artist's idea before his sculpture was created.

It also illustrates the immediacy typical of Manzù. In the study, we can "see" the idea being transformed into a drawing; and the drawing is already a sculpture, a bas-relief that lives and breathes on the ground of the panel, a sensitive surface that seems to generate and release the images.

• A quick, expressive line spreading across the paper, brings out the form in a synthesis of volume and weight. The executioner, at left, "stands" on his feet. The partisan—Christ— "hangs" upside down with the whole weight of his body. The chiaroscuro, softened by the sfumato, "pulls" the figure out of the background. Everything is achieved with a simplicity of exceptional means.

• The drawing renders the idea Manzù had in mind. This is not a life study, but the experience of reality supplies and renews the drama.

# The Signs and Strokes of Mirò

Among the contemporary artists whose creative processes we can study, Mirò is one of the most interesting. In his canvases, he seems to reaffirm that the deepest meaning of painting consists in freeing a subjective world, communicated by signs, strokes, a colored "handwriting" on a flat surface.

This is how Mirò describes his method: "When I begin to paint, I do not plan to do a bird, a woman, or a precise object. Sometimes, an object appears, as in the 'three birds in space.' There are three birds here, but I didn't realize it until I saw them.

"(The titles? I invent them, sometimes to amuse myself, when I finish a painting. It is the painting that suggests titles, and not the titles that suggest a painting....)

"The last works are the three large blue canvases. I spent a lot of time on them—not painting, but thinking about them. It took an enormous effort, an incredible inner tension to reach the essentiality that I was after.

"The preliminary phase was intellectual.... It was like celebrating a religious rite, like taking vows.

"Do you know how Japanese bowmen prepare for contests? They start by placing themselves in position and concentrating, they breathe out, in, out. It's the same thing for me."

And what about technique? Does Mirò work directly with pigments or does he use outlines?

"First of all, after thinking and thinking for a long time, when I decide to paint, I start by preparing my grounds; it's the grounds that sug-

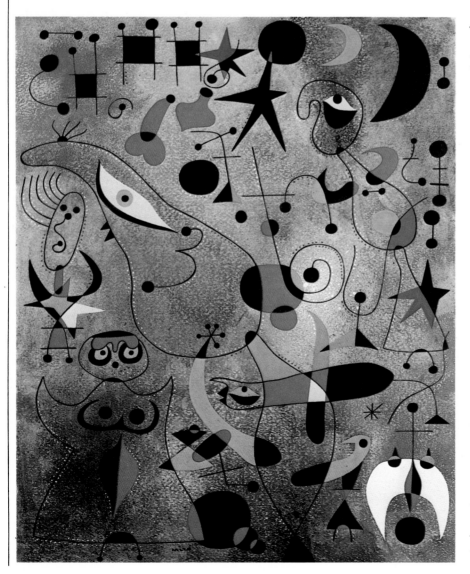

*Joan Mirò:* Awakening at Dawn (Constellations). *Gouache and oil paint on paper, 460 × 380 cm. Collection Mr. and Mrs. Ralph F. Colin, New York.*

*Mirò fills his drawing with a mass of lines expressing the enchantment of poetry and the joy of living in the magic of "structure" and the purity of color. His works thus communicate extraordinary artistic sensibilities.*

gest the graphic design for me. Sometimes, I use the ground of the material I am drawing on.

"Then I start to draw with charcoal, extremely precisely (I get to work at the crack of dawn). In the afternoon, I only look at what I've drawn. The rest of the day, I prepare myself mentally; and finally, I start to paint."

To draw or to paint?

"When I paint, I try to determine a relationship between the strokes and the colors, a balance that gives life and that lives in terms of that relationship. Thus, on a black, I can put blue and red tones that have a sculptural and poetic meaning, in order to give life and color to that black. The point of departure is a sculptural quest; the rest comes after. All the things in the painting, every shape and every color, are organized to meet the demand for balance, and every part is linked in a precise and consequential relationship.

"One thing leads me, almost automatically, to do another, in a sequence that is not only that of balance, but also rhythm: the picture then becomes a play of rhythms, like poetry: with shapes and colors instead of words and verses."

Balance, proportions, rhythms.... Every procedure requires a preliminary phase: the idea. This is the basis for the composition, for planning and working it out, for the drawing, and the color.

Do line and color coincide for Miró?

"I like to speak in lines—which are strokes—and colors. A line, a color: a woman; a line, a color: a bird. It is the drawing and the painting that, by means of the symbol, suggest the idea of the woman and the idea of the bird."

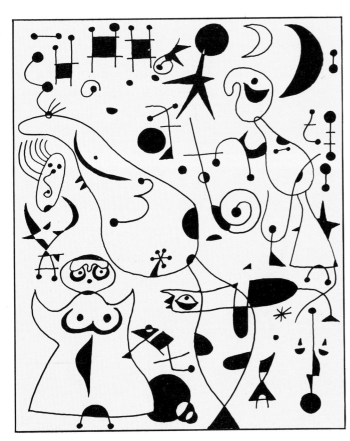

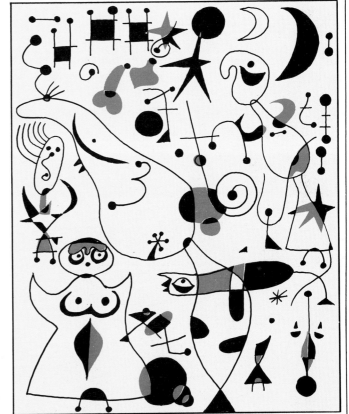

*Miró's great discovery is of the elements—lines able to express an idea and define a space. Letters of the alphabet, adopted by earlier artists, are replaced by Miró's diverse lines. Here, his most recurrent element is the stars.*

*The first diagram shows the initial phase in Miró's painting—black imprints on a neutral background. The next diagram shows the introduction of reds and blues on the black.*

# When Drawing

"The layman thinks that in order to create you have to wait for inspiration. He is mistaken. I am by no means denying inspiration; quite the contrary. It is a driving force that can be found in every human activity, and artists have no monopoly on it. However, this force does not appear unless it is activated by an effort, and this effort is *work*. Just as appetite comes with eating, so too, work brings inspiration, even if the latter does not appear at the very start. But it is not only inspiration that counts; what really counts is the result of inspiration, that is, the art."

These words were written by Igor Stravinsky, the Russian musician who was a friend of Picasso's.

In his autobiography, Stravinsky deals repeatedly with the problem of "creation," confirming that the important things are: willingness to work, practice, application, self-confidence, even in regard to drawing. You may have noticed that when we tried to define the successive phases of drawing, we spoke of the idea, the real and the mental image, the design or interpretation—but never inspiration.

If you want to draw, you don't have to wait for inspiration. Drawing means looking around and inside yourself in order to see what interests you, what moves you, the things you can get to know and possess by drawing them.

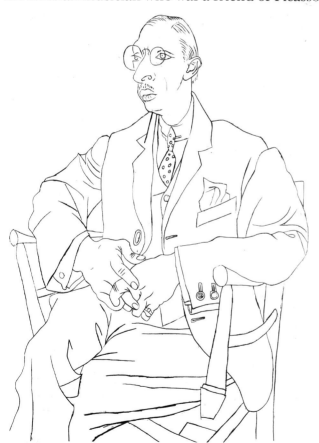

*Pablo Picasso:* Portrait of Igor Stravinsky, *1920. Graphite, 624 × 485 mm.*

*The portrait of Stravinsky testifies to Picasso's friendship with the Russian maestro as well as his ability to interpret and express with the simplest of means: a continuous line (blue in the diagram).*

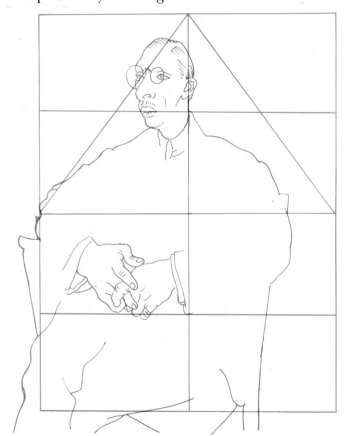

*The figure is seen almost from the front. It is constructed on a central axis in a pyramidal composition, which can be called classical (red in the diagram). The line follows the contour without interruptions or corrections. It manages to give "weight" to the figure, which leans on the arms of the chair. The line also synthesizes the composer's character in the drawing of the hands and the details of the face.*

# From the Whole to the Details

In his *Notes and Thoughts,* Ingres recommends: "When constructing a figure, do not proceed in terms of fragments. Work with everything at the same time and, as has been rightly said, draw the totality."

If a drawing, whether rough or carefully detailed, is to be expressive and complete, it needs a common denominator: synthesis. A sketch ignores or only suggests the details. A drawing analyzes and delineates the details, and then orchestrates them into a formal balance of tones and chiaroscuro to make a totality.

Our vision of the things surrounding us is unified. In order to maintain this same unity in a drawing, you must, as far as possible, make everything advance at once. The shapes, the chiaroscuro, the color may be separate and successive elements, but they must encompass the entire subject in a single synthesis. This does not mean that you have to draw and color everything at the same time. We are merely saying that a drawing does not emerge and develop the way we write a letter. It does not move from top left to bottom right. Nor do the shapes, colors, or chiaroscuro develop in a mechanical sequence.

On the contrary. In order to maintain the unified character, correct proportions, and overall balance, we proceed by degrees. First we sketch the whole picture in generalized lines. As we proceed gradually specifying the outlines and adding the chiaroscuro, we try to keep the overall composition "under control."

Every detail is seen in terms of the rest of the composition in a series of relationships that will unify all the parts. This enables the artist to see beyond the process of depicting and clarifying, to the image of his final aim or goal.

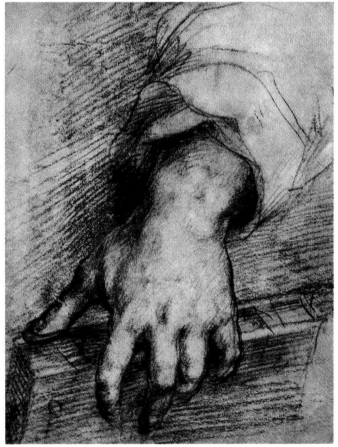

*Andrea del Sarto (1486-1531):* Study for the left hand of the Madonna of the Harpies. *Pencil, 266 × 206 mm. Uffizi, Gabinetto dei Disegni e Stampe, Florence.*

*In their great compositions and figure studies, artists often prepare their work on the basis of "details." They make a series of drawings of these details, focusing separately on the elements that are then "joined together" in the final composition. Special attention has always been paid to the study of hands and feet, which are among the most expressive elements in a drawing.*

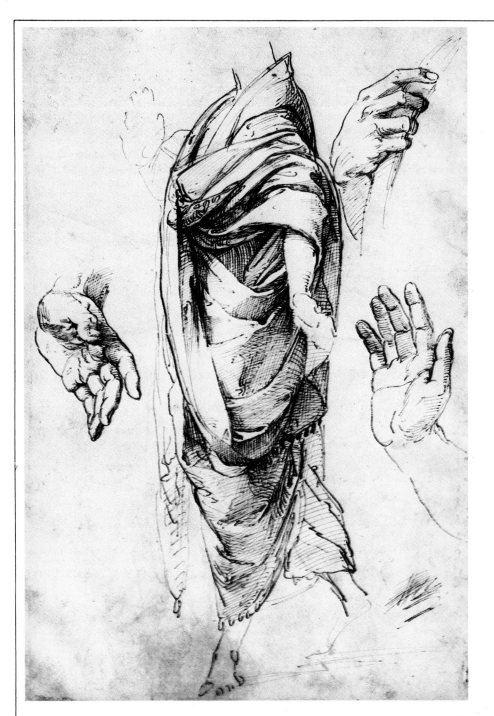

*Raphael (1483-1520):* Study of Hands and Drapery.
*India ink. British Museum, London.*

*Raphael's pen-and-ink drawing focuses on the overall drapery of a figure (leaving the head outside the framework) and on the details of the hands, drawn on a larger scale.*

*The artist was obviously drawing from life, trying to capture the shapes of the creases and folds, defining their outlines and chiaroscuro with decisive pen strokes. The only indecisiveness is in the position of the right hand; two positions are suggested in the drawing of the figure, and then specified and detailed in the sketches alongside the figure.*

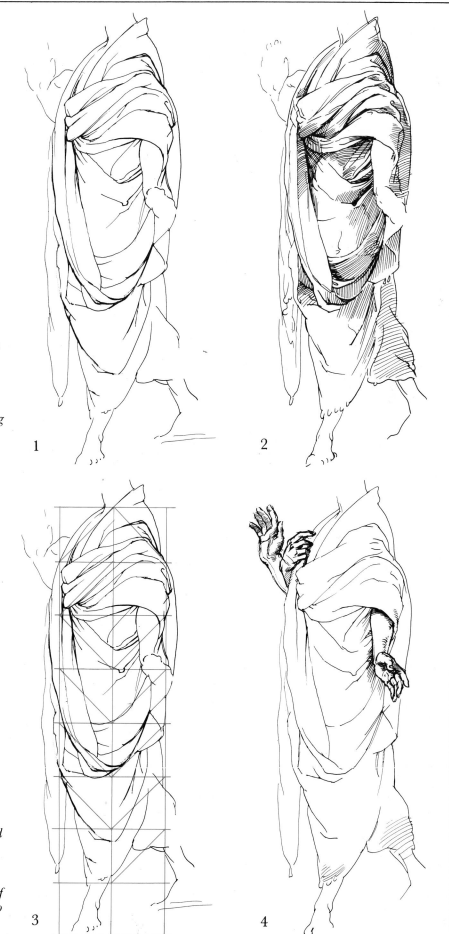

1. This sketch is meant to reconstruct the first phase of Raphael's drawing, outlined with an expressive line that interprets light and shade in its thickness and vibrations.

2. This reconstruction of an intermediate phase of the study shows the first crosshatching as the artist begins to indicate the most important areas of the chiaroscuro.

3. The folds in the drapery, although free and natural, suggest a simple and rigorous geometrical composition.

4. This diagram hypothesizes the completion of the drawing with the hands done according to the artist's studies.

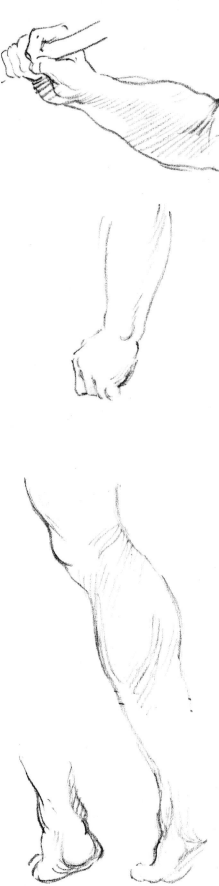

*Michelangelo (1475-1564):* Study of Male Nude Turning Left. *Black pencil and pen, 403 × 260 mm. Teylers Museum, Haarlem.*

*This drawing is one of Michelangelo's many studies of the human body. These were either preliminaries for other works or illustrations made to improve his knowledge of anatomy. This drawing deals with the problem of motion in a foreshortened figure seen from the back, while the studies of arms and legs pinpoint the details. The drawings of the isolated arms, in particular, demonstrate a different position than the upper limbs in motion—the right arm held out, the left arm held alongside the body.*

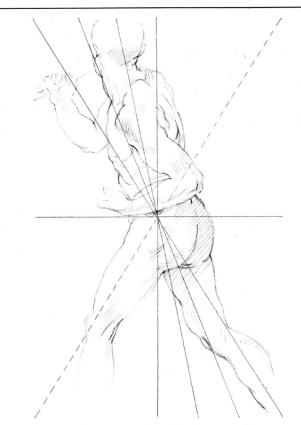

*This diagram visualizes the effect of motion on a figure composed along several dissecting angles, stressing the sense of rotation according to a calculated balance.*

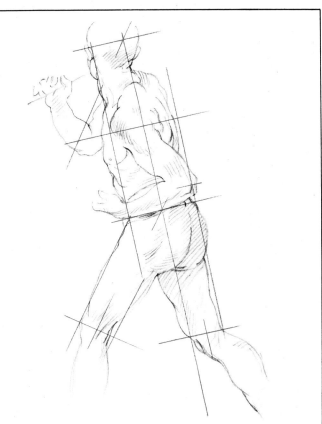

*Beyond the anatomical structure, we can also pinpoint a geometric structure that delineates the figure.*

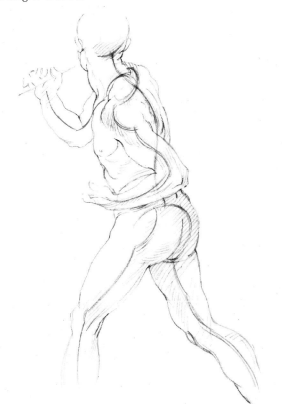

*In the structure of the figure, the left leg (in the foreground), corresponds to the right hand, which is held out. The same correlation exists between right leg and left arm, according to the characteristic motion of the human body.*

*The superimposed image suggests a different solution for the arms, as indicated in the detailed sketches of the right arm held forward and the left arm held back.*

# Drawing Details

The drawing develops from the whole to the details in a progression that gradually focuses on the main motifs. It is then up to the artist to decide which they are.

Beyond a few specific points in our subject (for instance, the darker or lighter areas), we can bring out other aspects that interest us in particular.

It is not only in the study of the whole that the artist pinpoints the details that interest him. Often, he sketches the whole (a place, a figure) synthetically, after which he focuses on only one or several details.

Remember the pencil portraits done by Ingres? The figure is masterfully drawn in a few strokes, and only the face is rendered more profoundly with chiaroscuro in its details. Or recall the female figures drawn by Emilio Greco. He uses chiaroscuro and precise details only in a few areas, where the shadow seems to conceal the secret of life, of the gaze, of breathing.

We too can try to draw a female figure. After sketching the shapes and emphasizing the chiaroscuro, interpret the figure by fully synthesizing the totality (even blurring out the contours of the brightest areas) and focusing only on one or two details.

*1. Try to create, within the subject, the conditions of the "whole" and the "details." Next, show them in the drawing, using as your model a figure covered in heavy, flowing drapery.*

*2. Draw the profile of the figure and the main chiaroscuro. Half-close your eyes and work out the proportions of the tones according to the darkest points (the shadow of the sleeve, the blackness of the curve of the garment).*

*3. Reduce the strokes and the chiaroscuro, limit them to the essentials: the darkness in back of the figure, the tones of the hair, the darkness of the eye, the lines of the arm and the hand.*

# DRAWING FROM LIFE

**D**rawing from life is the oldest and most immediate method of drawing. You look around, then record on paper what you see and what to capture. An imitation? A copy? Not at all. An interpretation—if you see the things around you with your eyes, filter them through your personality, and depict them with your hand, in terms of your impressions, sensations, and intentions.

This is what makes life drawing so fascinating. No matter how hard it is, no matter how aware we are of failing to achieve what we are after, we nevertheless feel we are recreating something. The things in front of you may seem unique and objective, but they are viewed and interpreted differently by each one of us, even if we try to see them and draw them as faithfully as possible. All artists have drawn from life, and many have talked about it and advised others to practice it.

One of these many artists was Ingres: "Draw, paint, and, above all, copy, even if it's a still life. Every object obtained from life is a work, and this imitation leads to art. Anything that is true to life is beautiful. In nature, everything is harmony: the slightest bit more, the slightest bit less will disturb the order and strike a false note. You have to sing, achieving the same precision with a pencil or a brush as you do with your voice. The perfection of forms is like the perfection of sounds.... Drawing does not mean merely reproducing outlines. It is not just sketching. It also means expression, internal form, planes, modeling...."

And Picasso, who always drew from life, said: "I've put a bunch of leeks into this still life, and I want my picture to smell of leeks. I'm after likeness, a likeness that is deeper and realer than reality, that reaches the surreal."

*Villard D'Honnecourt (active between 1225 and 1250):* Album. *Page from graphite tip, with some pen and ink, on parchment, 230 × 150 mm. National Library, Paris.*

*Among the many didactic, religious, symbolic, architectural drawings in the* Album, *we find a curiously rigid figure of a lion, face front. The artist added the following words: "It has been drawn from life."*

# Directional Lines

Now we can't draw everything we see. We can't count the leaves on a tree or stop the clouds as they drift across the sky. So then what and how do we draw when we draw from life?

At the outset of this course, we suggested drawing a tree as our first subject. There were several reasons for this choice: the nature of the tree, whose structure repeats the developmental process of a drawing; the compositional balance of the whole which requires a precise working-out of the relationships of the parts; the clear outlines of the branches, which cut empty spaces into the background, spaces that we read as original forms. Finally, the numerous ways of rendering a tree exemplified in the work of the most varied artists.

However, there is another reason, a fundamental reason why the tree is an ideal subject if you wish to draw from life. Trees offer special possibilities for finding *guidelines* within their mode of development. Although we can't capture and depict *everything*, we can, nevertheless, use the **lines of direction** or the **lines of force** as guidelines to recognize and interpret the *life and movement*, the essence, of any form in nature.

*Renzo Vespignani (1924):* Garbage Dump, *1946. Colored inks, 345 × 194 mm.*

*A landscape made of nothing, finding its poetry and strength in the guidelines of the horizon, the diagonal terrain, and the smoke from the train.*

*Renzo Vespignani:* Street on the Outskirts, *1957, colored inks, 700 × 500 mm.*

*In this setting on the outskirts of Rome, the lines of force are chiefly the riverbank wall in the foreground (diagonal) and the gas tank in the background (upward).*

In a mountain, the lines of force show how the mountain took shape (just think of Cézanne's Mont Sainte-Victoire). Or else, they show the fluctuations caused by the beating of gales. Any tree, no matter what its species, is bent by the wind in the course of its development, and some of its branches will thrive better than others. In a wave or a cloud, the force lines show the movement of the current or the wind. They will also show the movement and vitality of a body or the expression and character of a face.

We have already established the equation: drawing = awareness. Now, we can add a second equation: **drawing from life = awareness of the development of the subject,** both in life and art.

Remember what Emilio Greco said about nature: "If we gaze at a rock in a river, we realize that the slow rolling of this rock across the riverbed has given it a particular beauty."

If we merely look, we imagine things as fixed and unchanging. And that's how we draw them, as inanimate. But if we truly *see* them, we observe the changes and continual transformations of things. And that's how we interpret them in our drawings:

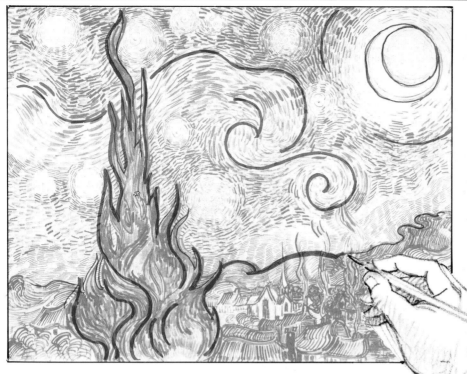

Vincent van Gogh: Starry Night, 1889.
Pen and India ink. 470 × 625 mm.
Kunsthalle, Bremen.

*The force lines in* Starry Night *are obvious in the whorls of terse pen lines in the sky and in the flamelike spirals of the cypress, which anticipate the brushwork in the final painting.*

an animal in its movements, the tree in its development, the cloud in its fleeciness, the rock in its rolling, the mountain in its sufficiency, and man in his existence in the world.

Thus, drawing from life means that every time we observe a form we must find the lines have influenced its past and that can influence its future—the lines that we have called *the essential guidelines*.

What can we do to discover these essential lines, to understand their strength and depict them?

It may be hard to define a logical procedure for grasping something that is profoundly indivisible as well as mysterious and vital. Nevertheless, we can try to suggest a method. Ultimately, this method becomes the personal approach for each artist, and each artist finds it himself, through practice:

- **see** what you have in front of you, read the shape, the movement, the light, observe the outline against the background, half-close your eyes and record the proportions, tones, colors.
- **express** your emotions in the drawing, depict the things you feel when you look at life through the sensitivity of the line and the quiverings of the chiaroscuro.
- **simplify** by synthesizing form and chiaroscuro more and more in a sequence of drawings. This

does not mean working sketchily. You have to bare the reality and the line, you have to find the law of composition and transformation in the essential lines.

## Seeing

If you want to prepare yourself to observe, if you want to sharpen your powers of observation and liberate yourself from the "categories" inherent in every object, then follow Renzo Vespignani in exploring the outskirts of Rome, one of his most interesting themes:

"I drew 'my' outskirts of Rome from life, and by no means quickly. Whenever I went out to do these drawings, I would get up at seven a.m. and keep working until one in the afternoon. And there was nothing off-the-cuff about my method. These were true and proper drawings, ends in themselves, autonomous works, not preliminary sketches for an engraving. When I draw from life, I carry my plate outdoors, my stool, my instruments, and I engrave directly, on the spot. Reality is fascinating, it suggests so many things to me."

But before drawing, we have to see.

"Certainly, observation is the basis of everything. Whenever I make a mistake, I realize that I have misunderstood a form because I have

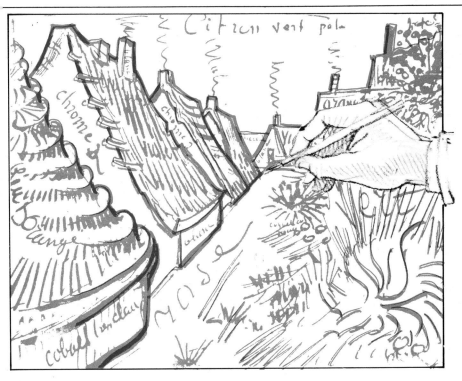

*Vincent van Gogh:*
Farmhouses in Saintes-Maries.
*Pen-and-ink drawing from a letter to his*
*brother Théo. National Vincent van Gogh*
*Museum, Amsterdam.*

*In the foreshortening of the country lane lined with houses, van Gogh emphasizes the lines*
*of direction chiefly in the diagonals of the sloping roofs.*

worked out an abstract idea of this form, I have attempted to provide a certain solution for both the form and the idea by following the abstract idea without checking the reality. For it is reality that provides the bones for form, it is the structure that holds everything together.

"People do not know how to draw because they do not observe, because when they draw a loaf of bread, they do not *look* at this loaf here, instead they think about that bread there—an abstraction. What I am saying is that we all think in categories. Bread is a certain type of category. But actually, no two breads are alike. And drawing means seeing in what way *this* bread is truly unique, it means showing the form, the lines, the contours. Knowing how to reproduce them on a piece of paper then becomes a purely technical matter."

**Expressing Yourself**

To gain a better understanding of how you can *express* your impressions and sensations of reality and infuse your drawing with the life and movement of reality, read through the letters that Vincent van Gogh wrote to his brother Théo:

"I could never tell you how happy I am, despite all the new difficulties that keep cropping up every day and that will continue to crop up, I can never tell you how happy I am to be drawing again.

"I'd been thinking about it for a long time, but I considered it impossible and beyond my capacity.

"Today, however, while feeling my weakness and my awkward embarrassment about many things, I have regained my mental calm, and every day more and more of my energy returns. ... Previously, I drew exclusively with a pencil, underlining and accentuating with a pen—sometimes with a reed quill, which has a wider stroke. The subjects I treated required this method, because they demanded a great deal of 'draftsmanship'—drawing in perspective, for instance, the village stores, the smithy, the carpenter's shop, the cobbler's shop."

If we draw from life, what should we choose: a figure or a landscape? Here too, in deciding on a subject, the direct experience is crucial:

"I have just finished two larger drawings.

"The first one, *Sorrow,* is bigger—just a figure, with nothing around it. I've changed the pose slightly: the hair no longer drops down the back, it falls over one shoulder, partly in a pigtail, so that you can see more of the shoulder, the neck, and the back. And the figure has been drawn more attentively.

"The other drawing, *Roots,* shows some tree

roots in a sandy terrain. I have tried to put the same feeling into the landscape as into the figure; the attachment of the roots to the convulsive and passionate earth, yet half wrenched away by the tempest. I wanted to express that same struggle for life in the pale, scrawny female figure and the black, twisted, knotty roots.

"Or rather, seeing that I tried to reproduce nature faithfully, as I saw it, without waxing philosophical in either drawing, involuntarily, something of that struggle appears. Or at least it seems to me that there is feeling in the drawings, but I may be wrong; well, you can judge for yourself."

## Simplifying

You master the laws of composition and transformation only after a lot of practice: after doing a hundred drawings and putting aside a hundred, after thinking you won't make it and then regaining faith that there is a bit of you, of your experience and sensibility, in every drawing. Matisse kept even his unsuccessful drawings for, as he explained: "Some day, they may teach me something, if only because they *are* failures. You learn something every day. How else could you manage?"

Once, when Matisse showed a critic a portrait of a girl, he pulled out some fifty other drawings, all of them preliminaries for that one female portrait.

"Here," he said, "you have a whole series of drawings of a single detail: the girl's lace collar. The first few drawings were done very minutely, motif by motif, why, almost thread by thread. In the next set, I kept simplifying, until the last drawing, here. Since I knew the lace almost by heart, I could translate it into an ornament with a few rapid strokes. I made it into an arabesque without destroying its character as lace, as this particular lace. I used the same method for the face, the hands, and all the other details. A lot of work goes into a picture like this, but also a lot of joy. You can see for yourself the beautiful position of the hands, which rest firmly in the lap. You can bet I didn't find the best solution in just the twinkling of an eye. But this is exactly how the hands ought to be, so that their position harmonizes with the posture of the body and the expression on the face."

Fifty studies for a single detail, fifty moments in the quest for the essence, for the definitive drawing. About drawing from life, Matisse counseled a girl who was drawing: "Basically, when you look at a subject, you should only aim to copy it. Yes indeed, only copy it. But while working, if you are looking at a landscape, a person, a bunch of flowers, whatever, then the struggle, the revolt will surge up, and that is the moment when you precisely translate the subject according to your individual temperament. The painters who have nothing to say merely copy stupidly and they manage only to be boring and useless."

*Henri Matisse:* Woman in Armchair, *1941.*
*Charcoal 510 × 650 mm.*
*Private collection.*

*In Matisse's drawing, the lines of force and directions overlap and intersect one another becoming the brief curves that unite the figure and the plant by their position and softness.*

# A Drawing a Day

A drawing a day. This is not so much an exercise as a habit, a way of seeing and approaching things and people, a way of copying and gaining self-understanding.

This is what you have to do: always carry a pencil and a pad of paper, and any time you feel like drawing, any time something strikes your fancy or your interest, then draw.

It doesn't matter if the drawing doesn't come out as you want it to, it doesn't matter if it doesn't look like the subject or render the idea perfectly. Sooner or later, it *will* look like the subject and it *will* render the idea.

Gertrude Stein was close friends with Picasso. One time, when she looked at a portrait he had done of her, she became speechless, she felt that the portrait did not even resemble her. Picasso was unfazed: "In a few years, you will resemble the portrait," he told her. He was defending the autonomy of the artist to interpret, to see and draw in terms of his own personality. Picasso could give that answer because he had been working all his life, drawing every day. He had seen and interpreted the world around him, first traditionally, then more freely, in terms of his many profound points of view.

Drawing begins with life drawing. Why? Because it prepares you to do the following:

- **See:** Before you depict, life drawing forces you to attentively observe what you have in front of you and to free yourself from taking the subject for granted.
- **Be aware** of the proportions, colors, perspective, volume, and depth—all the elements that involve us in reality.
- **Think out** the choice of framework, composition, definition of form, chiaroscuro, color.
- **Synthesize,** as you draw everything perceived in the framework—so that the separate objects become a unified composition guided by the links of force.
- **Express** feelings and impressions through lines and color, so that your drawing interprets the world around you, but interprets it through *you.*

*Jen Frédéric Bazille (1841-1870):* Manet Drawing. *Charcoal with white chalk highlights, 305 × 232 mm. Collection R. Lehmann, New York.*

"May. I am feverishly working from life, almost always in the garden, as if to demonstrate that I have profited from the voyage. Naturally, it is right now that I am faced with many difficulties. (And so the month wanes unnoticed....)." (Paul Klee: *Diary III, 1902-1906*)

"Thursday, January 23 in the park of the Villa Borghese, I drew some strangely-shaped tree trunks. The laws of line are analogous to the laws of the human body, but smoother. Anything I learn I apply immediately to my compositions."

(Paul Klee: *Diary II, 1901-1902*)

"I work in tempera, using only water, to avoid any difficult technique. I proceed calmly and attentively, one thing at a time....For me, color serves only to decorate the plastic impression. Soon, I will try to transplant nature directly into my present legacy of figures.

*Paul Klee (1879-1940):* Garden with Watering Cans and Cat, *1905. Watercolor, 140 × 185 mm. Collection of Felix Klee, Berne.*

*Klee's watercolor, filled with light and life, is part of his rich experience of working with nature. Beyond the freshness and vivacity of the scene, we cannot help recalling Klee's talent for aligning colors. The watering cans and the pail are lined up: blue, green, yellow, red (harmonious colors). The yellow and the red are repeated in the chair and the stool on which the purple cat lies sleeping.*

*Paul Klee:* Terraced Garden, *1920. Kunstmuseum, Basel.*

*We find the same color alignments fifteen years later, in this nonfigurative painting.*

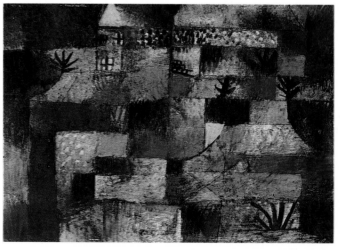

You can move more freely with an empty knapsack, but you risk ignoring strict principles. To put it bluntly, truth will suffer. I especially do not want to have to rebuke myself for erring out of ignorance."

(Paul Klee: *Diary II, 1901-1902*)

"Genesis of a work:
1. Rigorously draw from life, perhaps in perspective.

2. Turn the first image upside down, strengthening the guidelines in terms of the overall meaning.

3. Put the paper back in its original position and harmonize 1 = nature and 2 = representation."

(Paul Klee: *Diary II, 1901-1902*)

Let us repeat Paul Klee's experience with colors using colored pencils. We will draw the same or similar objects to his, all of which can be found in a garden or cellar: a pail, watering can, clay flower-pot, a demijohn. It is easy to find the right relationship of tones by putting together objects which have basic or harmonious colors.

- Start by drawing the composition, putting the objects together in correct proportions and perspective (check the angles by constructing the axes).
- Now pass on to the colors. In the first example, the adjacent colors are the red-orange of the watering can, the blue of the pail, the green and yellow of the glass and straw of the demijohn. In the second version, the colors (from left to right) are: blue, green, red-orange. And in the third version: blue, red-orange, and the gray of the newspaper.

Thomas Gainsborough (1727-88): Cat Studies, c. 1765. Charcoal, tempera, and white chalk, 332 × 459 mm. Rijksmuseum, Amsterdam.

Let's turn from Klee's curled-up cat to the various positions of a cat captured in charcoal by the British artist, Gainsborough. A cat, by its very nature, offers a myriad of movements and poses, and plenty of possibilities for finding synthetic lines expressing its characteristics. The sinuous, continuous line is developed by study and application, as demonstrated by these and other sketches.

These sketches by Thomas Gainsborough provide the elementary patterns of form and movement.

*Théodore Géricault (1791-1824):* Sketches of a Striped Stray Cat, *c. 1817. Pencil on cream paper, 319 × 398 mm. Fogg Museum, Harvard University, Cambridge, Mass.*

*The French painter Géricault favored animal subjects. The immediate and incomplete quality of these quick sketches testifies that he studied from reality. They capture the movements and expressions of the cat from various vantage points, including the details of its head and paws. The artist sought the synthetic line that could fully express the animal's elegance, sleekness, and character.*

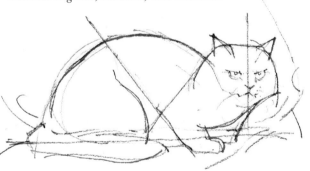

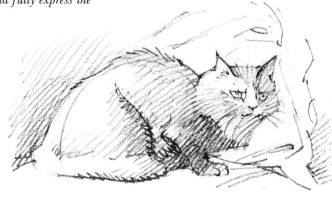

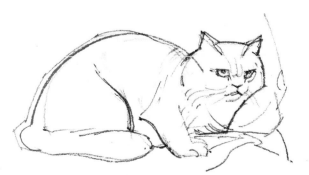

*Let's try to draw a cat. We have to synthesize the figure with an expressive stroke that focuses on a single detail or moment.*

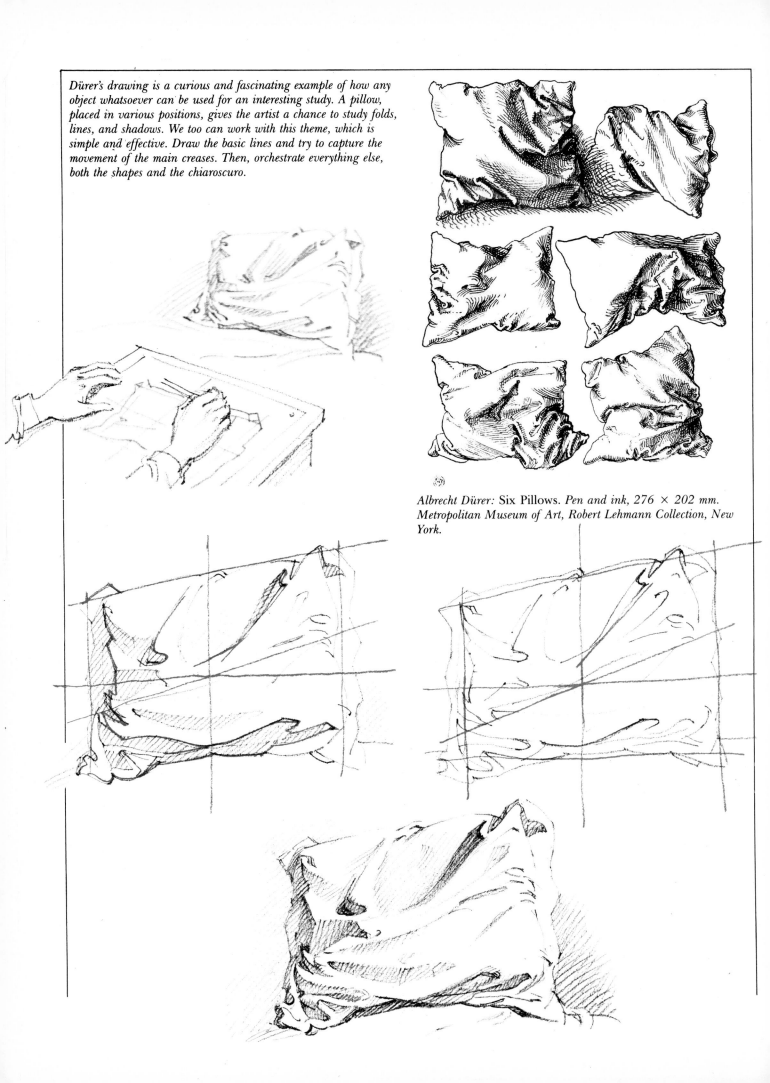

Dürer's drawing is a curious and fascinating example of how any object whatsoever can be used for an interesting study. A pillow, placed in various positions, gives the artist a chance to study folds, lines, and shadows. We too can work with this theme, which is simple and effective. Draw the basic lines and try to capture the movement of the main creases. Then, orchestrate everything else, both the shapes and the chiaroscuro.

*Albrecht Dürer:* Six Pillows. *Pen and ink, 276 × 202 mm. Metropolitan Museum of Art, Robert Lehmann Collection, New York.*

# The Study of the Nude

The human figure has always interested all people, not just artists, from the first appearance of drawing down to our time. Greek art established the so-called "heroic nude," an ideal form and model later used by the artists of the Renaissance.

As in so many other areas, it was once again Leonardo da Vinci, in his *Treatise on Painting*, who furnished precise information on "finding the nudes." He condemns "wooden and graceless *nudes* that look more like a sack of nuts than a human being." As always, his recommendation is the fruit of thorough experience and knowledge.

Ultimately, he is telling us to indicate the principle lines and shadows, and then gradate the others on this basis. This will prevent us from giving every single muscle the same "weight," the same importance.

Da Vinci can also be credited with being the first to reproduce "from nature" the human skeleton and musculature as well as the organs of the human body. These he would examine from several sides, frequently in successive sections, and with extraordinary clarity.

Before depicting a figure, whether in a portrait

*Leonardo da Vinci:*
Canon of the
Proportions of the
Human Body. *Gallerie
dell'Accademia, Venice.*

*This drawing illustrates the concept of Vitruvius, the Roman engineer and architect of the 1st century B.C., who wrote in his treatise* On Architecture: *"Thus, the center of the human body is naturally the navel. In fact, if you had a man lie supine and spread eagle, and you placed the center of the compass in his navel and drew a circle, his fingers and toes would touch the circumference. Furthermore, the figure of a square could also be found in the body, along with the circle. If you measure the distance from the soles of his feet to the top of the head and then from the fingertips of one outspread hand to the other, the lengths will be the same."*

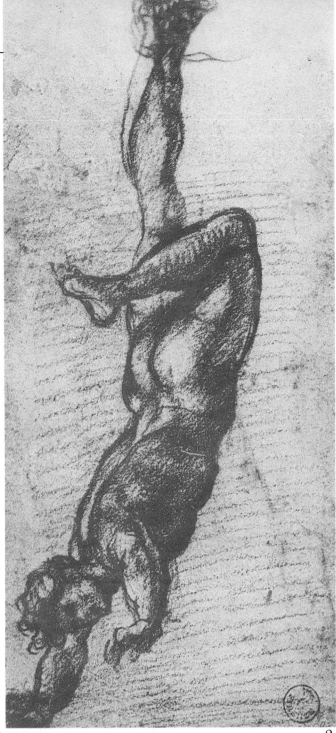

1

2

*1. - 2. Andrea del Sarto (1486-1531): Two Studies for the* Captains Hanged in Effigy from the Palazzo delle Mercanzie. *Red crayon. Uffizi, Gabinetto dei Disegni e delle Stampe, Florence.*

*This second drawing actually preceded the first. It shows the anatomical structure of the figure, which was then dressed in the rich costume. This process confirms the seriousness and commitment of the painters of the era.*

or in a more complex scene, many artists need to "construct" their subject by studying its anatomy. Andrea del Sarta was one such artist. Michelangelo studied the nude of the Sybil before dressing her for the Sistine Chapel. Likewise, Raphael visualized his Madonnas first in the chaste splendor of their nudity, and only then in the softness of their mantles.

The first artist to tackle the problem of the nude on a theoretical and practical level was Leon Battista Alberti. In his treatise *On Painting*, he discusses the method of constructing the human body: "Just as a man dresses, first draw him *naked*, then wrap him in clothes; thus paint him *nude*, first putting on his bones and muscles, then covering them with his flesh."

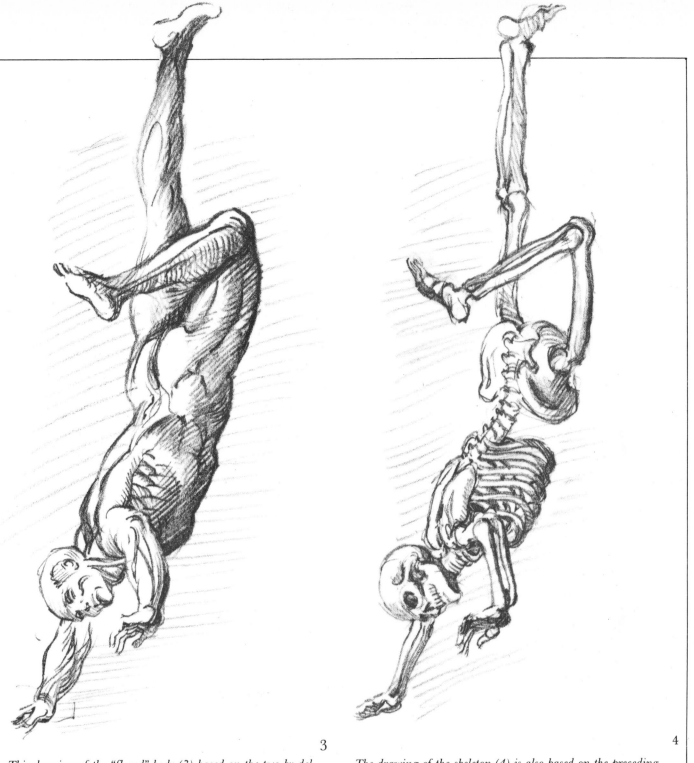

3

4

*This drawing of the "flayed" body (3) based on the two by del Sarto. The study of anatomy can be helped by the analysis of the musculature. The Renaissance painters did such studies from plaster models rather than from life.*

*The drawing of the skeleton (4) is also based on the preceding drawings by del Sarto. It is meant to complete the analysis of the human anatomy as shown by examining the principles of the skeletal and muscular makeup of the nude figure.*

We can learn from this passage in looking at drawings by the masters to study the nude. We can examine both the traditional nude, anatomical renderings and the clothed figure. We have therefore tried to find the bone and muscle structure in an ideal progression that finishes in the dressed body wrapped in clothes.

The examples and the exercises, based on draw-ings by Andrea del Sarto and Annibale Carracci, demonstrate the need to know the makeup and workings of the human skeleton as well as the organization and movements of the muscles.

We can repeat the experiment. Place a sheet of tracing paper on one of the drawings reproduced here. Then find the shapes and positions of the bones and muscles as suggested by the drawing.

Part Three of Leonardo da Vinci's *Treatise on Painting* is devoted entirely to various features and movements of man and proportions of the members, that is, to problems of depicting the nude figure, its proportions and movements. "Vary the measurements of man in each part of his body, turn these more or less and from diverse aspects, increasing or decreasing them a bit more or a bit less on one side, so that they shrink or grow on the other side. Remember, painter, that in the movements you depict, stress only those muscles employed in your figure's motion and action; the more a muscle is used, the more you emphasize it, and the less a muscle is used, the less you bring it out; and those muscles that are not being used are left slow and soft and unemphasized."

In regard to coordinating the movements of the parts of the body, da Vinci points out: "Do not repeat the parts for the same motion of the figure that you are rendering; that is, if the figure is running, do not depict both hands in front of it; show one hand in

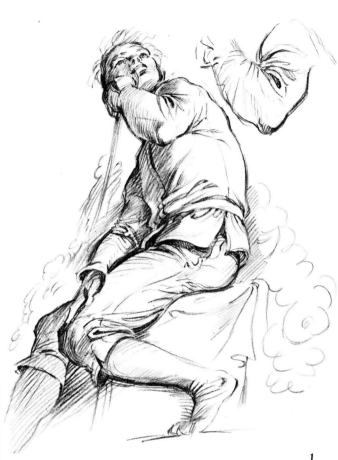

1

1. In this drawing, based on the original by Carracci, I have imagined this figure of a seated man in the clothes of the time, and drew him as Carracci would have treated a clothed figure.

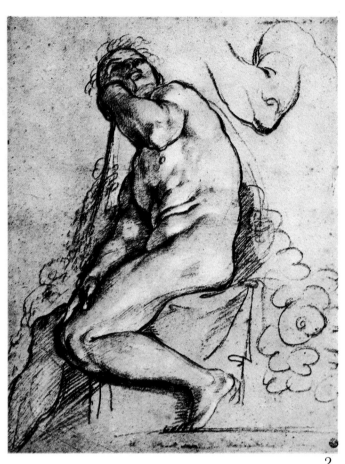

2

2. Anniibale Carracci: Study of a Nude Man. *Louvre, Paris. The original drawing by Carracci is a study of the nude male taken from life. Note, in particular, the foreshortening of the left arm, sketched in a different position.*

Next, copy them as well as the draping of the clothes.

In order to draw the skeleton and the musculature, you can refer to the two examples illustrated in the drawings. Find the elements (bones, muscles, clothes) necessary for your drawing.

Many artists of the Renaissance as well as those who looked to the Renaissance as a model focused on "reading" the nude under the clothes. These artists ran the range from Andrea del Sarto to Ingres (see the nude study of the slave playing the guitar for the painting *Odalisque and Slave*, p. 58).

These artists also applied this method to their studies of portraits, seeing first the construction of the human figure, and then the complete composition with clothes. During the 17th century, the depiction of the nude became a basic exercise for *students* of painting and was therefore ultimatedly labeled "Academic." These nudes were drawn from life but also from nude drawings by the masters.

In the neoclassical climate, the nude became "the most beautiful work of nature," a model that everyone spontaneously visualized and the central

front and one hand in back, otherwise the figure could not run; if the right foot is in front, then place the right arm in back and the left arm in front, for without this arrangement the figure could not run well. If you do a second figure following, with one leg thrown forward, have the other figure turn down its head and have the upper arm change its movement and go forward; and thus it will be thoroughly free in its motion."

As for the facial expressions, "this is how you should depict an angry face: Have your angry figure grab someone by the hair with his head bent to the ground, and with one knee on thorax, and his right fist raised; have his hair up, his eyelashes low and narrow, his teeth narrow, and the two extremes of the mouth arched, the neck thick, and in front, in order to make the enemy submit, full of wrinkles."

(Leonardo da Vinci: *Treatise on Painting, Part III*)

3. *In further investigating the human figure according to the methods of the Renaissance masters, we have "flayed" the model (removed the skin) in order to observe the musculature of the figure in the same position.*

4. *The study can conclude (or better, in a creative process, it could begin) with the observation and analysis of the skeletal structure as a basis for studying the human anatomy.*

theme of visual representation. Our era, however, seems more interested in a deeper knowledge of the human organism and ignores *artistic anatomy.*

Anatomical drawing is based on life studies. This makes the live model highly important if not irreplaceable. Often, however, there are problems in getting a live model. Beyond this, the study method illustrated in these pages is meant to suggest a particular vantage point for tackling the problem of drawing the human figure. Developing from the drawings and experiences of the past, this study progresses from the clothed figure to the nude, to the musculature and skeleton. In creative terms, however, the process can be reversed; we can pass from the structure of the bones and muscles to the nude, and then finally to the clothed figured.

Ultimately, we are proposing an "ancient" but different approach to studying anatomy and drawing the human body, and also to thinking and seeing.

The grids of these Tintoretto drawings serve above all for transferring them to a larger scale. It was the workshop apprentices who used these

# Diagrams for Proportions:
# Exercises with Two Drawings by Tintoretto

*Tintoretto (Jacopo Robusti, called; 1512-1594):* Study for the
Battle of Zara. *Charcoal. Uffizi, Gabinetto dei Disegni e delle
Stampe, Florence.* 1

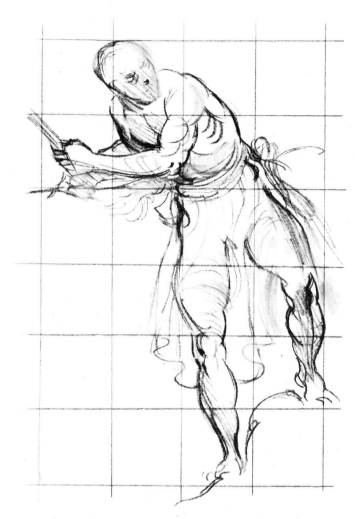

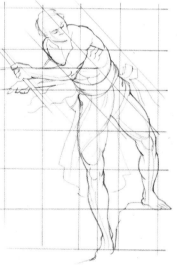

*To make your work easier, especially when you first begin
drawing, you can trace the outline of the figure, either on
transparent paper or on white paper placed on the model over
illuminated glass (even a window). In this diagram, you can find
the details of the body parts, imagining them from the frontal view.
If you have the desire and time to get more out of your drawing,
you can copy the figure, transferring it onto a larger grid. Find
the main geometrical "dimensions" of the legs, arms, trunk, and
head, as indicated in the diagram.*

sketch-diagrams to transfer the figure to a canvas or wall on the basis of a grid enlarged a certain number of times. For the moment, we can treat each grid as a "proportional diagram" that establishes the relationship between the various parts of the body. We can use these schematizations when we practice drawing the human figure, especially for the proportions. Let us take the first drawing by Tintoretto (1), a study for the *Battle of Zara,* and analyze it.

If we examine the right leg of the figure, we find that there are four grid units for the distance between the waist and the foot, three for the leg alone. The foreshortened torso is limited to two units, and the forearm is contained within the diagonal of a single unit. The upper arm, is foreshortened even more. The left thigh is compressed within the diagonal of one unit, while the lower part of the left leg fills two units. And so on.

Now let's transfer the grid to a different piece of paper and draw the figure on this second sheet, but from the front. Using the measurements indicated by the original grid, we can gauge the proportions of the limbs.

Draw the figure as if you were seeing it frontally (or as if it were reflected in a mirror). This is easy because the outline or contour can remain almost identical; and on this, we can construct the figure, seen from the front instead of the back. We will thus have the essential lines of the face, the left arm thrusting forward, the foreshortened right arm in back, the straight right leg, and the left leg bent with the knee in the foreground.

We can do the same thing with Tintoretto's other warrior (2), picturing him from the left and drawing him from the left. Finally, we can draw the figures in different poses, always constructing them in terms of a network of regular squares. This makes it easier to work out the proportions of the body parts: three squares for the length of the legs, two for the chest, two for the arms, etc.

## The Proportions of the Human Body

In all eras, artists have tried to conventionalize and normalize the measurements of the human

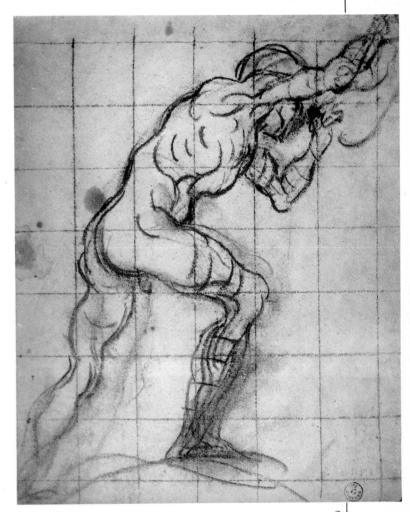

*Tintoretto:* Study for the Battle of Zara. *Charcoal. Uffizi, Gabinetto dei Disegni e delle Stampe, Florence.*    2

*In its schematic rendering, the Tintoretto drawing shows the artist's typical motif: the elongated figure in a diagonal, with the grid ready for enlargement. As we have already observed in the preceding drawing, we will use the grid as a proportional diagram and as a basis for doing a larger drawing of the same figure, but from the other side. The outline will remain the same but symmetrically reversed, in other words, seen from the left and, therefore, with the left arm and leg in the foreground, the face foreshortened, the right arm stretching out, and the right leg bending in the middleground.*

—87—

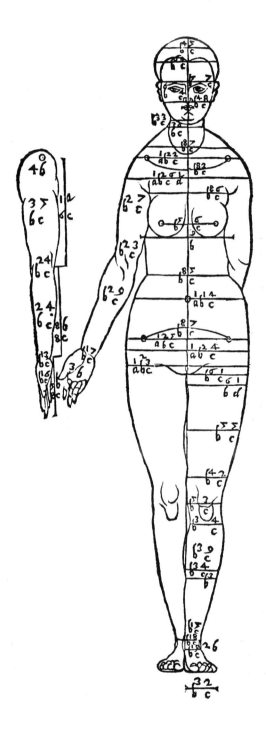

*Albrecht Dürer:* On the Symmetry of Human Bodies, Book IV, *1591. Plate from Book IV, Venice.*

body. Their goal was to obtain an *exemplary type,* for both male and female.

Generally, the head is the basic unit for determining the scale of proportions. The anatomical canon was developed by the Egyptians and codified by the Greeks, whose intentions were philosophical rather than artistic. But even if we respect this canon, proportion is actually a personal choice for each individual artist. Each artist creates his own ideal, rather than a dogma of perfection. All this is of great interest to anyone who draws or is beginning to draw the human figure for the first time. This cannon will guide us as we experiment with the proportions used by the masters. Subsequently, we can each find and use our own "canon," that is, a system of proportions based on individual experiences and personalities.

We therefore need know only the principles of the theory of proportion, in order to tackle the problem of constructing the form of the human body geometrically, independent of anatomical knowledge and realistic observations. The first artist to discuss anatomical proportion was the Italian painter Cennino Cennini. He inscribed the human figure within a circle, the height of the body being eight times the length of the face, and the face three times the length of the nose. The Italian architect and sculptor Lorenzo Ghiberti (1378-1455) suggested the method that later became widespread, of constructing the human figure on the basis of a geometric grid. Later, Alberti based his theory of proportion on the anatomy and movement of the body. However, it was Dürer and da Vinci who demonstrated that there are several possible rules for drawing a human body. This was a result of their constant search for an ideal of beauty that was not merely an aesthetic example, but also an expression of the personality. Anyone who draws or paints (and Leonardo realized this) will unconsciously use himself as a model ("the painter paints himself"). Canons, geometrical diagrams, tracings, are thus the foundations and points of departure for finding your own rules and your own proportions through direct experience and in the way you see, measure, and express yourself.

In the 14th century, Cennino Cennini took up the medieval canons, dividing the face into three parts: forehead, nose, chin: "From the edge of the nose for the full length of the eye, one of these measures; from the end of the eye until the end of the ears, one of these measures; from one ear to the other, the length of the face....from the stomach to the navel, the length of the face; from the navel to the node of the thigh, the length of the face; from the thigh to the knee, two lengths of the face; from the knee to the heel, two lengths of the face; from the heel to the sole, one of the three measures; the foot as long as the face. The woman lacks one rib on her side, which is in the bones of the man. The handsome man is tan, the beautiful woman is white, etc. I will not tell you about the irrational animals, for there is no measurement for them. Trace and draw as much as you can from life, and try it. It is good practice."

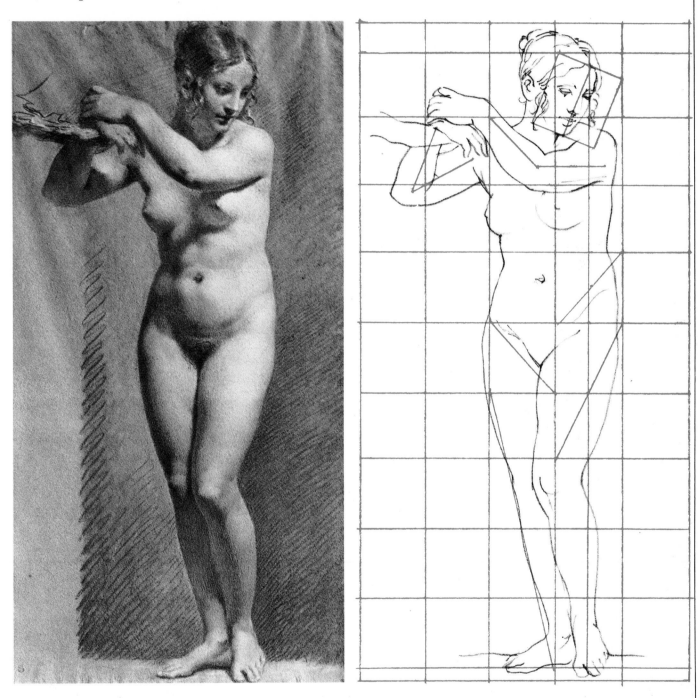

*Pierre Paul Prud'hon (1758-1823):* Female Nude. *Black pencil with white lead touches on blue paper, 580 × 339 mm. Louvre, Paris.*

*This study by Prud'hon can serve as a "model" for practicing proportion. We can go beyond the exercise of the female nude emphasized by chiaroscuro. Place a grid of 9 × 5 squares on the figure and imagine that the side of the square is the unit corresponding to the length of the face.*

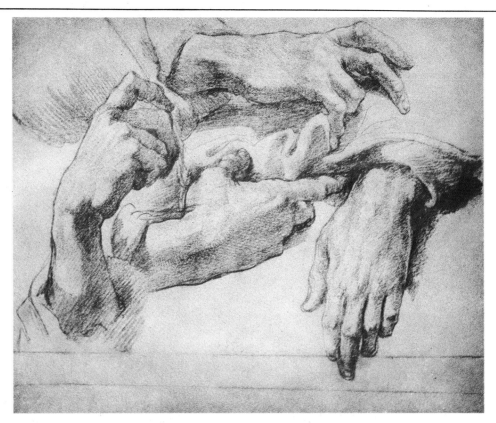

*Andrea del Sarto:* Studies of Hands. *Red chalk. Uffizi, Gabinetto dei Disegni e delle Stampe, Florence.*

## A Drawing a Day: The Hands

The study and rendering of the human body offers the most thorough and most educational opportunity for anyone who wants to learn how to observe and draw.

Before tackling the depiction of the entire human figure, it would be logical and useful to draw several elements individually. One of these elements would be the hands. Hands are difficult because they are particularly expressive. They have always been of absorbing interest for artists because they are something like an acid test.

Let's look at these studies of hands by great artists, and analyze the elements that can help us understand how they were done. Then, we'll each draw our own hands, observed directly or in a mirror placed in front of us.

- *The Hands of Andrea del Sarto*
  There are four different positions here. Study them closely. They seem to follow one another in a sort of circular movement from left to right. The artist has focused on the geometrical proportions of the hands, as seen in the blocklike shape of the palms, and the articulated shapes of the fingers.

- *The Hands of Leonardo Da Vinci*
  Before appreciating the shape of the hands, their foreshortening and the way they are held, we have to admire the composition. The hands seem to be moving gently along curved lines— an impression emphasized by the right hand, vaguely outlined next to the left hand and then depicted further up.

- *The Hands of Hans Holbein*
  These three significant and fascinating sketches have more than educational interest for us because of the way the hands are presented. The left hand is shown above and then below (more carefully, with greater stress on its volume). And between these two renderings, we see the sketch of the right hand drawing itself and the other hand.

- *The Hands of van Gogh*
  These studies are extremely important because they reveal the artist's hard work seeking and determining his road as a painter. They dramatically illustrate the desire to learn how to draw and the difficulties involved. While the lines may be uncertain, repetitive, and heavy, the resulting sketches are "blocked" in the synthesis of a form that has been thoroughly investigated.

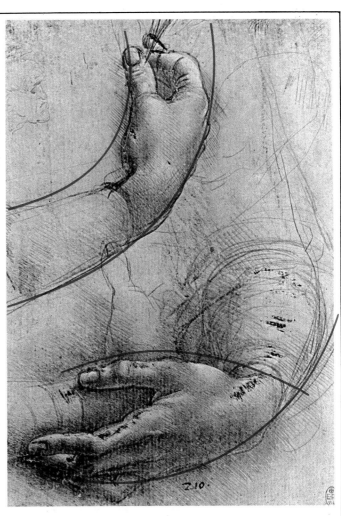

*Holbein:* **Studies of Hands.** *Silverpoint, red crayon, black pencil on prepared paper, 201 × 153 mm. Louvre, Cabinet des Dessins, Paris.*

*Leonardo da Vinci:* **Studies of Female Hands.** *Silverpoint and white lead on prepared paper, 215 × 150 mm. Royal Library, Windsor.*

*Vincent van Gogh:* **Studies of Hands for "The Potato Eaters."** *Black pencil, 300 × 330 mm. National Vincent van Gogh Museum, Amsterdam.*

## Let's Draw Our Own Hands

We have observed and analyzed some of the many examples of the masters to be found in the history of art. How should we draw now?

As usual, the most immediate and most convenient model is you yourself, in this case, your hands. One hand will hold the pencil and draw, while the other can be moved and posed.

1. Before doing anything else, try to see the *shape*. Free yourself of your habitual image of hands. Pinpoint the features that distinguish your hands from others.

2. Next, follow the *directions* of the straight lines that ideally locate and *contain* the shapes of the hands. Limit yourself to these main guidelines.

3. Without losing sight of the shape and the synthesis of the whole, that is, the geometrical scheme created by the guidelines, pinpoint the *characteristics* and the details.

4. For now, at least, limit yourself to drawing only the outline of your hands using an expressive line. Vary the pressure and thickness to suggest characteristics of the shape and the chiaroscuro.

# The Drawings of the Masters

No method of teaching people how to draw is more productive and convincing than the study of the masters and their theories. We can learn from the great artists by analyzing both their works and their writings.

- First, by reading what they wrote. they usually wrote for themselves rather than for others, in order to clarify the mystery and fascination of the creative process of drawing.
- Next, by analyzing the art of the masters to understand their methods and procedures. Retracing each artist's creative process and reconstruct the historical background will help us to acquire their insights and experiences and understand which methods to use for dealing with problems in our own drawings. We have been following this system from the beginning of this course in order to absorb the convictions and experiences of the great masters rather than relying on our personal attitudes and opinions.
- We can also learn from the masters by copying their works—looking at their drawings, paintings, and sculptures and drawing them ourselves. Through such direct analyses of their works of art, we can increase our knowledge and improve our methods of drawing.

Let us return to the *Treatise on Painting,* written by the 15th century Italian painter, Cennino Cennini.

Cennini was the first to advise copying the masters: "After drawing for a while, do your utmost always to draw the best things which you can find done by the hands of the great masters. And if you are in a place where many fine masters

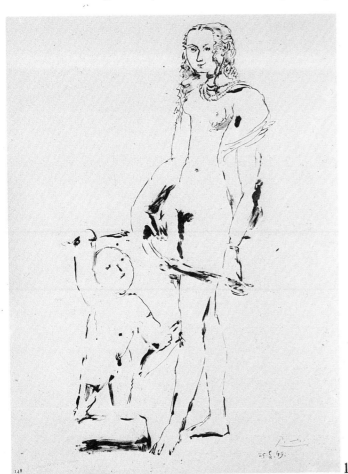

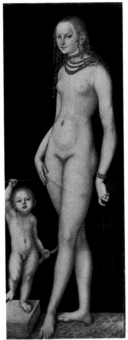

*1. Picasso:* Venus and Cupid, *inspired by Cranach, 1949. Lithograph, 750 × 370 mm.*

*2. Lucas Cranach (1472-1553):* Venus and Cupid, *c. 1530. Painting, 165 × 60 cm. Staatliche Museen Preussischer Kulturbesitz, Gemäldeglareie, Berlin.*

*Picasso liked to copy the great artists in his own way, but with respect and admiration. He tried to fathom their sensitivity and their intentions.*

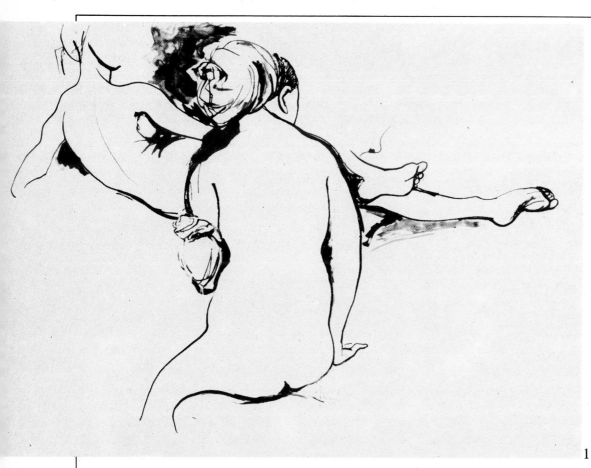

1. Renato Guttuso (1912):
After Ingres, 1973.
Gouache, 730 × 510 mm.

2. J. A. Dominique Ingres:
Woman Bathing, known as
"The Bather of
Valpincon," 1808.
Painting, 140 × 95 cm.
Louvre, Paris.

have been, all the better. However, I would counsel you as follows: Make sure you always take the best [art], and whatever [art] has the best style. As you continue from day to day, it would be natural to take over the manner and air [of each individual work]. If you wish to copy one master today, and another tomorrow, you will not absorb anyone's style. Then, whatever imagination nature may have granted you, you will develop your own manner, proper for yourself, and it will have to be good."

In discussing the most important things for a student to do, Leonardo da Vinci listed the study of the masters right after the study of nature: "The youth must first learn perspective; then the measurements of all things; then the hand of a good master to become accustomed to good habits; then nature, to confirm the reasons for the things he has learned; then he must view the works of various masters for a time; then he must make a habit of practicing and producing art."

In his diaries, Eugène Delacroix often refers to his direct experiences with the works of the great artists, which he never tired of seeing, studying, and drawing: "10 August 1850, Antwerp, museum. Did a drawing by Cranach. Admired *Souls in Purgatory,* in the best manner of Rubens.

Couldn't get enough of the paintings of the *Trinity, Saint Francis, The Holy Family."*

Then later on: "15 April 1883. Before the session, I went to see Courbet's paintings. I was struck by the vigor and relief of his main painting—what a work, and what a subject."

Among the experiences that Vincent van Gogh described daily to his brother Théo are his copying exercises. For instance, February 12, 1881: "My dear Théo … I tried to copy Daumier's *Drinkers* and Doré's *Bath,* but it was very difficult. Soon, I hope to start Delacroix's *Good Samaritan* and Millet's *Woodcutter.*

Delacroix and van Gogh were not the only artists who found it useful to see, read, and copy the great masters of the past. Cézanne, in a letter of 1903, writes: "Dear Monsieur Camoin, Conture told his pupils: 'Have good relations,' that is to say, 'go to the Louvre'—but after seeing the great masters there, you have to hurry out and confer with yourself, contact your inner nature, to find the instincts and feelings of art that reside within us."

The study of the masters must therefore instantly lead to the study of nature. In order to grasp how useful it is to draw the works of the masters and in order to understand these works

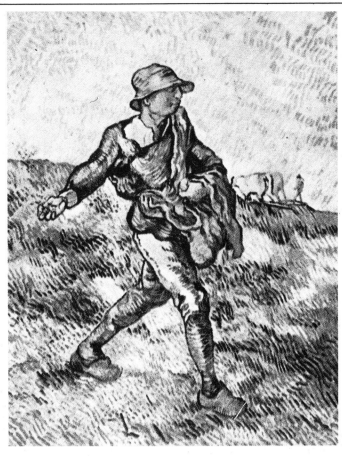

1. *Vincent van Gogh:* The Sower. *1890, canvas. 80 × 64 cm.*

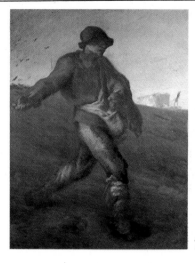

*2. Jean François Millet (1814-1875):* The Sower, *1850. Canvas, 101 × 82 cm. Courtesy of Museum of Fine Arts, Smaw Collection, Boston.*

*It is logical for an artist like van Gogh, desperately searching for himself, to look at the works of the masters in order to find the "path of painting" and to copy them with the same enthusiasm and passion as when copying reality. Van Gogh studied the classical artists and the Impressionists, but hoped to unite line and color.*

1. *Vincent van Gogh:* Pietà. *Canvas, 73 × 60 cm.*

*2. Eugène Delacroix:* Pietà, *1850. Canvas, 35 × 27 cm. Nasjonalgalleriet, Oslo.*

and, above all, ourselves in dealing with them, we ought to read a passage in Guttuso's *Craft of Painting.* Here, he speaks of his contrasting emotions when he visited Raphael's *Stanze.* We should also read a passage by Reynolds, the great English painter of the 18th century: "I very clearly remember my disappointment at my first visit to the Vatican [Reynolds was seventy-six]; but when I confessed my feelings to a student, whose sincerity I esteemed, he too admitted that Raphael's works

1. Masaccio (1401-1428): Adoration of the Magi. *Painting, 21 × 61 cm. Staatliche Museen, Berlin.*

2. Henry Moore (1898): Studies of Masaccio, 1922/24. Pencil.

1

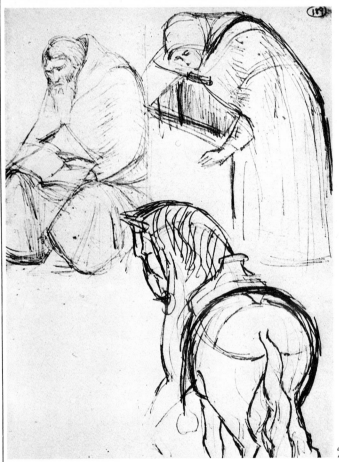

2

had had the same effect on him, or rather had not had the effect that he had expected ... it was necessary to become like a little boy." He then began to copy these paintings and found:

"Despite my disappointment, I began to copy some of these remarkable works. ... In a short time, I came to feel a new taste, a new sensitivity within me."

This seems to be the essential point, and it explains why we should copy the masters. Such an exercise enables us to appreciate thoroughly their gifts and greatness, as we imitate their efforts and application. Guttuso often copied the painters of the past. Why? "Between periods of intense work, I devote myself to copying. Copying is always a form of criticism, the result of reflection. When I copy, I try to be as faithful as possible, to let my hand reconstruct the motions of the *other* hand. However, at times I may go astray and linger on something; but this lingering comes from my need to discover a reason, to expose what I feel the other hand has hidden."

Guttoso concludes: "Another reason I set about copying is to discover how a painter might have completed a painting. Incidentally, when can we say that a painting is completed?" His question also applies to drawings, in which the challenge and fascination of the "incomplete" are even more urgent.

Painters are not the only ones to copy the masters. Henry Moore, the great English sculptor, owes a great deal to his studies of the Italian Renaissance and his efforts to copy Giotto and Masaccio: "No one can say exactly what has influenced me, because I have sometimes been influenced without realizing it. But my excitement, my emotions each time I looked at Masaccio, the Chapel of the Carmine. ... Nor have I forgotten all the other things. Every morning for three months, I went there and spent at least ten minutes there or more, sometimes even half an hour, before moving on to see something else. ... Now this must have had a great influence on me, for every time we meet something that moves us in life, that has meaning for us, it leaves a deep mark on us. I can't say exactly, but I know perfectly well that I would not be the same sculptor, had I not known the works of Giotto, Michelangelo, Masaccio, and others, and had I not drawn those figures, those heads."

These are just a tiny number of statements by artists dealing with the works of the masters who preceded them; but their comments suffice for us to glean some conclusions and valuable advice:

• Do not copy just any artist (chosen only because you have reproductions of his works). Study and copy an artist you feel close to, an artist whose way of seeing and working seems closest to your own.

• Don't try to be slavishly faithful to the original. You have to do something *different*. Copy in your own style, with *your* own way of feeling, by reading and interpreting the meaning of the work.

*1. Vincent van Gogh:* Japonoiserie: Flowering Plum Tree, *1887. Canvas, 55 × 46 cm., National Vincent van Gogh Museum, Amsterdam.*
*2. Vincent van Gogh:* Japonoiserie: Bridge in Rain, *1887. Canvas, 73 × 54 cm. National Vincent van Gogh Museum, Amsterdam.*

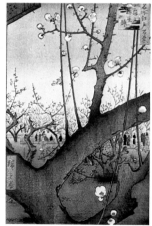

*Andrô Hiroshige (1797-1858):*
Flowering Plum Tree.
*Woodcut from the series* One Hundred Views of Edo, *1856/58. 37 × 25 cm. Musée Guimet, Paris.*

*Andrô Hiroshige:*
The Ohashi in the Rain.
*Woodcut from the series* One Hundred Views of Edo, *1856/68. 37 × 25 cm. Musée Guimet, Paris.*

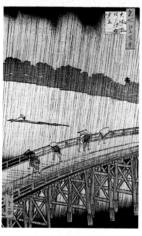

## Japanese Art and Vincent Van Gogh

"Please keep Bing's objects ... I've remitted money instead of earning it, but having them gave me a chance to study Japanese prints calmly. Without them, your apartment would not be what it is ... my entire work is virtually based on Japan. ... Japanese art is declining in its place of origin, but it is establishing new roots among the French Impressionists." Van Gogh wanted to have these Japanese prints in order to copy them, for he knew he could enter into the spirit of this way of seeing and drawing only by copying them. And indeed, he copied the prints, inventing them, making his copies even more "Japanese," as he sought a stylization and personal interpretation of their meaning.

Van Gogh's letter to his brother Théo refers to Bing, the dealer in Japanese objects, who had opened a shop for Oriental art in Paris. This shop made a crucial contribution to the impact of Japanese art in France.

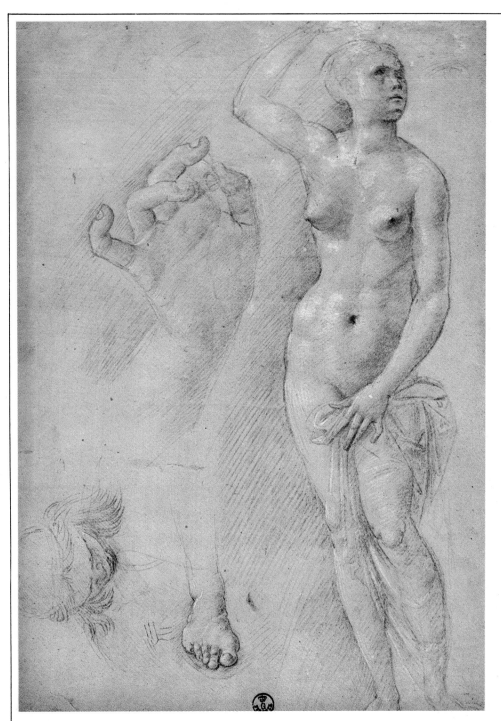

*Florentine School: Study of Venus, 1470/80. Metalpoint pen, white-lead highlights, on orange-red paper. 273 × 190 mm. Uffizi, Gabinetto dei Disegni e delle Stampe, Florence.*

*This drawing of Venus was one of the suggested "models" of its day. It is typical of the studies done by Florentine painters during the 15th century, serving as an "example" to copy and imitate.*

*The goal of our exercise is not to copy the figure slavishly, but to redo some of the details on a larger scale, for instance, the left hand. We can see that the right hand has already been enlarged in the drawing.*

## Seeing and Copying

To "find" the great masters of the past rather than merely seeing the reproductions of their works in books and analyzing or copying these "models," we have to go and "speak" to them in galleries and museums.

Direct contact with the works of paintings and sculptors becomes a true dialogue whenever we can look at their paintings, drawings, sculptures without intermediaries, without reproductions or criticism. How should we observe? First of all, we

have to be free and give in to the pleasure of "reading" and participating in the extraordinary event of the artwork—an event that recurs every time we see it. Then, we have to find the process of genesis and development, but with our own instruments, in terms of our own interests, our own problems and hopes.

We should always seek a direct contact whenever possible. Then we can go through books and journals. And, by referring to our direct contacts, we can try to repeat the process of creation, by drawing the masters *directly.*

## Drawing from the Great Artists, the Masters

Copying the masters is not just an exercise for beginners. Nor was it the province of 19th century painters looking at the great artists of the Renaissance. If you need convincing, just look at the examples on this page: Michelangelo's study of Masaccio's fresco of the *Dedication of the Church of the Carmines,* or Rubens's study of Michelangelo's statue *Night* from the Medici tomb in Florence, rendered from three different angles.

Michelangelo's drawing is obviously a precise and careful rendering of the drapery and volume of the painted figure. Rubens's work is a "life" drawing, or rather a series of "life" studies of a sculpture.

However, both of these drawings are unusual for revealing the personalities of both the original artist and the copyist. Above all, they demonstrate the strength and significance of the drawing in respect to the original art works.

The crosshatching of Michelangelo's chiaroscuro shows his admiration for Masaccio's new conception of space and volume as well as his desire to "rediscover" them. In Rubens's drawing, we can discern his wish to "recover" Michelangelo's sculptural sensibility by means of a minute inquiry and pinpointing of details that are not in the original statue (for instance, the left hand). Rubens moves around the figure, seeing it and drawing it from several points of view.

These studies are illuminating examples of the copying process, showing the immediate assimilation, interpretation, and reinvention of the artist, and his awareness of the deep affinity between the master's style and his own temperament.

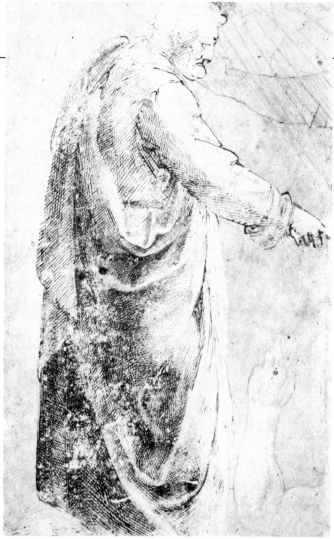

1

*1. Michelangelo (1475-1564): Copy of Masaccio's* Dedication of the Church of the Carmines. *Pen and brown ink, 294 × 201 mm. Graphische Sammlung Albertina, Vienna.*

*2. Masaccio:* The Tribute *(detail), 1425. Fresco. Church of the Carmines,*
2 *Brancacci Chapel, Florence.*

*1. Peter Paul Rubens: Copy of Michelangelo's* Night. *Black stone, pen and brown ink, highlights in yellow and white gouache, 245 × 350 mm. Netherlands Institute, Custodial Foundation, Paris.*

*2. Michelangelo:* Night, *detail from the Tomb of Giuliano de' Medici. Marble. San Lorenzo, Medici Chapel, Florence.*

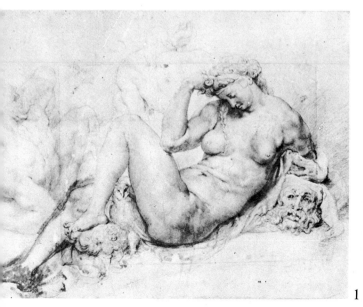

1

2

During his youth, Marco Zoppo signed some of his works *Marco Zoppo di Squarcione* to indicate not only his apprenticeship in the workshop of the painter Francesco Squarcione (1397-1468), but also because Zoppo had been adopted by his teacher. Born in Cento in 1433, Zoppo arrived in Padua in 1453. Here he became part of the cultural and artistic climate dominated by the personality of Mantegna and by the archeological and antiquarian interests of the Squarcione circle.

His traditional interpretation of "Antiquity" linked him to the Mantegna sphere. He was very important in the field of book illustration and in developing a new style of drawing. He also contributed a great deal to manuscript painting. The *Taccuino* (album) of London, formerly attributed to Mantegna, is one of the finest and most typical examples of Marco Zoppo's graphics. It is a sound reference point for reconstructing Zoppo's activities. The *Taccuino* is made up of 36

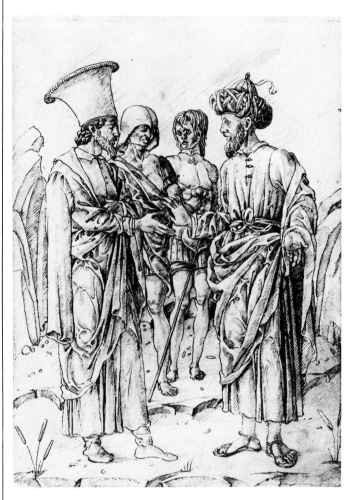 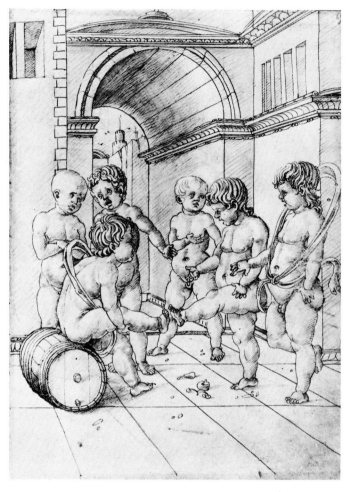

*Marco Zoppo:* Four plates from the "Taccuino of London," *British Museum, London.*

## Books of Models

The Middle Ages made wide use of *exempla*—handbooks of drawings containing figures and compositions for "copying." This era did not demand that artists work from life; they were supposed to copy the well-known works of the masters. These albums were used constantly in artist's workshops to train apprentices and to prepare paintings. In general, the drawings in *exempla* were based on famous cycles of paintings, for example those of Altichiero Altichieri, which served as models for apprentices for many years.

A fundamental document is the *Universal Chronicle* (c. 1460) illustrated by Maso Finiguerra, a Florentine goldsmith. Using a theatrical presentation of the heroes of the classical world, he created a rich and original parade of fashions and ornaments. His collections of models are nearly always made up of drawings of figurines, faces, and draperies on colored paper with white gouache strokes to reinforce the bright accents. This method evoked the material and modeling of oil painting.

There are also other kinds of models, the following two categories are the most widespread: 1) designs of decorations, moldings, and accessories; and 2) more complex compositions, including examples from the famous collections of North Italian artists such as Jacopo Bellini or Marco Zoppo. These were actually catalogues of models destined for their workshops.

parchment leaves containing 50 drawings. These can be chronologically dated in the 1470s, although the problem of interpreting them still remains open. In any case, they clearly reveal the originality of Marco Zoppo, an incisive and talented painter. The richly varied drawings contain numerous motifs: weapons, landscapes, nudes, architecture, and so on. They have many expressionistic accents and they almost parody the classical world. As an animated book of "models," this opus transmits a new and original spirit.

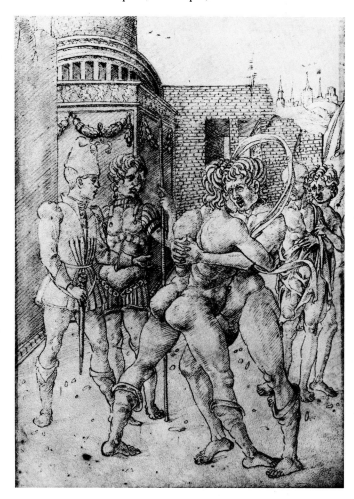 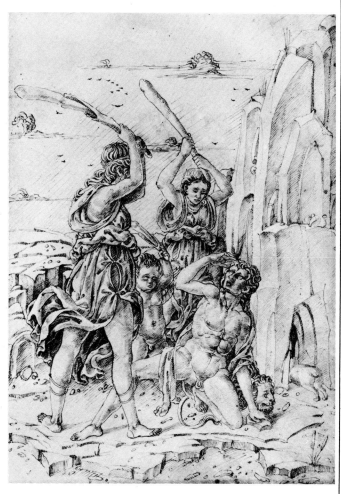

A special discussion would be required for the collections of reliefs, measurements, and drawings of ancient architecture and fragments. One of the most interesting is the volume by Giuliano da Sangallo (c. 1443-1516).

Drawing was now the most suitable medium for recording impressions and observations, especially in studios and workshops; these were based on research into the mechanisms of life and the morphology of nature. The late 15th century was dominated by these forms of knowledge, which could be transmitted visually; and the invention of engraving increased the potential of this legacy.

Engraving was defined as a "truly very singular commodity," for even very distant countries could enjoy engravings of art works, especially by Mantegna, a practical and well-organized artist. He was the first to reproduce his *Seated Madonna* in several copies. In this way, he demonstrated that he fully understood the twofold function of prints as an expressive medium and as an instrument for circulating models. Certain motifs in drawing and painting were transmitted and became known because of engravings: Botticelli's draperies, the costumes in the *Chronicle,* the dancing figures of cupids, the suits of armor worn by Marco Zoppo's warriors, and Pollaiolo's nudes were all widely circulated in engravings. This tendency reenforced the pure graphic style with a technique based on contours and lines.

## Copying Drawings

Copying the works of the great artists has always been more than an homage to their skills and talents. This exercise enables the copyist to repeat the specific experience of creation, and renew it in all its aspects, directly, from the composition to the lines, colors, and chiaroscuro.

"Drawing from the masters" has thus become a "classical" exercise. It can provide an easier and quicker result than working from life. However, we have to *orient* our work according to a precise program.

Let me explain. Rather than by combining in a single drawing *all the observations* that a *critical copying* of a drawing allows, it is better to separate the various aspects of observation in a series of drawings based on the original. Naturally, many problems can arise. The most fundamental problems are, as usual, composition, shape and chiaroscuro, and color. Let's look at three drawings by different artists, and copy them according to precise instructions. That is, we will make three studies of each drawing—not copies, but reworkings that focus on the most interesting aspects.

Claude Lorrain's drawing is an extraordinary example of the many forest landscapes to be found in European art. This French artist manages to render the magical atmosphere of the clearing, which is bathed in silvery light. He uses a tiny number of tones, virtually creating a monochrome watercolor.

Degas' pastel, with its luminous tints in an interplay of hot yellows and reds, testifies to his incredible artistic technique. The extremely simple composition is constructed on vertical lines.

Gustav Klimt's drawing displays his poetic and painterly universe. The pattern of the wallpaper melts into the rich decoration of the clothes worn by the lovers; while the original composition by this Austrian master recalls the fascination of Japanese drawings.

On page 104, we have printed several studies of these drawings in order to bring out themes not discussed by us. By doing several studies in this way, you can decide your own interpretations. Naturally, your interpretations do not have to agree with these. There are many possible approaches, all of which are useful for testing the dynamics of a drawing and for suggesting ways of viewing it.

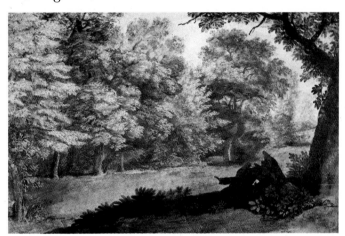

*Claude Lorrain:* Clearing in a Woods, *c. 1645. Pen, brown ink, brown, gray, and pink wash, with white lead highlights on blue paper, 224 × 327 mm., British Museum, London.*

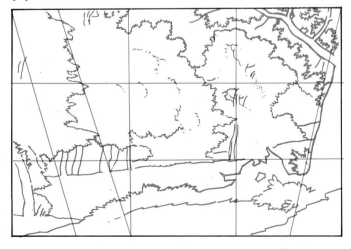

*Edgar Degas (1834-1917):* After the Bath, *Pastel, 622 × 655 mm. Louvre, Cabinet des Dessins, Paris.*

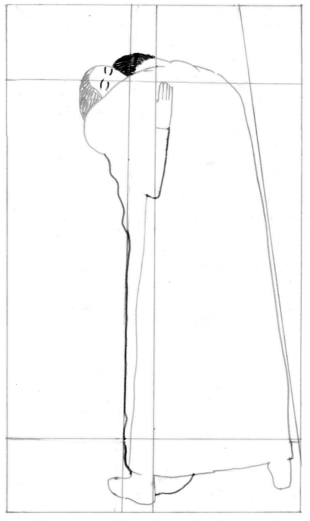

*Gustav Klimt (1862-1918):* Drawing for the mosaic of the Stoclet Residence, Brussels, *1909. Mixed media on paper, 194 ×
121 cm. Österreichisches Museum für angewandte Kunst, Vienna.*

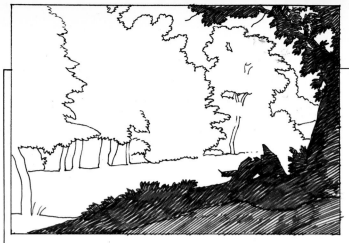
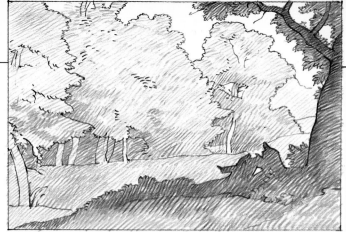

*Chiaroscuro done in pen (left), and a synthesis of colored pencils (right).*

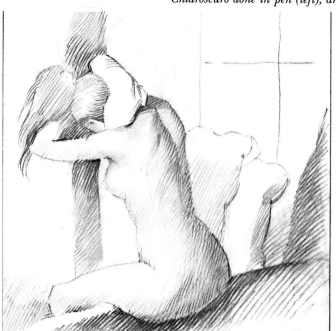

*Chiaroscuro done in red pencil (left) and a synthesis in colored crayon pencils (right).*

*Diagram of decoration and selection of colors.*

# Measurement and Drawing

If you want to faithfully depict an object in its characteristic shape and size, you have to eliminate the distortions caused by the way we see things.

For instance, we see "in perspective." That is, the more remote parts of an object, building, or landscape appear smaller than the closer parts. If we wish to render these things in their own reality, we have to use traditional, objective methods based on the rules of geometry. This will help us to measure and draw the real characteristics, that is, to create the plan, the design.

The interest in and study of plans goes back a long way; they were already documented in ancient Rome. However, the general practice of drawing plans did not really begin until the Renaissance, when artists wanted to do life studies of the remnants of older architecture.

Rome became a mecca for those who wanted to see, study, and understand the vestiges of the ancient world. Brunelleschi (1377-1446) came to Rome with Donatello (1386-1466) and "measured cornices and drew plans of these buildings." Leon Battista Alberti came here, and so did Vasari, the art historian, who described "all the edifices of Antiquity that could be important for any reason … in order to bring out their useful elements. I have incessantly investigated, measured and sketched everything I could." Another artist who came to Rome was Simone del Pollaiolo (1457-1508), who "began to view the ancient monuments and, delighting in them, he measured them with utmost diligence." Upon returning to Florence, he described them in such great detail that he was nicknamed "the Chronicler." All in all, a huge number of Italian and foreign architects came to the Eternal City.

In 1515, Raphael suggested to Pope Leon X that he initiate an intense campaign of surveying the remnants of ancient Rome. Palladio (1508-1580)

*Giovanni Battista Piranesi (1720-1778):* The Colosseum, bird's eye view. *Pen and ink, 510 × 750 mm. Staatliche Museen, Berlin.*

*1. Villard de Honnecourt:* Cathedral of Reims, *c. 1230. Black ink on parchment, 237 × 156 mm. Bibliothèque Nationale, Paris.*

collected a great mass of notes, on which he based his "drawings of Roman antiquities."

Countless students—not only architects, but also humanists and men of culture—came to Rome in order to study its monuments or simply to breathe its magic air. Sometimes, they would come again in order to continue their studies or relive their initial emotions.

Along with their views, these artists also produced building plans, designs, cross sections, objective renderings of details that interested them and aroused their emotions. In this way, they transformed their drawings into personal interpretations.

The architectural drawing not only *documents* the form of the building or object. It also helps to

*2. Giuliano da Sangallo:* Plan of St. Sofia, *c. 1514-16. Pen and ink, graphite, sepia, on light paper, 440 × 740 mm. Codice Barberini, Biblioteca Vaticano.*
*3. Andrea Palladio:* Arch of Constantine, *c. 1554. Pen and ink on paper, 292 × 205 mm. Royal Institute of British Architects, London.*

In his biography of Filippo Brunelleschi, Giorgio Vasari writes: "He sold a small farm he owned in Settignano, and leaving Florence, he traveled to Rome. Here, upon seeing the grandeur of the buildings and the perfection of the temples, he was so absorbed that his mind seemed to be elsewhere. And thus, being ordered to measure the cornices and to do plans of these buildings, he and Donatello lost no time obeying and spared no expense, nor was there any place in Rome or out in the countryside that they did not see, and they measured everything that was good. And because Filippo Brunelleschi was free of familial concerns and deeply devoted to his studies, he went without food or sleep, his only interest was the architecture of the past; I mean the good ancient structures, not the German and barbaric architecture, which was quite common in his time."

(Giorgio Vasari: *The Lives of the Most Excellent Painters, Sculptors and Architects*.)

*reconstruct* the creative process, to *understand* the transformation, and to *fathom* the meaning.

We cannot hope to restore any building (or any man-made object for the matter) except by means of a precise and careful reading of all its aspects. Above all, we cannot prepare any restoration project if we do not proceed on the basis of a design. Think of all the buildings that have been destroyed by accidents or natural disasters such as earthquakes. Think of all the efforts, especially more recently, to reconstruct them with their original characteristics. We now realize the importance of objective blueprints, scale drawings, views, details—in a word, the plan.

However, the plan has not only this documentary value. Actually, when we reconstruct the plan of a particular building or man-made object, we start with the final result and then retrace the process, the measurements, the materials—all the characteristic elements. And ultimately, we have all the necessary data for defining our object.

What has happened? We have designed the project—backwards!

If we stop and think about it, we realize that the sum of information that we have gathered equals the project itself, reconstructed bit by bit, moment by moment. And there is certainly no better process or method of study or work if we want to thoroughly understand the object we are examining.

*Raphael:* Sketch of the Pantheon. *Pen and ink on white paper, 278 × 402 mm. Uffizi, Gabinetto dei Disegni e della Stampe, Florence.*

*This drawing shows the interest in Roman architecture shared by one of the greatest painters of the Renaissance, who, like other artists, was also an architect.*

"If a stranger wishes to learn about the spirit that accompanied the rise of Venice and her strengths in becoming powerful and victorious, he should not try to reckon the wealth of her arsenals, or the number of her military division, nor should he dwell upon the luxury of her palazzi, or ponder the secret of her councils; rather, he should climb to the highest level of the steps surrounding the alter of Torcello. Then, gazing as the helmsman did along the marble ribs of the gracious church nave, he should repopulate the veined bridge with the shades of perished sailors and try to feel within himself the strength of heart that was kindled in them when for the first time, after the pillars were planted in the sand and the roof was closed against the furious sky still glowing with their home fires—for the first time in the shelter of these walls, amid the murmering solitary wave and the beating of bird wings, sailors unfamiliar with that rock—the ancient hymn surged, in the might of their choral voices; the sea is His and He made it,

## The Stones of Venice

"John arouses the liveliest amazement in all the Venetians, no matter who, and I do not believe that they have made up their minds whether he is a poor halfwit or a genius. Nothing manages to deter him; it does not matter whether the square is crowded or deserted, he is always absorbed in making daguerreotypes, with a black cloth over his head, or in crawling around the capitals, covered with dust or cobwebs, as if he had just arrived from a voyage with a witch on her broomstick." That is how John Ruskin's wife, Ettie, describes the English writer's fascination with Venice, with its weathered stones, "measuring, drawing, sketching, making daguerreotypes, ascending stairs on sticks and scaffolds, examining mosaics and paintings in flickering candlelight, spending whole days meticulously studying the Gothic."

It is not surprising that Ruskin wrote: "There is a powerful instinct in me, which I cannot analyze, to draw and write down the things I love. ... I would like to draw every single stone of the whole of San Marco in Venice, all Venice, and then squeeze it into me, bit by bit...."

John Ruskin, a British writer and art critic, was a true Victorian genius. In November 1849, he arrived in Venice, intent on enlightening his fellow Englishmen about the true significance of architecture. The subject of the resulting book, *The Stones of Venice*, was the artistic example and social structure of this extraordinary, fascinating, and decadent city. Ruskin filled his notebooks with jottings, descriptions, and watercolor sketches; these notebooks are among the most important documents of his surveys and drawings.

His drawings reveal the enthusiastic traveler hungry for knowledge, the curious and sensitive

*John Ruskin (1819-1900):* Byzantine Capitals, from The Stones of Venice).

*Ruskin was not content to sketch views of the chief Venetian monuments. He deepened his investigation by doing precise drawings of details, such as this series of capitals - a significant example of his work.*

and His hands will prepare the land.

"Although the rooms of the Doge's Palace no longer have the character of the men who built them, they are true summits of inestimable treasures. Treasures so precious, to be sure, and so majestic that sometimes, strolling in the evening along the Lido, where, over the façade of the Doge's Palace, looms the great chain of the Alps surmounted by silvery clouds, I was awed by the sight of the Palace and the mountains, and I thought that God had wrought a greater work by instilling in the miserable dust spirits so powerful as to erect glorious walls, choruses, traces of ardent legends, to elevate these masses of granite beyond the celestial clouds, and drape them in the changing mantle of purple flowers and rustic shadows."

*(John Ruskin:* The Stones of Venice, *"Torcello" and "The Doge's Palace")*

observer able to see, the student, and finally the draftsman who united all these qualities in his works. He observed and described the elements of an architecture par excellence: the Venetian Gothic. Ruskin's portrait of Venice is a unique itinerary for reading the topography of the city, and also its history, in order to investigate the enigmas of its various styles: Gothic, Byzantine, and Renaissance.

It is not enough to do views of streets and palazzi. We have to measure, observe, report, and then do scale drawings, designs, sketches of acades, porticos, columns, capitals, balconies. This is the only way to understand architecture, to appreciate it fully and deeply, and above all, to see it through the eyes and memory of someone who viewed an extraordinary city and whose visit was an extraordinary experience.

*John Ruskin:* Study of the Marble Tarsias on the Façade of Casa Loredan. *Watercolor (from* The Stones of Venice).

*John Ruskin:* Southern Wing of San Marco, seen from the Loggia of the Doge's Palace. *Watercolor (from* The Stones of Venice).

The Swiss painter Paul Klee writes about his boyhood experiences in his diaries (no. 10): "The evil spirits that I drew assumed physical shape. I then sought protection with my mother, and I complained because the little demons were peering through the window."

And in no. 27, he says: "In the restaurant owned by my uncle, the fattest man in Switzerland, there were tables with polished marble tops. Because of their age, the surfaces were thickets of furrows. In each labyrinth of lines, you could see grotesque human figures and you could capture them with a pencil. I worked feverishly, thus documenting my taste for the bizarre."

(Paul Klee: *Diary*, nᵒ 10 and 27)

## Paul Klee's Room

These two drawings, done at an interval of one year, have the same theme: Paul Klee's room in the house at no. 8 Marienstrasse. The room is seen in two different ways. The first drawing is a view in perspective; the second is an analytical ground plan, with numerous written comments.

In the first drawing, which Klee did when he was only seventeen, he used wiggly strokes as the basis for the superimposed gouache painting.

The second drawing is more curious and certainly the more interesting of the two. In it, Klee made a plan, indicating every object: the notebook, the pen on the table, as well as the cat in the lower left-hand corner (and we can find the cat again in the still life with the garden implements, p. 76). He also added a few comments (such as "work table: oh, irony!") chiefly in order to personalize his room. In fact, at the intersection of the two arrows with their indications of the four cardinal points, he wrote: "hic ego!" (Latin for "here I am!").

The images of the room, in both the perspective version and the ground plan, are meant to reveal a fundamental element in the life of young Paul: his adolescence, from first turmoil to adulthood. These are illustrations of a long narrative that was amply developed in Klee's diaries. The artist's interpretation is personal in both the perspective view and the ground plan, which loses all the objectivity of geometric rendering to become an absolutely personal drawing. Both works confirm his quest for an analytical understanding of his own self through his environment.

Artists have always been interested in the rooms in which they live and work: not only as an "enveloping space," but also as the "space" in which their own personalities are manifested in a thousand details.

These details are included and commented on, both in Klee's perspective view and in his ground plan. They are annotated with a care and attention that go beyond the simple graphic facts.

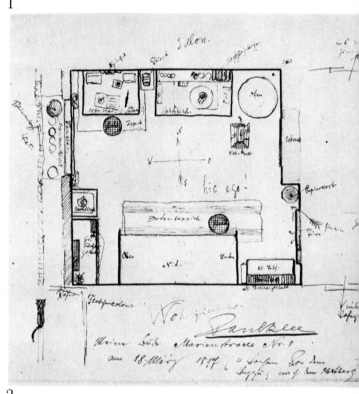

1

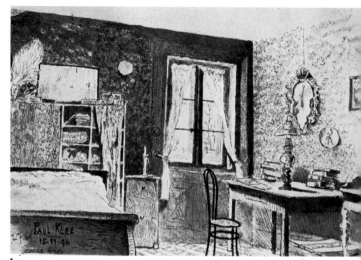

2

1. Paul Klee: My Room, 1896. Pen and India ink and watercolors, 121 × 192 mm. Paul Klee Foundation, Berne.

2. Paul Klee: My Room, 1897. Pen and brown ink, 170 × 214 mm. Paul Klee Foundation, Berne.

## Drawing a Spatial Design

Pretend that you are inviting me to your home, that is, that you want me to get to know it. You can describe it to me in words, spoken or written, or you can present it in drawings, illustrating it objectively in thorough ground plans, cross sections, and wall views; or more subjectively by using perspective sketches. The basic geometrical drawings, defined by strict measurements, will depict things as they are (though, of course, on a smaller scale). The sketches, on the other hand, will show your home as *you* see it.

In order to know your home, that is, to *understand* it, we need both types of depiction. But first, we have to do a scale drawing. We have to measure the rooms (their length and width) and do a ground plan in the correct proportions, that is, as if we were looking down at them from the level of the window sills.

You know what *measuring* means, and we will soon learn how to measure without making any big mistakes. Drawing in scale means depicting in a given ratio the things that we have measured. For instance, if you want to draw a rectangular room 16 × 20 feet on a scale of, say, ¹⁄₁₀₀ths of its size, you divide 16 × 20 by 100, and you then draw a rectangle ¹⁄₁₀₀ the size of the room: 1.92 by 2.4 inches. If you want to increase the scale to ¹⁄₅₀th its size, then the resulting rectangle is ¹⁄₅₀th the size of the room: that is, 3.84 by 4.8 inches.

*These diagrams illustrate the process of measuring the spaces in an apartment: entrance (I), living room (S), kitchen (K), bedroom (L), and bath (B)*

Measuring and drawing in scale are not difficult if the rooms are square or rectangular and the walls orthogonal, that is, forming right angles. But things get more complicated when the shapes of the rooms are irregular, that is, when the angles formed by walls are not 90 degrees. In such cases, we have to do more than measure the sides of a room. We also have to measure its diagonals (the lines connecting opposite corners). This will prevent us from making mistakes.

Do the following exercise: measure your apartment and then draw the space. There is nothing that is more personal, nothing that you are more familiar with. And yet … no sooner have you started looking attentively at the space you want to measure and draw—a space you see absentmindedly every day—than you begin discovering all sorts of new things. You notice how many interesting things there are in a home, which you only *think* you know.

Okay, all well and good. But once you've made the ground plan of your home, of what use will it be? First of all, it will enable you to truly grasp the environment you live in. Furthermore, this ground plan will be highly useful, even indispensable—so much so that you ought to entrust its documentation to an outside draftsman. The ground plan will be something you can study and use in hundreds of ways: such as for interior decorating, reconstructing, checking measurements, and rearranging furniture. Are you certain that you are completely satisfied with your home? Is there nothing you can do to improve it? Are all the doors necessary, is the furniture nicely arranged?

If you draw a ground plan, then everything will seem clear to you: the arrangements, the passages, the free spaces. You can now play around with this "map" and see if you can find ways of living better.

## Using a Ground Plan (Measurements and Drawings)

As we have said, the ground plan of your home gives you a complete and proportioned overview, a "map," in just a few small inches. You can see the main walls (the larger ones) or the structure in reenforced concrete (the quadrangular piers), the partitions (thinner walls), the doors, and even the furniture (fixed: closets, kitchen and bathroom items; and movable: couches, beds, chairs, tables, etc.)

Thus, by studying the plan of your home, you can work out a series of analyses and designs for improving (if ever so slightly) the way you live.

*An example of the dimensioned floor plan of an apartment. Note the dimensions on the door axes, indicating width and height, and the position of the external dimensions, which gradually become more detailed.*

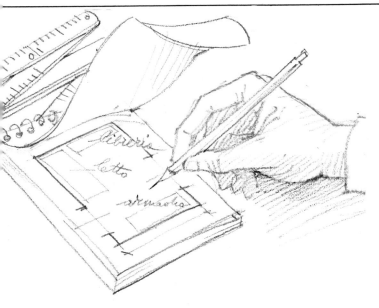

- The first and most obvious analysis is to verify the "functionality" of your apartment. What does this mean? You have to check whether you are making the most of your living space, whether the rooms are arranged functionally. Can you go directly from the kitchen to the dining area, from the bedroom to the bathroom? Are the passages generally direct, without useless and annoying detours? Is there enough space in each room, and is the space being used effectively and efficiently?

- Next, analyze the furniture, from the doors to the closets, from the kitchen to the living room.

How often have you felt like rearranging your furniture in order to make your apartment more spacious and more functional? But you never went ahead with your plan, it seemed like too much trouble, or else you were afraid there wasn't enough space: you might not be able to open that door or, you wouldn't be able to get into that hallway.

But now, with your floor plan, you can picture, imagine, project, and test all the changes you like, every modification, every rearrangement, every new design with a simple stroke of the pencil! A scale drawing, accurately proportioned, can give you a precise idea of all the possible ways of carrying out your plans. You can test, suggest, and experiment. And if you want to be even more practical, you make cardboard cutouts of the furniture in scale (say, 1/50) and move these "furnishings" around on your floor plan, trying out different arrangements without ever leaving your desk.

*These diagrams, based on the data of measurements of the surroundings, illustrate the possibility of studying various furniture arrangements using cutouts of the furnishings.*

The need to safeguard our traditions and our artistic heritage is particularly acute today, but it is not peculiar to our era alone. The medieval world was so fascinated with antiquity that even the chiefs of the barbarian hordes invading Italy were charmed by the majesty of the ruins of earlier edifices. The Greek historian Procopius of Caesarea (late 5th century A.D.) was the secretary and confidant of the Roman general Belisarius. According to Procopius, Belisarius asked Totila, king of the Goths, to respect the monuments of Rome: "The men who justly appreciate the laws of civil life, embellish with works of art the cities that are as yet without them; on the other hand, foolish men strip them of their ornaments and thus shamelessly hand down the memory of their wicked characters. Of all the cities under the sun, Rome is the largest and most beautiful, for she was not born from

## Knowing and Safeguarding Our Artistic and Cultural Heritage

There are so many interesting things to see and draw in your city, in your state. By measuring and drawing them, you will create a documentation that is also a living record, a memory. Hopefully, you will want to draw not only to get to know things, but also to preserve and protect them. Which things? Some of those "wonders" that enrich your country. From the most modest to the most important, these wonders form that grand network that has become our artistic heritage.

In Italy, for example, the Central Institute for Cataloging and Documenting the Italian Artistic Legacy has been collecting material on architecture, painting, sculpture, and the applied arts for many years now in order to record and protect the heritage of Italian history and civilization.

Imagine what would happen if every one of us, every citizen who knows how to draw, attempted to record some element of our cultural and artistic legacy. For this heritage ultimately constitutes our living environment, which is gradually disappearing around us. It's like a bottle in a straw covering: originally the straw protected both the bottle and its contents; but the straw has worn away, and now the bottle is covered with a plastic netting.

Imagine the enormous possibilities of documenting and safeguarding our surroundings.

*The ground plan of Varese Ligure clearly emphasizes the urban and architectural character of the town, as articulated in the two arcs of houses defended by towers.*
*(The plans on pp. 114-115 were drawn by students of architecture at the University of Genoa).*

the power of one man; instead, the long line of Emperors and the convergence of works by the most illustrious men, employing infinite riches throughout many, many years, have beautified Rome with masterpieces gathered from all over the world. And thus, this city, as you now see it, which was built up little by little, and which these men will leave to their descendants, symbolizes the culture of the entire world. Hence, the man who would destroy so much grandeur, would make himself guilty of a terrible crime in regard to all men of the future, for he would deprive the ancestors of the monuments to their valor, and he would deprive the grandchildren of the enjoyment of seeing the magnificent works of their grandfathers. If you destroy Rome, you will not be wiping out someone else's city, you will be wiping out your own city."

Above all, think of training and developing an awareness of our artistic heritage, as a legacy for all of us. In this way, the knowledge and conservation of our cultural goods would not just be up to the government. Each of us could take part and enjoy our legacy if we lived and worked *within* our artistic and cultural heritage.

So our suggestion for the drawing of the day is more demanding than usual. It involves not only us, directly, but also our environment. Find some object in your city, some little-known, perhaps endangered, item, that deserves attention because of its cultural and artistic value, something that you feel should be documented, described, drawn, or photographed, so that others may know it, preserve it, and. if necessary, restore and revitalize it.

- This object can be a building or group of buildings, a fountain or chapel, a rustic item, a loom or coffee grinder, even a costume, a lamp, a piece of furniture...

  Look around and see how many things we risk losing if we don't record them.

- An object or building can be documented in any number of ways. You can describe it in writing, photographs, or drawings. The most complete approach unites all three of these methods and is based on a plan.

Naturally, you can choose the method you prefer. In any event, we have prepared a rough draft, which we feel illustrates quite thoroughly the scope of your choice in recording the civilization of your country and your city.

There is an apt statement by Leonardo da Vinci: "Love is the result of insight and knowledge, and the more certain this insight and knowledge, the more powerful our love."

We draw in order to know, and we know in order to love. Thus, drawing also means loving, preserving.

*An ancient Ligurian boat for fishing and cargoes.*

*A winder, a typical tool from the Italian pronvince of Chiavari.*

# The Façades of Portofino

By making a ground plan, we "dismantle" an object. We can then examine it thoroughly and "reassemble" it. In other words, a plan shows us how a building, a chair, an instrument is made. We can understand the way it works, and we can document its various aspects.

This possibility of documentation allows us to record something that interests us, to preserve it in drawings we can look at whenever we like.

This is the case with the plans of the painted façades of Portofino, Italy. Famous for their rich decorations and splendid colors, these façades were on the verge of disintegrating because of neglect, the poor condition of the eaves, the wet laundry flapping against the walls, and the salt air. Their condition was so bad, in fact, that it was felt that any potential restorers might arrive too late,

finding no trace of the designs and colors of the façades. They would be unable to restore them.

A group of draftsmen and teachers at the Faculty of Architecture in Genoa was formed under the direction of Professor Paolo Marchi and coordinated by the architect Vittorio Garroni Carbonara. Their goal was to make plans and drawings of the buildings on the wharves of the port. The scale was to be ¹⁄₂₀; that is, the depictions would be one-twentieth the size of the originals. They would include not only the precise nuances and specimens of the color tones, but also all the decorative details: the cornices, fascias, balusters, and the pyramid-shaped stones.

The plans of the decorated façades thus constituted a set of documents to which the restorers of the individual elements could refer in the course of their work. Without these reconstruction blueprints, Portofino would not be the same.

*Paolo Marchi and Vittorio Garroni Carbonara:* Plans of the Painted Façades on the Quays of Portofino.

# Travel Notes

*Eugène Delacroix:* Album of Sketches of Morocco, *1832. Pen and ink and watercolors, pages 23v and 24r, each 193 × 127 mm. Louvre, Cabinet des Dessins, Paris.*

Travel notes are a special kind of drawing, and their significance is more than historical. They constitute a reason and a pretext for drawing. Anyone who likes to draw will make quick jottings as souvenirs of his travels, sketching—almost doodling—places, moments, emotions. Travel notes seem to combine all the features and characteristics of drawing. In addition, their rapidity and immediacy test the artist's sensitivity. We have already seen that painters, draftsmen, and architects of all periods have made travel notes—even in our time, despite the invention of the camera. Because a sketch is the result of observation, capturing an impression in a few essential strokes, it leaves more scope to the imagination than any other kind of picture.

## Delacroix in Morocco

During his travels in Morocco, the French painter Eugène Delacroix kept a diary, noting dates and places, and describing the landscapes, streets, excursions. He also supplied data on the quality of the light and on variations in the humidity. In this way, he managed to transmit the mobility and adventure that he experienced during his journey on horseback. For Delacroix, this voyage meant the discovery of color: the green of a valley or a palm tree; the blue of the sky or of distant mountains; the orange of a reef; the red of a saddle or a turban; the yellow of a wall or a dune.

Delacroix added colors to his drawings either in small touches, to specify a decoration or costume,

*Eugène Delacroix:* Studies of Arab Women *(from the* Album of Sketches Done in North Africa and Spain)*, 1832. Watercolors on graphite lines, 158 × 213 mm. Louvre, Cabinet des Dessins, Paris.*

me. ... And yet it's so simple: to paint as I see, to transfer a blue, a red to the canvas without thinking! I am enchanted by golden shapes in the rivers: will I still hesitate to gather all this light, all this sunlit happiness?"

He describes the landscapes and the inhabitants:

"I try to sketch a portrait, more than anything I would like to capture that ambiguous smile. The model grimaces unpleasantly and says in a disappointed tone, Help, and leaves. An hour later, she comes back in lovely clothes and with a flower in her ear. What has happened, and why has she returned? Is she playing a flirtatious game, does she enjoy giving in after saying no? Or is it merely caprice, unmotivated, pure and simple caprice, so common in them? I understand that, as a painter, I have to go along with the model's inner life: a silent and pressing urgency, an almost physical possession, for a decisive result. ... I am working hastily—I pray that it's not a fixation—hastily and heatedly.

"I am putting into this portrait the things that the spirit has allowed my eyes to see and, above all, I think, the things that my eyes alone would never have seen, that intense intimate fire. ... The loftiness of that noble forehead remind me of Pae of his judgment: 'There is no pure beauty without something strange in the proportions.' And the flower in her ear listens to her fragrance. I now work better, more freely."

or in large strokes, to evoke the landscapes. A few shapes, drawn purely in pencil, were glossed with notes on colors to jog Delacroix's memory. Then, in his studio, he could develop these sketches into watercolors or larger paintings. The contribution made by Delacroix's travel jottings resides chiefly in the new brightness of his colors, thanks to the watercolors, and also in the relationship between the text and the illustrations. This relationship is based on the arrangement of the scene in vertical planes on the page, while the alternating rhythm of writing and drawing fuses into an overall image that is extremely homogenous.

The writing—two or three lines per page—follows the pictures and also connects them to one another. This makes Delacroix's journal a prototypical travel album.

## Gauguin on the Island of Morea

In June 1891, the French painter Paul Gauguin, searching for light and color, landed in Tahiti and then immediately went to the island of Morea. His travel notes are collected in his book *Noa-Noa.* Gauguin writes: "I have begun to work. But the landscape, with its frank, burning colors, dazzles

## Paul Klee in Tunisia

Klee's paintings often reflect his experiences with the landscapes he visited. His voyage to Tunisia contributed to developing his sense of color, and echoes of that trip recur in the colored spots of his canvases.

Within an abstract structure, with overly bright, sharp-edged colors, we see forms, lines, arabesques which, together with the strong hues, evoke memories of an objective world: ocean, desert, sun, houses, domes, trees, gardens. Thus, while these pictures may seem remote from reality, they are reminiscent of landscapes. The blue recalls southern seas, the pink and the yellow recall desert dunes, the greens recall tropical vegetation. Klee once said: "The object is the world, even if it is not this visible world."

*Paul Gaugin (1848-1903):* Four Tahitian Women, *1891.*
*Watercolors on pencil lines, pasted to a page of the manuscript of* Noa-Noa,
*288 × 304 mm. Louvre, Cabinet des Dessins, Paris.*

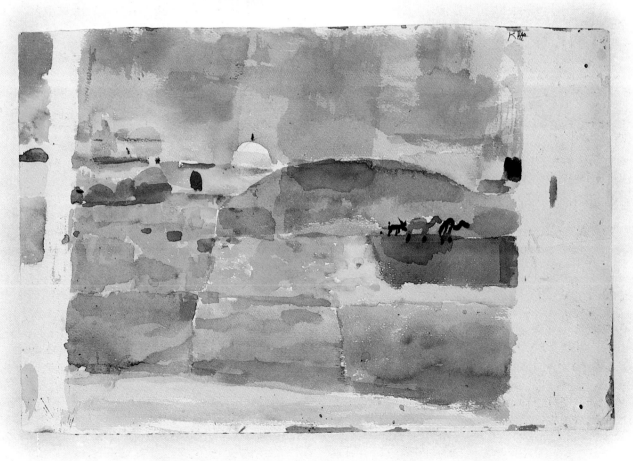

*Paul Klee:* Before the Gates of Kairuan, *1914. Watercolors, 207 × 315 mm.*
*Kunstmuseum (Paul Klee Stiftung), Berne.*

"My old custom of observing the things of the world through the eyes of the painter whose works have impressed my mind aroused a singular thought in me. It is obvious that the eyes are formed according to objects that they have seen since infancy; hence, a Venetian painter must see everything more clearly and more serenely than other men.

"We who live in alternately muddy and dusty streets, and in colorless places where every reflection dims and darkens, we who live sometimes in restricted environments, we can educate our eyes with delightful clarity. When I crossed the lagoons in full splendor of the sunshine and observed....the gondoliers moving free and easy in their multi-colored clothes, singing while their faces stood out against the azure background of the atmosphere and the surface of the beautiful light-green water, I was presented with the best, the most vivid painting of the Venetian school." (Johann Wolfgang von Goethe: *Travels in Italy*, Venice, October

1

## Goethe in Italy

Goethe was one of the most famous travelers ever to set down their experiences in sketch pads. Why and how did he draw? When he traveled to Italy, his writings and drawings told of his enthusiasm for the nature and architecture of Italy, but also for drawing itself as a medium for capturing the fascination of images more immediately than words.

Friedrich Riemer, a collaborator and confidant of Goethe's, explained that Goethe's drawings must be understood as sketched ideas, "the figurative and symbolic expression of the things that occupied his imagination and urged themselves upon his mind." However, Goethe, was essentially a poet, and, even when drawing, he could not help heightening and transfiguring the reality he contemplated into a "poetry of landscapes." Gazing with attentive eyes, he makes shapes and colors into compositional elements in both his writing and his sketches: "The vivid colors, dimmed by the light suffusing the air, will thus be visible even far away ... so that they bring out the contrasts between the cold and the hot tonalities. Thus, the shadows of a light blue gradually stand out where the light melts into green, yellowish, reddish, and brown, to merge with the faint, dim blue of the faraway background." In Goethe's words, we find the beginnings of what would be one of his major works, *The Theory of Colors*.

Goethe, though not a great draftsman, was certainly a great poet. Nevertheless, his desire to draw, and his need to learn how to draw in order to say something, is particularly significant for us. Goethe loved watercolors, and he sketched his views with a monochrome pencil and delicate colors. He loved figures; he felt and understood that the human body contained every problem and every solution: "I went to school, I learned how to draw the head and all its parts, and it was only now that I began to understand the ancients. ... On the first of January, I moved down from the face to the clavicle [collar bone], I lingered on the chest and the other areas, I carefully studied everything from inside to outside: the bones, the muscles. ... During the next few weeks, I will look with clear eyes at the most beautiful statues and the most beautiful paintings in Rome."

It almost seems as if these experiences helped him, above all, to see Italy, to appreciate its landscapes, cities, and ruins, its sunsets. In his travel

8, 1786)

"The pavers, who had been working until the last moment, put down their tools and interrupted their labor with jokes. All the balconies, all the windows, one after another, were decorated with carpets, and seats were placed on raised pavements at either side of the street; the ground-floor tenants and all the children came out, and the street was no longer a street: it was more like a huge ballroom or an enormous decorated gallery. Clothes hung from the windows; all the scaffolds were covered with ancient embroidered rugs, and the numerous chairs heightened the illusion of a ballroom; the benign sky seldom remembers people without roofs over their heads. Thus, the street seemed more habitable. Leaving my house, I felt as if I were in a palace, among people I knew, and not in a street among strangers. (Johann Wolfgang von Goethe: *Journey to Italy*, "The Roman Carnival," 1787).

notes, he recorded the things that his education and sensitivity suggested: "Wherever we go, a rich and varied landscape emerges before our eyes, palaces and ruins, gardens and overgrown fields, fading distances and brief, foreshortened harvests, humble little houses, stables, arches of triumph and columns,—in sum, that characteristic concert of truly southern and Roman objects."

This particular desire for self-expression in drawings, this need to "progress in drawing in order to succeed in doing something easily" distinguishes Goethe's grand tour of Italy from the traditional travels of educated Germans for whom, a journey to Italy was both an obligation and a pleasure in the 18th century.

One last comment: Goethe used his drawings and notes not only to record the images and monuments of his travels; many of them, together with written descriptions, were meant to inform his friends in Weimar, to give them some idea of the beautiful and important things he had seen in Italy.

2

*Johann Wolfgang von Goethe:*

*1.* Landscape on the Albani Hills.

*2.* Trees on a River.

*3.* Arch and Shady Path in Park

*4.* Staircase in Garden

3

4

*(1-4: Forschungs und Gedenkstätten der klassischen deutschen Literatur in Weimar.)*

## The Sketches of an English Tourist in Italy

Mary D. Tothil was one of countless English people who visited Italy. She kept an album that was meant for her four travel companions, but which was then lithographed in a private edition. This *Journal of the Wanderings of Four Wanderers in the Riviera in Northern Italy* nimbly and ironically depicts, by means of a pen and a pencil, the most important stages of her vacation on the French and Ligurian coasts and in Northern Italy.

The album leaves become the pages of a written and illustrated journal, in which the author smiles at her own misadventures. She also depicted folklore scenes, utterly romantic landscapes, and amusing encounters. To understand the difficulties of riding a mule, just look at the tourist grabbing the mule's tail to slow down his descent! There is a skillful sketch of little boys playing with toy boats and washtubs transformed into boats: the boy in the foreground is shaded with quick crosshatchings, the background is barely indicated.

Freshness emanates from the expressive sketch of two young porters lugging the Englishwoman up the long stairway.

The author probably recorded her daily impressions on individual pages or in an album and then did final versions of texts and drawings in a notebook. Here, the verbal and pictorial descrip-

Juvenile sports at Alassio. 2

*we stop for Sunday.*

1

active porters. 3

*Mary D. Tothil:*

*Mary D. Tothil:*
*1. Excursion on the Heights of Ventimiglia, 1870.*
*Lithograph 245 × 160 mm.*
*2. Juvenile Sports at Alassio, 1870. Lithograph, 65 × 70 mm.*
*3. Active Porters, 1870. Lithograph, 65 × 70 mm.*

*From M. D. Tothil:* Journal of the Wanderings of Four Wanderers in the Riviera in North Italy. *London: Simpkin, Marshall and Co., 1870, 19, 25, 23.*

tions overlap, complementing and expanding one another.

### Le Corbusier in the Orient and in America

The French architect Le Corbusier (1887-1965) was never content merely to look when he was in an Italian city or on a Greek island, in front of the Campo dei Miracoli in Pisa or the Parthenon in Athens. In order to see truly, he drew and noted impressions, shapes, volumes, for the pleasure of deepening and remembering what he saw. In these notes and comments, he tried to find a truth that he knew already or was in the act of discovering. He always carried a sketch in which he did quick drawings of a landscape or a city, pictures of vast and profound spaces or complex volumes, all collected in a few inches of paper.

Every sketch or design is generally accompanied by a comment, almost an underscoring. These are sketches by an architect, but also by a traveler who observes and wishes to retain a detail, a feeling.

For us, Le Corbusier's work is a lesson in modesty. We realize that we cannot remember everything. We have to draw and write brief comments. And we must not look superficially, we have to "see" incisively and critically and not limit ourselves to a mere camera.

In a letter to a group of young people (1936), Le

*Le Corbusier: Sketches from the album* Voyage to the Orient: *1. Istanbul: three views of Saint Sophia.*

*2, 3. Athens: The Parthenon and the Propyleum with the Temple of the Victorious Athena.*

*4. Mount Athos.*

Corbusier writes: "How can we enrich our creative potential? Certainly not by devoting ourselves to architectural journals. We have to go on voyages of discovery through the inexhaustible kingdom of nature!

"I would like architects [and this also applies to people who are first starting to draw] to take a pencil and draw a plant or leaf or express the meaning of a tree, the essential harmony of a seashell, the stratifications of clouds, the ever-changing ebb and flow of waves playing on the sand."

The sketches that Le Corbusier did as the steamer gradually left Manhattan, suggest an experiment in "seeing." You should also try to do rapid drawings like these as you approach or leave or circle an object, as I did when I visited New York.

Carrying a pad and a box of thin, soft pastels in various colors, I took a boat ride around Manhattan island and tried to do quick sketches of the successive views that emerged for seconds at a time, circling past me as the boat cruised along. By using the pastels to render the volume of the skyscrapers and covering the surface of the paper in just a few seconds with soft streaks rich in tone, I managed to capture the changing impressions of a fantastic panorama, an island crowded with skyscrapers like a box filled with pastels....

*1. Sequence of images of skyscrapers in Manhattan sketched in pen and ink by Le Corbusier on a boat moving away form the shore.*
*2. Manhattan behind the Brooklyn Bridge in a recent photograph.*
*3. Series of impressions in colored chalk pencils I sketched from a Circle Line boat around Manhattan Island.*

intorno a Manhattan - aprile '69. Colatore

3

## Studying an Environment (Piazza Navona)

When I was a student, I would go and draw Piazza Campidoglio in Rome together with other students. I was always amazed and disappointed by the spectacle of the foreign tourists. No sooner had they stepped off the pullman than they shot entire rolls of film—whereupon they instantly left. They had seen nothing. All they had was the "satisfaction" of bringing home travel pictures to show their friends.

Travel jottings are the very opposite. They reveal a desire to see, to participate in the surroundings by drawing them, to relive the atmosphere, to review the trip and its details every time we look at our sketches.

If ever you happen to be in a square of an Italian city and you would like to study and understand the space, just do the following:

- Walk about the square, freely enjoying the spaciousness. Look around, discover potential compositions and details, mingle with the other people—in a word, take part in the life of the square.
- Pick the spots on your walk that let you observe the most important views, and then, from these vantage points, sketch the views, leaving enough space for the sky, rendering the perspective lines correctly, creating, to as great an extent as possible, the interplay of foreground, middleground, and background.
- Note the details that arouse and excite you. Sketch them, letting them complete your vision and memory of the whole.

The location plan in the blue rectangle of Piazza Navona, Rome, indicates the different viewpoints from which these various sketches were made.

1. View of the square, with the side fountain in the foreground, and a foreshortened view of the church of Sant'Agnese (the diagram synthetically illustrates the perspective design).

2. A detail of the shrine in the façade of one of the houses flanking the square; foreground depiction.

3. View of one of the bell towers of the church of Sant'Agnese, with the statue of the Fountain of Rivers in the foreground (the diagram suggests a method for combining the various elements).

4. The central sculptural group of the Fountain of Rivers shown against the church façade.

5. Detail of a gate with ancient lock in a building on the square.

6. View of the dome of the church of Sant'Agnese, from the Fountain of the Rivers.

As an example of this approach, I wandered through Piazza Navona in Rome. After working out a small plan of the successive points of view, I sketched several views and details of the square: an overall vista; a detail of the dome of the Church of Saint Agnes with one of the statues of the Fountain of Rivers in the foreground; a detail of the fountain against the façade of the church; a closeup of the "little Madonna", the sacred shrine on the wall of one of the buildings; and the complicated lock on a house door next to the church.

This is one way of scrutinizing a square and of recording and remembering a tour of it—one way among many.

## Jottings of a Tour

When we recall the travel records in the history of art, we can scarcely resist taking along a notebook on our next trip, so that we can sketch everything we want to see, to remember and reexperience it. But in the meantime, we can sketch our impressions while taking a walk or a short ride—perhaps on the way to work.

How should we draw and what should we draw?

The fascinating thing about drawing is the endless wealth of possibilities for expressing ourselves. Thus, our jottings during a walk or a ride can express all sorts of things—even the subtle and impalpable impressions that enrich, and give meaning to, our observations and perceptions. By drawing, we can connect the most important moments of our walk or ride, the ones that characterize it most sharply: points of architecture and the landscape as well as panoramas of the most interesting views and the most exciting vistas.

We can also stop and capture certain details, ones that interest us and arouse our curiosity: a doorway, a shrine, a balcony, the outline of a tree, the profile of a lamppost. Naturally, the lighting effects and the shadows contribute to the dynamics of what we see: a backdrop in the shade, an illuminated wall contained by the line of the eaves; two vertical walls that cut off the brightly lit background, a strip of sky between rooftops; the sudden revelation of a luminous space, or a landscape or monument beyond a shadowy corner.

While sketching, don't worry whether the drawing "comes out right."

- More than anything, begin by enjoying the pleasure of seeing and studying the spectacle in front of you.

- Next, analyze the feelings aroused in you by the various points of your walk or ride, the surprises, the contrasts, the brightness.

- Don't limit yourself to just one drawing. The most important thing here is the narrative, the series of sketches that, in sequence, repeatedly evoke your trip or walk, helping you to rediscover the important points and to relive the most significant moments.

*A page of travel jottings by the contemporary Italian architect Giovanni Michelucci, studying the architecture of the past. Here he focuses on the overall plan of a building, the volumes, and the perspective view, and certain details.*

# SEEING SHAPE

Your drawing should always show your pleasure in drawing. It should never lose its sense of immediacy and freedom, its happy relationship with the world, its *joie de vivre*. Only after these conditions are fulfilled can we examine the various aspects of drawing, one by one, for educational reasons. Let's begin with the problem of form and shape.

In his *Treatise on Painting,* Leonardo da Vinci discusses the concept of "form" (Italian: *forma*) several times. First, he points out that a painting consists of four aspects: surface, figure, shadow, light, and color. He then concludes: "A painting subdivides into two main parts: the *lines,* which circumscribe the figures of finite bodies and require draftsmanship, and the *shadow.* However, this draftsmanship is so excellent that it seeks not only the works of nature, but more infinite ones than those that are made by nature."

Thus, our discussion of form will be followed (in the next volume of this series) by a discussion of chiaroscuro. However, in developing our approach to the problem of form, we will also include, and refer to, chiaroscuro and color.

We will focus on several basic aspects of the problem of form: (1) the hidden geometry; (2) the interpretation of form; (3) the significance of the outline and the expressive line; (4) ratios, relationships, and proportions; and finally, (5) the psychology of form.

*Few artists have equalled the Japanese in suggesting vibrations of light, color, and atmosphere merely by using the lines of shapes and contours, with minimal variations in tone.*

*Wu Chên:* Rock and Bamboo, *Yuan Dynasty, 1260-1368. India ink on silk, 225 × 180 mm. British Museum, London.*

1,2. *Villard de Honnecourt: Two pages from the* Album *(left:* 1
*detail). Graphite point, reenforced by pen-and-ink lines on
parchment, 230 × 150 mm. Bibliothèque Nationale, Paris.*

*Villard de Honnecourt constructs a series of human figures on
geometrical designs, virtually a manual to teach drawing.*

# The Hidden Geometry

Why do artists, especially those of the Middle Ages
and Renaissance, reveal the regular forms of a hid-
den geometry behind the shapes in their drawings?
   There are many reasons.
- The quest for perfection, which has always
  guided artists in the execution of their works,
  was sought in the perfection of geometry.
- In their desire to simplify the draftsmanship, to
  find proportions and movements, and deter-
  mine the overall framework of the picture, art-
  ists have enlisted the help of familiar forms.
- Hence, artists discovered several basic modules,
  elements of measurement and geometry that could
  constitute the basis for an ideal shape and form.

   Since mathematics did not help the medieval art-
ists achieve their philosophical, mystical, and aes-
thetic ideal, they turned to geometry and the use of
compasses. With the knowledge of scientific texts
and with the faith that inspires all art, the mini-
aturist, and then the medieval painters enlisted ge-

2

ometry in their art and thus, based all their
figurative compositions on geometry, starting with
a precise "scaffold." The results were first visible in
several miniatures of the 13th century. Further-
more, these miniaturists copied the designs of the
stained-glass windows, in which lead armatures
formed circles and quadrilaterals, and, inside
them, the scenes followed geometrical forms.
   Villard d'Honnecourt, in his *Album*, sketched
figures on a series of simple or intricate geometric
constructions: triangles, star-shaped polygons, rec-
tangles, circles. Here we see the beginning of the
method of drawing figures, as taught by the art of
geometry, in order to work easily. In these four
pages there are human figures reduced to geomet-
ric forms, and we must become familiar with them
if we want to know what use each of them can be.
   Actually, Villard d'Honnecourt's figure is a se-
ries of triangles, arbitrary shapes whose purpose is
only practical: to simplify seeing the human figure
so that the artist can draw more rapidly. Thus a fig-
ure based on a geometric construction can represent

the ideal human being, the "synthesis" of a man.

Iconography and geometrical forms proceeded side by side in the Middle Ages, and grew into the "divine proportion" of the Renaissance. In the early 1400s, Brunelleschi tried to discover "the way to build as used by the ancients, and their symmetries and musical proportions." These concepts were then defined by Alberti in his treatise *De re aedificatoria*. The Renaissance, going by the idea of the "imitation of nature," regarded geometry and figurative art as allies. But in working out their paintings, Renaissance artists used a simpler geometry in arranging their compositions and figures than that of the Middle Ages. While medieval artists had given their geometrical figures symbolic, religious meanings, Renaissance artists tended to express themselves more freely.

In the Renaissance, the "golden mean" became important. It refers to the aesthetic relationship between the measurements of the sides of a rectangle (the canvas) and measurements within the composition. It allowed artists to work out a compositional harmony without a geometric configuration. The golden mean was used by almost all the artists of the Renaissance, and was then continued (with its old religious connotations) in the Lowlands, where the Middle Ages survived longer than in Italy. It was employed masterfully first by Piero della Francesca, and then by Veronese, Rembrandt, and, above all, by Vermeer. Later, in the 19th century, Georges Seurat theorized about it and applied it rigorously.

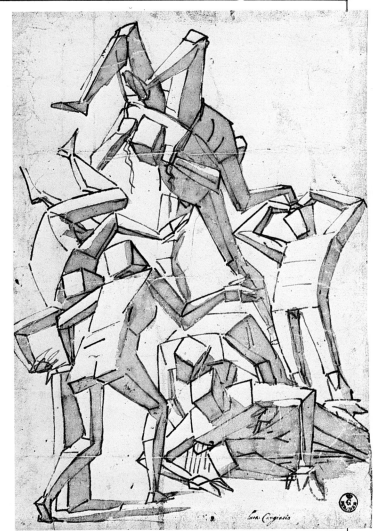

Luca Cambiaso (1527-1585): Studies of Volumes. *Pen and bistre, 340 × 240 mm. Uffizi, Gabinetto dei Disegni e delle Stampe, Florence.*

Cambiaso's so-called "Cubist" composition is planned as and must be understood as a study of spatial forms.

Hans Holbein the Younger: Studies of Heads and Hands. *Pen and black ink, 128 × 192 mm. Kunstmuseum, Kupferstichkabinett, Basel.*

In his spatial geometric figures, Holbein brings out the volume proportions of the male heads and the hands.

In *Parade,* Seurat applies a program, which he explains to his friend Gustave Kahn: "The Panathenaea of Faith represents a procession: I want to portray people of our time in the same manner, to show their essences. I want to portray them in paintings of color harmonies based on the directions of the hues, and in line harmonies based on their motion. I want to organize lines and colors in terms of one another."

Seurat wrote to the writer Maurice Beaubourg on August 28, 1890: "Art is harmony. Harmony and the analogy of contraries, the analogy of similar things, of *tone,* of *hue,* of *line,* seen in terms of the dominant and under the influence of an illumination of gay, calm, and sad combinations.

"The contraries are: For tone, a bit bright, a bit dark. For hue, the complementaries, that is, a certain red opposed to its complementary,etc. (red/green; orange/blue; yellow/violet). For lines, those that form a right angle.

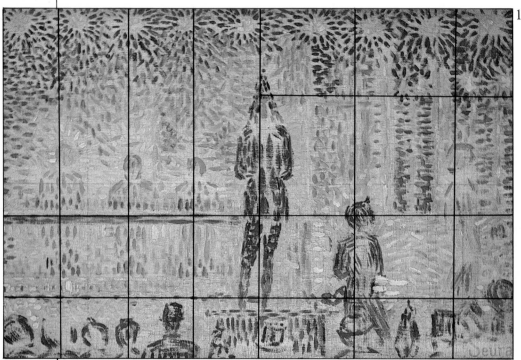

*Georges Seurat:*
*1. Study for* The Parade, *1887. Oil on wood, 168 × 248 mm. Stiftung Sammlung Emil G. Bührle, Zurich.*
*2. Study for* The Parade, *1887. Pen and ink, 127 × 190 mm. Private collection, Basel.*

## Seurat: Dynamism and Mystery

Among the artists who used geometry as the basis of their compositions, none was perhaps as effective as Georges Seurat (1859-1891). This French painter rigorously studied scientific methods and applied them in his works. He based his drawings and paintings on the golden mean, on axes and diagonals, in an intricate system of geometrical relationships.

### Parade

These paintings are characterized by the rhythm of the vertical lines that scan the composition. The rising and falling lines can be found in the axes of the figures, sliced by the horizontal lines of the sides and the background. The result is a basic compositional network: depth and perspective are suppressed, and the third dimension is replaced by a two-dimensional surface that has a decorative effect. The figures look like flattened silhouettes—clearly suggestive of the Japanese prints that influenced Seurat and the Impressionists. They are defined above by the row of lamps, and below by the outlines of the spectators. The composition unfolds like a frieze: at the center, the figure of the trombone player; to the right, in profile, the circus director and a clown; to the left, the musicians, at equal intervals from one another, in a rhythm interrupted by the skeletal presence of the tree.

The apparently light-hearted theme is merely a pretext for a composition in which linear and geometrical, tonal and chromatic harmonies are values in themselves. At times, the geometrical proportion, the linear and spatial structure manage to create effects of mystery, symbolism, and drama.

Because of its abstract forms and geometric composition, Seurat's *Parade* brings us to the threshold of the 20th century in art.

### Circus

The solutions used in *Circus* recur throughout Seurat's works. This painter was a committed

The gaiety of the *tone* is the luminous dominant; the gaiety of the *hue* is the hot dominant; the gaiety of the line is the lines above the horizontal. The calm of the *tone* is the equality of dark and light; the calm of the *hue* is the equality of hot and cold; and the horizontal for the calm of the *line*. The sadness of the *tone* is the dark dominant; the sadness of the *hue* is the cold dominant, and the sadness of the *line* is the descending directions. Given the phenomena of the duration of the light impression on the retina, the synthesis is the result. The means of expression is the optical blending of tones, of hues (local color and illuminating color: sun, kerosene lamp, gas light, etc.), that is, the lights and their reactions (shadow) which follow the laws of contrast, gradation, irradiation. The frame is in harmony opposed to that of the tones, hues, and lines of the painting."

theorist and a rigorous implementer of his and his master's theories. However, Seurat's final painting hints at an evolution. In the preliminary study for this work, the two clowns seem to hold an arc of a circle that occupies almost the entire base of the composition. In the finished work, only one clown remains, and all that is left of the circle is a small segment in his right hand, which is the edge of the curtain. The static aspect of the sketch thus yields to movement. This type of composition seems to confirm the reflections of the Russian painter Kandinsky (1866-1944) on the influence of the positions of geometrical forms in a composition. For example, a triangle resting on its base has a more static "sound" than a triangle resting on one of its angles.

Seurat's composition suggests the continuous and mellifluous movements of the acrobat and the ballerina galloping around the arena. What is so brilliantly new about Seurat's approach? Seurat places an oblique rectangle, almost a square, in the clown's hands over a grid of orthogonal (horizontal and vertical) lines. To this unstable equilibrium, the artist adds virtually a Catherine wheel of fireworks, suggested by arcs intersected by the sides of the square. The prototype of such arcs is the curtain held up by the clown's right hand; and the arcs continue in the rotating movement of the acrobat, the ballerina, and the horse.

All this should not make us forget Seurat's colors: his theory of color in general, and his color technique in *Parade* and *Circus*. His method is known as "divisionism." It is based on a decomposition of the colors: dots of various pigments are brushed on next to one another or else various segments or spots or areas of pure colors are used. Seurat's method of chromatic decomposition is based on the laws of physics and optics pertaining to opposite and complementary colors, according to the chromatic circle, which he studied carefully.

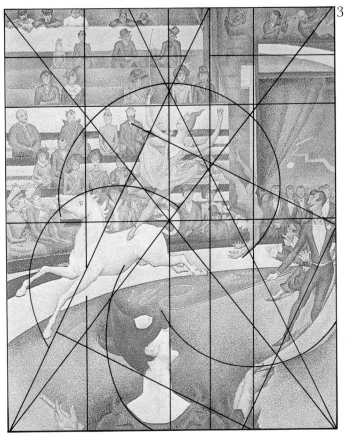

3

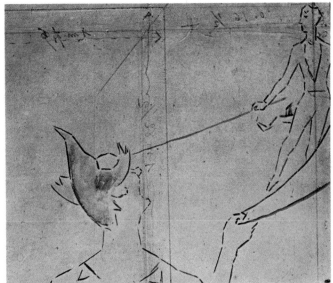

4

3. The Circus, *1890-91. Painting, 186 × 151 cm. Louvre, Paris.*
4. Study for The Circus, *1890. Watercolor, 305 × 355 mm. Louvre, Paris.*

## The Japanese Symbols

In Japanese art, geometry is more than just a simple schematization or rigorous verification of shapes or proportions. The Japanese artist seeks a precise meaning in geometrical shapes. Moreover, these shapes are drawn in sharp, quick brushstrokes that are often grainy on the paper. There is a search for a "line that moves everything," one that communicates meaning and leaves traces of motion in the spots, the bars, the dots, and the streaks. Balance in a Japanese painting is to be found not only in the drawing, but also in the relationship between the drawing and the script; for Japanese calligraphy is already a drawing within itself.

Gibon Sengai (1750-1837), who came from a rustic background, was one of the masters of Japanese painting. He sought the meaning of things in the things themselves: "From nothing to nothing and without depending on words or letters, looking always within your own nature. If you do not find truth in yourself, where can you seek it?" In this drawing (below), the three outlines—a circle, a triangle, and a square—represent "the Universe" reduced to its essential and elementary aspect.

Here, geometry is no longer hidden, it is manifest. It conceals mysterious and profound meanings. The circle symbolizes infinity, the beginning and the end in perpetual motion. Infinity per se has no outline or shape and hence, for us, no meaning.

Next to the circle, the triangle, in its rigorous definition, expresses the principle of any shape. The square (ultimately a figure composed of two isosceles triangles joined at their hypotenuses) symbolizes the objective world, which is made up of four elements: earth, fire, air, and water.

The triangle also symbolizes the individual in his three fundamental existential aspects: physical, intellectual, and spiritual. It is placed in the center as the element that ideally joins the objective world and the supreme reality represented by the circle, a form without a beginning or an end.

Ultimately, if we know how to see it and draw it, the universe is entirely here, in these three forms: the circle, the triangle, and the square.

*Gibon Sengai (1750-1837):* Symbols of the Universe. *India ink on paper, 51 × 109 cm. Idemitsu Museum, Tokyo.*

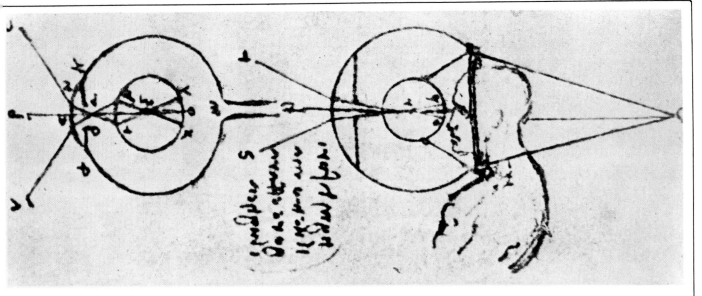

*Leonardo da Vinci:* Model of the Human Eye. *Ms. D, f. 3v. Institut de France, Paris.*

## The Eye

We have frequently spoken of "seeing" as an indispensable prerequisite for drawing. Now, starting our discussion on form and its depiction, let's first briefly discuss the eye.

The eye has an almost spherical shape. Its outside is made up of three concentric membranes: (1) The fibrous external membrane (with the transparent cornea in the front and the sclerotic in the back. (2) The intermediary vascular membrane, known as the uvea, from Latin *uva*, meaning grape, because it resembles a grape skin. Together with the choroid it forms the ciliary zone and the iris, the latter containing the crystalline lens. (3) The innermost membrane, the retina, which is an extension of the optic nerve.

If we examine a person's eyes, we see a kind of colored disk, with a more or less small black hole in the center: the pupil. The latter is in the middle of the iris, a colored fibrous diaphragm (blue, green, or brown, giving the eye its color). The function of the iris is to regulate the size of the pupil, that is, to determine the number of light rays entering the eye. When there is less light, the pupil widens; when there is more light, the pupil contracts. Thus, the iris works like the stop of a camera; or rather, the stop of the camera was constructed on the model of the iris.

Behind the iris is the crystalline lens. Its front is less convex than its back. Together with the cornea, the crystalline lens helps to refract the light-rays that enter the eye. The very fine muscles in the eye help to tense or flatten the lens, modifying its curvature and thus allowing us to see something near or far.

Light enters the pupil and then passes through the crystalline lens. It reaches the retina by passing through the posterior chamber, which is behind the lens. The light then strikes the back of the eye, the retina; this is the sensitive area where the nerve cells are located.

The retina is part of both the eye and the brain. It is made up of fibers and nerve cells in nine layers, and is attached to the brain by means of the optic nerve.

There are two types of sensory cells in the eye. Both have microscopic appendages called rods or cones, depending on their shape. These appendages constitute a dense carpet, which the light strikes, forming the images of our eyesight.

In the visible part of the retina, at the center of an area called the *macula lutea*, we have the *fovea centralis*, the most visible point of the entire retina. The eye's sensitivity is greater in the *macula lutea* and most acute in the *fovea centralis*, on which the image of the focal point is projected, so that we have a detailed vision of it, while the surrounding objects appear less and less distinct the further away they are from that point.

The visual process is well known. The structure and the mechanics of the eye and the eyesight have been studied thoroughly. But when we come to the problem of visual *perception,* we find many dubious and mysterious points. The eye sees and registers. But it is man with his brain, his sensitivity, and his imagination who must decipher the message in an original way and then draw it.

*Tintoretto:* Studies for Pluto and his Court. *Pen and ink, and watercolor. Uffizi, Gabinetto dei Disegni e delle Stampe, Florence.*

*Louis Boulogne (1609-1674):* Group of Sleeping Women. *Chalk pencils on colored paper. Louvre, Cabinet des Dessins, Paris.*

### Discovering Geometry in Drawings

If we look at the drawings of the masters, it is not hard to find geometric shapes that guide us through their compositions. Discovering these shapes, ferreting them out, tracing them on transparent paper can be useful and entertaining. In fact, they can help us understand the genesis of a work and the significance of the drawn lines and surfaces.

Let us examine four drawings by different artists:

• The drawing above, by Tintoretto, is a study for *Pluto and His Court.* The skillfull composition is alive with movement, purposefully rendered. In this scene, the various characters sitting at the side of the god are organized into a pattern of motion. Each bursts with a tension, which seems to trigger a revolving motion around Pluto. This circular movement is achieved by the hidden geometry typical of Tintoretto's graphics, one usually based on either darting diagonals or circumferences or arcs.

• In Louis Boulogne's drawing, the sense of abandonment in the two figures is produced by the composition—specifically, the arrangement of the women. The figure seen frontally (leaning on the right-hand diagonal of the first upper rectangle) rests her head on her horizontal left arm. Her right arm seems to frame her head.

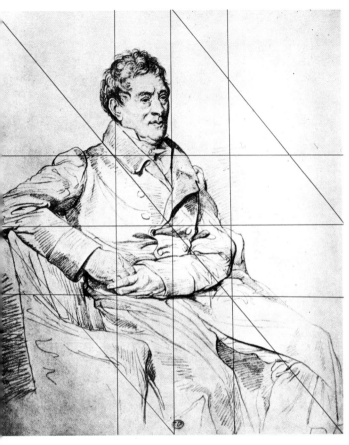

*A. D. Ingres:* Portrait
of Monsieur Gatteau.
*Conté crayon. Louvre,
Cabinet des Dessins,
Paris.*

*Camille Corot (1796-1875):*
Girl with Beret. *Graphite,
290 × 222 mm. Palais des
Beaux-Arts, Lille.*

The figure seen from the back also has her head on her left arm, which is folded but horizontal. She is leaning on the left-hand diagonal of the last rectangle.

- Ingres's portrait of Monsieur Gatteau repeats a composition found in many of the painter's portraits: the ground plan accentuates the diagonal, which seems to divide the page or scene into two parts. The left-hand part almost entirely encompasses the figure, while the right-hand part suggests the space of the room. In this drawing, the composition continues the rhythm of the diagonals—emphasizing the geometry of the triangle—in the directions of the arms, in

the line of the armchair, and in the positioning of the legs.

- Corot's drawing immediately suggests the serenity and relaxation inherent in a composition structured on two triangles (which form a pyramid) whose bases are the shorter sides of the rectangle of the paper and whose vertices are the extreme points of the middle axis. The concentrated volume, the serene position are emphasized by the folded arms. The latter, following the motion of the scarf, complete the pyramidal composition. There is no artifice here: only a secure, vibrating line that seems to express the delicacy of the subject with a sensitivity of its own.

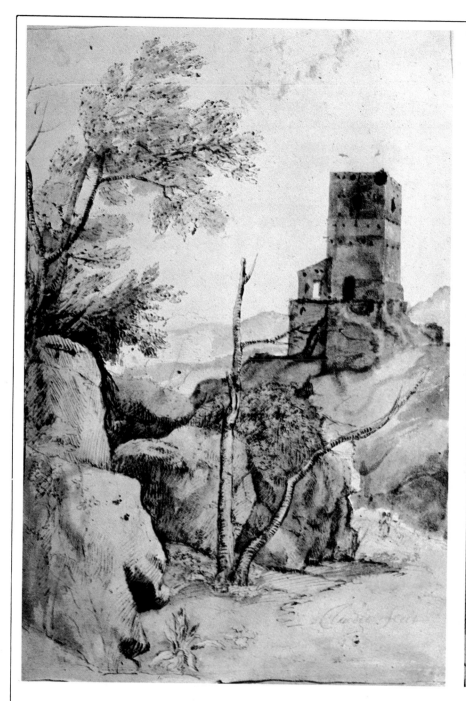

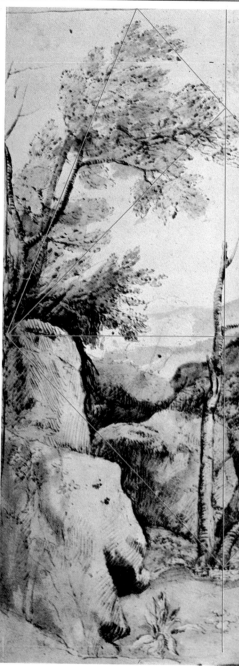

## Discovering Geometry in Real Life

Finding geometric figures and regular shapes in real-life images can help to give us a framework for testing shapes and proportions. But to find this hidden geometry in real life, we have to "see" it, that is, we have to "read" the world around us, explore it, track down its "geometry," arrange and frame its endless number of irregular forms in regular forms: squares, triangles, circles, polygons.

Imagine finding yourself in front of the scene of the above drawing, *Country Landscape,* and imagine painting the framework chosen by Claude Lorrain: a rock at the left, a cluster of trees above it, a dramatically bare trunk in the middle, the ruin of a tower at the right, and finally, two figures trudging along the path, placed there to suggest the proportions and relative size of the landscape.

How should we go about drawing this scene?

I am certain that within a few weeks you will draw it simply and naturally, by observing it and discovering the overall form and the shapes of the various elements. You can do this by looking first for the major lines of direction, and then for the subsequent smaller lines, in a gradual succession that involves deepening the contours and adding

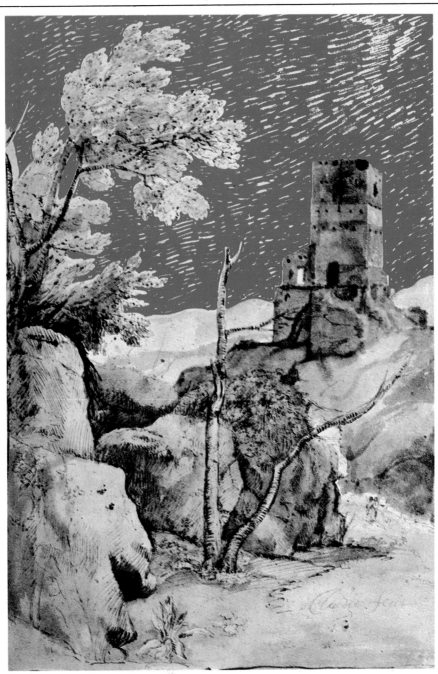

*Claude Lorrain:* Country Landscape. *Pen, bistre, and watercolor, 320 × 215 mm. British Museum, London.*

chiaroscuro, the light and the atmosphere of the scene.

But for now, when we are still several weeks away from that point, let us look into the composition chosen by the artist. Locate the axes of the painting, the hidden geometry that can ultimately be found in any subject, helping us to define its shape.

- Imagine that it is your task to select the composition. Place the vertical axis of the painting in the upright tree trunk, and the horizontal axis along the horizon, so as to leave enough of the sky in the upper part of the drawing. This allows breathing space for the tower and room for the group of trees on the left side.

- The composition is thus defined by the central element (the tree with its vertical and diagonal trunk), the foreground (the rock and the trees), and the background (the hill with the tower).

- In an even simpler analysis of the composition, we can see that the composition is cut in half by a horizontal axis, so that the lower part is the landscape (tree, rocks, and hill), and the upper part is the sky. The latter is linked to the earth by the foliage and the trunk of the tree, while the tower is outlined against the spacious sky.

## The Golden Mean

We have already spoken of the "golden mean" as a fundamental element of proportions and geometrical relations in the Renaissance. This particular "golden" relationship of two segments, $a$ and $b$, is defined by the equation: $a{:}b = b{:}(a-b)$, that is: $b^2 = a\,(a-b)$

In practice, this means that a so-called "golden" rectangle has a particular characteristic that makes it pleasing to the eye. Look at the rectangle $a \times b$, and construct a square in it, $b \times b$. In the remaining rectangle $(a-b) \times b$, construct a further square $(a-b) \times (a-b)$. Then, in the remaining rectangle, construct yet another square, and keep on in the same way.

In order to construct our golden rectangle, we can proceed as follows:

1. Draw a square with each side $b$.
2. Find the middle point of the base of the square and connect it with the top right-hand corner, that is, find the diagonal of the vertical half of the square.
3. Using a compass with its center at the middle point of the base, draw an arc and extend the base of the square until it intersects the arc. Base $b$ plus the extension equals segment $a$.
4. Finally, construct a rectangle whose sides are segments $a$ and $b$. This will be the golden rectangle.

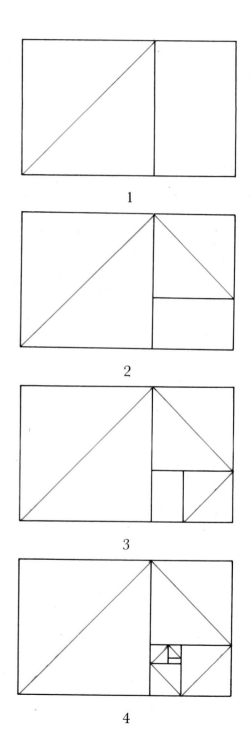

*These diagrams illustrate the development of the squares contained within a golden rectangle. The spiral, constructed on the diagonals of the squares, is the "golden spiral."*

# The Interpretation of Shape

The instruments invented and employed by the drawing masters of the Renaissance give an artist so much security. It would almost seem as if drawings, made precise and specific by grids and fixed by perspective constructions, could express only one kind of shape: objective shape.

Fortunately, however, we do not draw only what we see—and, of course, each of us sees in a different way. Above all, we draw what we think and feel. Thus, a form, which would seem altogether unique, becomes the expression of the artist's personality, along with the chiaroscuro and the color. Just look at the figures drawn by Pisanello, Pontormo, or Rubens, and you will see that the same ideal of beauty can be interpreted and depicted in various ways, even though the "way of seeing" has not changed substantially from the Renaissance to the early 20th century.

Cézanne brought a notable change. The new-ness of his approach dismembered painting and the familiar language of drawing. The spectator's focus was made to shift from the *synthesis* of the components to the *components* themselves.

The painters of the 20th century have confronted various problems: the third dimension (depth), the fourth dimension (time), the harmonies of pure tones, the geometric line that controls the equilibrium of composition in a flat plane.

Braque and Picasso were the first Cubists to use multiple points of view and to involve all the senses in the participation of reality. "Picasso studies an object the way a surgeon dissects a corpse," said the French poet Apollinaire. Each part of the dissected object was put in the same place as, and overlapping with, all the other parts. As a result, the surface is an interweaving of profiles and outlines, suggesting a collage of space.

The *Fauves* (literally, "wild beasts") were not

*Pisanello (Antonio Pisano, known as; before 1395-c. 1455):* Allegory of Luxuriance. *Pen (bistre) on reddish paper, 129 × 152 mm. Albertina, Vienna.*

*Amadeo Modigliani (1884-1920):* Caryatid. *Pastel. Musée National d'Art Moderne, Paris. (photo: Giraudon).*

"There are various kinds of drawings. Do you see these here: they are done precisely and accumulated laboriously, in white and black: a scholastic work that impresses me even today. They have a precise significance in my oeuvre. Dozens of them precede, accompany, and follow my paintings. Yet the drawings have no strict relationship with the paintings. For when I draw, I never think of the painting that has triggered them. I do most of these drawings in the evening, when it is too dark to paint. I seek the effect of light and shadow in them; I deliberately omit color. This is very hard work, requiring different optical perspective. But by taking this path, I am more certain of detaching myself from the painting, which would, otherwise, weigh on my mind all night long. Drawing is the best relaxation for me. Naturally, I thereby discover many things about painting, things I have been unwittingly seeking. The next day, when I get back to work, I find I have developed (without realizing it) specific

*Pablo Picasso:* Female Head, *1909. Black pencil and gouache, 615 × 476 mm. Art Institute, Chicago.*

interested in spatial dimensions. They focused on a different element of the dismembered art of painting: pure color. Omitting any indication of volume, the Fauves let color exert its full expressive strength.

In regard to his monumental composition *The Dance,* Matisse writes: "When the drawing is finished and I decide to add color, I have to modify all the planned shapes. I have to fill it all in in such a way that the totality remains architectural."

During the same period, the German Expressionists created a new type of painting. They used pure colors, deformations, and shapes taken from nature in order to allusively reveal feelings, passions, spiritual states.

This milieu produced the Russian artist Kandinsky, for whom "every shape [form] is the outer manifestation of a content and must manifest its inner content as expressively as possible." Kandinsky's thought developed to the point of becoming "abstract," while remaining expressive and extraordinarily vivid. These abstract forms, which attracted and fascinated him, were "beings that, however abstract, live, act, and make us feel their effect." In Kandinsky's drawings, the colors gather together in dynamic compositions based on diagonals and geometric forms in movement. Above all, Kandinsky understood that for the artist who wishes to create a new reality unrelated to the surrounding world, the fundamental issue is not the subject. The artist should not interpret a shape, he has to create a new shape.

Paul Klee, who was close to Kandinsky, tried to express the invisible, "a whole universe of which the visible is merely an isolated example." In Klee's paintings, all the concrete references are transformed into signs as if by magic. And "since, by its nature, drawing leads to abstraction, it can depict a reality that is *a priori* more fantastic, more fabulous, more abstract, and which can be rendered with greater precision."

Surrealism pushed the quest for the irrational even further. While De Chirico's vistas did not destroy the traditional perspective structure, the results were nevertheless hallucinating because of the long shadows, the empty architecture, and the shifts of vanishing points.

The long odyssey of the interpretation of form is still continuing today. It will go on until man, looking around and inside himself, creates a new reality with drawing and color, a reality that is more real than real life. This new reality belongs to each one of us, and we can all find it for ourselves in the interpretation of forms, in our personal interpretation. But in order to interpret and transform, we must first know and possess forms and shapes and we must understand how the masters drew and transformed their reality.

considerations that are useful for the painting in some way or other. But this doesn't hit me until later, and things are not always this simple. There are other drawings that cannot be forced. I believe that they are the most beautiful. Do you see these pen-and-ink drawings? They render only the relationships, according to a rhythm. I have made a series of lithographs, similar to these. These are the drawings that succeed most rarely. They conceal determinate conditions, moods, and excitement. These conditions are not consistant with a painting project. When I am in this mental state and I take the pen in hand, I already know that the drawing cannot fail. I'm never wrong. I see it distinctly before my eyes, my hand is guided, I find it as easy to render what I see as in a dream. Alas, such moments are very infrequent!" (Henri Matisse: *Writings and Thoughts on Art*)

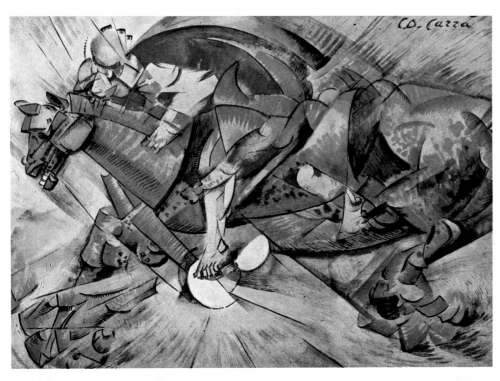

*Carlo Carrà (1881-1966):* The Red Horse, *1912. Pen and watercolor, 260 × 362 mm. Collection Dr. Riccardo Jucker, Milan.*

*Wassily Kandinsky (1866-1944):* Improvisation, *1915. Watercolor, pencil, and brush, 375 × 480 mm. Collection Mrs. Bertram Smith, New York.*

—143—

*1. A goblet or two profiles, depending on whether you focus on the background or on the foreground.*

*2, 3. A line drawn across a circle or a square creates two reversible figures. The reading of the profile depends on which side you focus on.*

# Ambivalent Figures

In order to draw, we have to see. In order to see, we have to read the form of an object, as it is in real life, in its features and proportions, and not as we *think* it appears.

One of the handiest and easiest methods for "reading" shape and form is to see the outline of an object against its background.

To practice this method, we will deal with *ambivalent figures*.

A figure is ambivalent or ambiguous if it seems to change when:

- we can focus on either the drawing or the background;
- we can interpret it differently in relation to its spatial position.

Well-known examples in the first category are black *silhouettes* that, when placed on both sides of a sheet of paper, create a white space. We perceive them as either black profiles against a white background or a well-defined white object against a black background.

The inversion of object and background has always been used to create enigmatic configurations: for instance, the drawing (1) that can be read either as a goblet or as two human profiles.

A classic example of the second category of ambiguous figures is the drawing of a transparent cube. When you focus on the cube, one of the surfaces seems to be in the foreground while the corresponding surface seems to be in the background (the cube would then be seen from above). But if you stare at the drawing for several seconds, the depth is reversed, so that the side that was originally in back is now in front, making it appear that you are viewing the cube from below. This is because the same series of stimuli can act upon the eye to create different perceptions. And it is our perceptual system, our brain, that *decides* what is the front of the cube and what is the back.

Many figures have these kind of ambiguous depth perceptions. The cube just described which

is one of the best-known examples, is called the "Necker cube," after the Swiss geologist Louis Albert Necker. This scientist was the first to show (in 1832) that these two images constitute "an unexpected and involuntary change of apparent position of a crystal or a solid represented by an incised figure."

Naturally, the problem is not limited to a cube or a transparent crystal. It involves the overall problem of three-dimensional perception of a two-dimensional drawing.

Since the retinal image is always two-dimensional, just like a photograph, there is always an ambivalence in depth perception, given that the perceptive system (the brain) is capable of selecting one of multiple orientations of a linear segment.

How is this choice made? In terms of the so-called principle of "frequency." That is, the observer perceives the "best" figure, the "simplest." And so the perception of a cube is the simplest of several possibilities, or at least one of the simplest.

The specific interpretation also involves a further factor, one more important, especially for drawing: familiarity with the subject, habit. The more familiar we are with a form, the more simple

it appears. Simplicity and familiarity are thus the fundamental elements in three-dimensional perception of a two-dimensional drawing.

*The cross outline turns inside out and rolls in our view, depending on whether we focus on the white or on the black.*

*The spatial effect of a cube depends on how the angles are staggered or overlapped, as demonstrated by the Necker cube.*

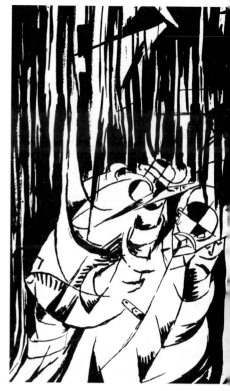

*Umberto Boccioni
(1882-1916):
Mental States: Farewells.
Lithograph.*

*The three drawings exemplify
the quality and potentiality of
lines. Undulating, oscillating,
they wrap around the outlines of
the locomotive and the figures.*

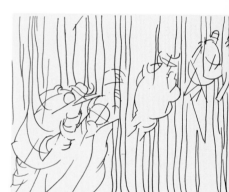

## The Dynamic Interpretation of the Futurists

In the early 20th century, there were several vanguard movements that contributed to altering our way of seeing and depicting reality. Italian Futurism was one of the movements that achieved international significance, even in Russia. Its influence was felt not only in painting, sculpture, and architecture, but in every aspect of life.

The Italian Futurists wanted to add a fourth dimension to the three dimensions of depth: movement, depicted in its successive aspects. With the Futurists, dynamism, the symbol of modern life, became the theme of art: "We will put the spectator in the center of the painting," the Futurists proclaimed. They would no longer walk around an object in order to see it and draw it from several points of view. Instead, the inner world, life, would revolve around them.

Marinetti, the literary founder of Futurism, lauded the mechanical forms of our era: "We will sing the praises of the factories hanging from their clouds of smoke; the bridges that look like gigantic gymnasts; the steamships that sniff the horizon, the locomotives that trample the tracks...." Their artistic program was as follows: "Depict and magnify contemporary life, which is incessantly and tumultuously transformed by victorious science." This refers both to the subject matter and the technique. "Our yearning for truth cannot be quenched by traditional Form and Color! For us, the gesture will no longer be a halted moment in the universal dynamism; it will be the dynamic sensation made eternal. A figure is

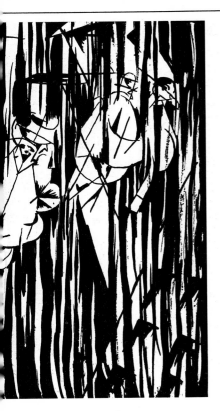

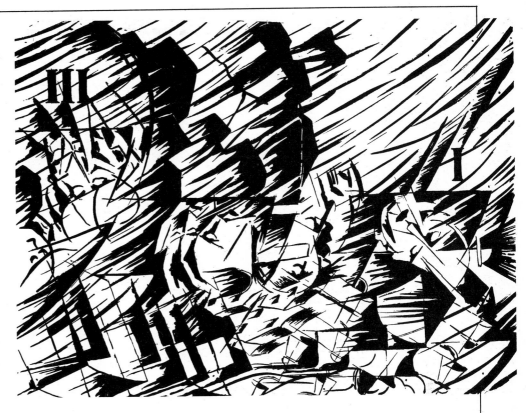

*Umberto Boccioni:*
Mental States: Those
Who Leave.
*Lithograph.*

*The vertical lines are almost a veil concealing the figures, which are arranged at slight angles on the diagonal.*

*Umberto Boccioni:*
Mental States: Those
Who Remain.
*Lithograph.*

*A sloping line, dynamic, with sharp strokes, sweeps like an impetuous wind around the figures:*

never stable before us, it keeps appearing and disappearing incessantly. For with the persistence of the retinal image, objects in motion multiply, become distorted, come in quick succession, like vibrations in the space they cross.

"Thus, a racing horse does not have four legs, it has twenty, and their movements are triangular."

In short, the Futurists employed the following techniques: deformations due to light (following in the footsteps of the Impressionists); the technique of the Divisionists for a better rendering of colors; a suggestion of primitivism (in the wake of "Le Douanier" Rousseau); the dematerialization of light; and finally, the treatment of tones beyond any similarity with objective reality.

The first Futurist works were consistent with this program. For instance, Boccioni's *Mental States,* three lithographs based on paintings: *Farewells, Those Who Leave, Those Who Remain.* We read the following in the preface to the Exhibition of Painting at the Galleria Sprovieri: "We thus achieve what we call: painting of the mental states, and the painting of sounds, noises, and smells. In picturing of various plastic mental states during a time of leave-taking, certain perpendicular lines, wavy and broken, attached here and there to forms of empty bodies, can easily express langor and discouragement. Confused, trembling lines, straight or curved, that merge with sketched gestures of entreaty and haste, express a chaos of emotions. Fleeting horizontal lines, swift and convulsive, brutally slicing faces with empty profiles and edges of bouncing countrysides add the sculptural emotion aroused in us by a person who takes leave."

"In real abstract painting, a primary color signifies that the color functions as a background color. Primitive color thus appears in a very relative way; above all, it is freed from the individual and from individual sensations, and it expresses only the mute emotion of the universal. In real abstract painting, the primary colors are a representation of the primary color in that they more fully express the natural while remaining real.... If, in the representation of form, the limitation of form is achieved by means of a closed line (outline), this line must be rigid to the point of being straight. Then, the outer aspect (the appearance of the form) will be in balance with the exact depiction of extension, which can also be represented as straight lines.... Thus, by means of extension and limitation (the two extremes), we obtain the balance of position: the rectangle. Thus, extension is achieved without individual limitation by means of the diffrence of surface colors, as well as by means of the rectangular proportions

## The Adventure of a Tree

The tree has always been a favorite theme of artists. And for Mondrian, the famous Dutch abstract painter, the tree offered the possibility of experimenting with the evolution and transformation of form. Mondrian drew and painted numerous trees over a four-year period, and we are presenting some of them here as examples of his pictorial conception.

Starting from the Cubist decomposition, Abstract Art tended to wipe out volume and depth, foreground and background. Oblivious of the subject, abstract artists sought an equilibrium of colored shapes by flattening all the elements on to a single plane—the pictorial surface.

For Mondrian, the tree is a symbolic entity—the complex of branches represents the space, and even space itself, spreading in all directions. The tree is also a "tragic conflict of space and matter" in the agonizing balance of "limited" shapes and unlimited space.

Mondrian's drawings and paintings of trees reveal the dramatic conflict between indefinite sphericalness and linear continuity. His work thus developed from the representation of a space in which the tree opens and is articulated (1908), to the interplay of two-dimensional curves on a single plane in *Flowering Apple Tree* (1912).

1. The charcoal drawing shows the trunk and the interweave of branches in space suggested by the formal and chiaroscuro layout and by the lines of the trees in the background. The diagram indicates the underlying arrangement of

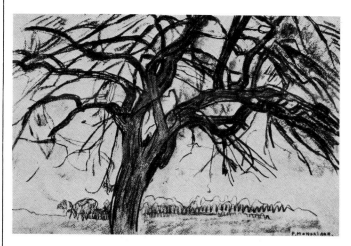

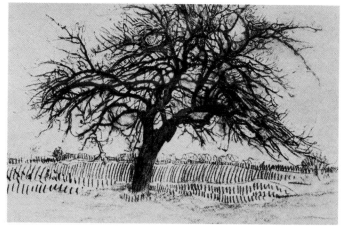

*Piet Mondrian (1872-1944):* Study for the Red Tree, *1900-10. Carbon pencil. Slijper Collection, Blaricum.*

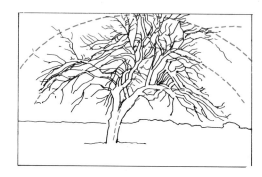

*Piet Mondrian:* Tree, *1909-10. Graphite. Heybroeck Collection, Hilversum.*

of the lines and the surfaces of color. Color is not negated by the rectangle, but only limited. Finally, in the rectangular surface, the color is perfectly determined.... Realistic abstract painting is still useful for achieving nonrepresentation, that is, the final stage of art as we know it now: representation from life, but not yet of life per se. When it is transformed into authentic life, then the art we know today will come to an end. Nevertheless, a great deal must happen before the new representation is absorbed in its totality by human beings. This art comprises the final form of art in its limitations, but it is already a beginning."

(Piet Mondrian: *Die nieuwe beelding in de schilderkunst*, in: *De Stijl*, I, 1917-18)

circular developments upon which the artist based the image. This image, arranged in terms of a specific geometry, leaves the realistic and expressionist charge intact and suggests the foreground design against the background.

2. The graphite drawing of a tree clearly derives from van Gogh's graphic style. The development of the branches is organized in circular motions. Here the artist sought a finer hatchwork and a more complex network of lines, though regular or parabolic curves still guide the composition. The background is about to turn into a backdrop, moving closer and closer to the foreground.

3. In the painting on cardboard, the artist is trying to gradually integrate the tree into the surrounding space, which is depicted as a backdrop behind the trees. As we move closer, this space, the earth and sky, becomes more and more interwoven into the trees, eventually disintegrating, imprisoned in the branches. In *Blue Tree*, Mondrian advances toward the destruction of naturalist space finally caging it in an abstract weave of lines, almost blocking its dynamic potential.

4. The shape of the tree has become a composition of lines in which space is virtually purified. Mondrian is no longer interested in the object, the space between the foreground and the background, or the volume of the tree—its trunk or branches. He now moves toward complete abstraction. The abstraction of the tree produces a new reality based only on the equilibrium of lines that enclose colored surfaces.

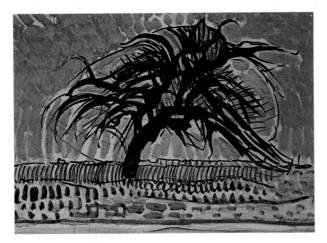

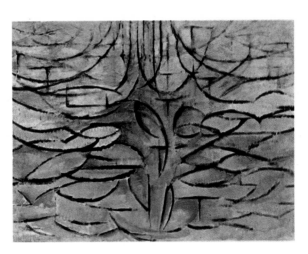

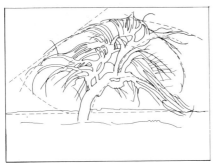

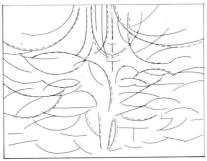

*Piet Mondrian:* The Blue Tree, *1909-10. Painting, Gemeentemuseum, The Hague.*

*Piet Mondrian:* Appletree in Bloom, *c. 1912. Painting. Gemeentemuseum, The Hague.*

## A Drawing a Day

Try to draw a form that you are not used to, one you can invent for yourself. A form that is real, but that contains a hidden and abstract geometry—not colored, not even monochrome or white; simply a model for testing and interpreting contours, outlines, shapes.

Take a page or two of newspaper and crumple it up. Then let it open and assume its own shape. You will thus have a new form to see, discover, and draw.

The drawings and diagrams on these two pages illustrate some of the possibilities:

1. The newspaper is at first inert and spread out. But once it is crumpled, it contains a latent dynamic that is liberated when you let the paper open up. Place the model on the table at a specific distance, moving and rolling it until you find it interesting. Initially, when you select a viewpoint, look for the greatest simplicity in both shape and chiaroscuro. In the example shown here, the overall outline can be inscribed in a series of broken lines, tangential with the

1

2

contours, and forming a polygonal figure that can be easily read.

2. The second picture illustrates a different example of the infinite shapes that a newspaper page can assume when it is crumpled up. This time, the major lines, which contain the shape and determine how we read it, are not all straight. The overall movement is a curve that emphasizes the outburst of the liberated paper; this curve is linked to the sinuous curve of the lower part. Here too, we can find a median line, which guides us in the proportions.

3. The third example is characterized mainly by the chiaroscuro. The portion in shade, defined by two straight lines and an S-shaped line, is the element on which the composition of the form and the chiaroscuro is based. As usual, you must first draw the lines containing the overall contour. Then, try to find the shape of the outline and the inner folds. Finally, start to draw the chiaroscuro, first the darker areas and then gradually reenforce the gray tones.

3

## Picasso's Bullfight

Picasso did a number of drawings of bullfights, a subject he was passionately interested in. This series is particularly instructive in helping us to understand the significance of the outline, its value and potential.

These life sketches were painted with thick black ink. They show the silhouette of the toreador, horses, and bull in various phases of the spectacle. A picador harrasses the bull while the matador waits on the side (the crowd is indicated faintly in the background). The matador then confronts the bull, waving his cape with his right hand. The bull charges the bullfighter, who is about to thrust the banderillas into the animal's back.

The artist used only a few brushstrokes, a few black spots, and yet.... The suggestive power of these shapes is extraordinary. Beyond their dramatic force, these drawings seem to have a thickness, a volume, a spatial charge that one would never expect from silhouettes. What is Picasso's secret? Let's try to analyze his marvelous ability.

More than anything, the spectacle of these figures against the white background perfectly captures the luminous and dramatic atmosphere of a bullfight, as if we were watching from a seat in the colisseum.

The synthesis, accentuated by the black spots uniting man and beast, expresses the shapes and movement with utmost immediacy, in a direct and spectacular dialogue. Finally, Picasso has an extraordinary anatomical knowledge of the bull and the bullfighter, as well as the ability to render not the entire silhouette, but only one part, leaving a profile of light on each figure, almost an illuminated side. The foreshortening melts into the white of the background, and the illuminated side suggests the volume of the figure and the surrounding space.

This seems to be a fundamental issue in interpreting the shape: everything should appear to derive from the outline, the black contours against the whiteness of the paper. The outline is not cut out like a shadow on a wall. Instead, we feel the shape, the movement, the volume, the atmosphere—all rendered by a spot, which is, however, an interpretation.

To achieve such an effect while rendering an image purely as a silhouette, we have to fully know the structure of the subject, we have to study its inner workings. We have to draw the details, including the internal ones, and then conceal them—not forget them—in the overall outline.

*Pablo Picasso:* Bullfight. *Three drawings from the third notebook on bullfighting, 1959. Ink.*

# Line, Outline, and Expressive Line

The outline is the imaginary line limiting the shape of an object. This line represents the contour or silhouette of the object and infers its shape and volume as defined by variations in light and shade, tones, and colors. Thus, the line we use in drawing the contour of an object becomes the essence of the drawing: a light that limits the shape, containing and suggesting the volume, with no other element but itself.

Piero della Francesca offered the following definition: "Drawing is the profile and contour contained in an object."

We first sense the line, connected more to the direction of a stroke than to that of our eyesight. For Leonardo da Vinci, the first drawing was the contour of a man's shadow on a wall. In his early history (as in his early life), when man depicted a face from the front, he drew the nose in profile in order to make the image clearer. Then, he gradually advanced: he recomposed the visual images in his mind, modified the partial linear impressions in terms of his own personality and sensibility, and emphasized the tendency to draw only in outline or in chiaroscuro or in color.

Thus, while the drawing of only the outline is the most ancient form of drawing, it still remains the simplest and most immediate for many people. Such a drawing merely circumscribes the external shape and suggests the internal elements. It is important to use a selective line which can render the image of the idea synthetically, choosing only the fundamental elements.

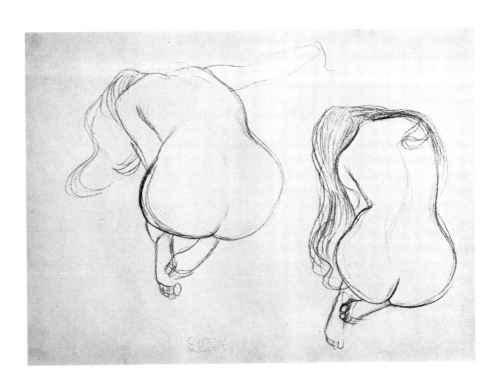

*Gustav Klimt:* Studies for Red Peaches, *1900. Pencil. Erich Lederer Collection, Geneva.*

*The sinuousness of the lines, which, while drawing and defining the form, seems to caress it, is deeply expressive of Klimt's sensuality. When we look at Klimt's drawings and follow the flow of the lines, it almost seems as if the line alone can communicate the intensity of the passions, the vibrations of the bodies, the emotions of the artist.*

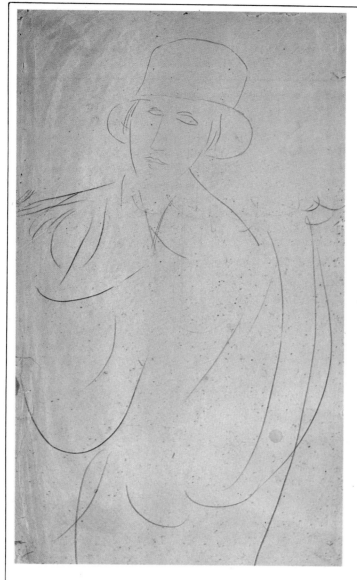

*Amedeo Modigliani:* Portrait of a Woman, *1918, pencil, 430 × 270 mm. Milan, Private Collection.*

*Modigliani's drawing seems to reach the limits of what lines can do. The outline is fragmentary, a set of interlacing curves, emitting an extraordinarily suggestive force. The drawing emphasizes the importance of what has been left out and only suggested by the contours.*

## Qualities and Characteristics of Lines

The expressive possibilities of lines are numerous. They are determined by several qualities and characteristics.

- *The medium selected.* The outline must be drawn in pencil, pen, charcoal, chalk-pencil, brush, etc. The medium you choose will give the line a precise character, according to the nature of the medium. Thus, a pencil line can be sharp or vague, light or strong. A pen line can be dark or light, narrow or wide. A charcoal line can be porous or dense. And a line drawn with a brush can be dark and intense or transparent and soft.

The important thing is to be familiar with the expressive possibilities of the various techniques. To gain such knowledge, all you have to do is experiment with various mediums and test the quality of the lines. But don't choose any model to draw. Select a subject that really interests you.

- *The weight of the line.* A line can be continuous or broken, depending on whether you wish to completely define a figure or leave it open to interpretation.

The best exercise is to study, say, the shape of a crumpled sheet of newspaper. Try to render its continuity and also its fragmentary character—first with a continuous line and then with a series of brief strokes.

You will see—and further exercises will confirm this—that while you are experimenting with models, you will emphasize a particular aspect of the problem. You have to focus on a specific facet—in this case, the line and its expressiveness.

- *The direction of the line.* A line can be straight, curved, or sinuous. Once again, beyond the suggestions and overtones of the subject, the choice depends entirely on you. Often, a straight line is used for preliminary diagrams, while a sinuous line is used for softness and for certain sensations.

As an exercise, you can draw a view of your room using only straight lines. Then, draw a pillow: first, enclose it in the straight lines of the rigid geometrical pattern; next, find the curves of the creases.

- *The quality of the line.* A line is almost always expressive; but at times, it can be deliberately "impartial." While a steady, mechanical line may

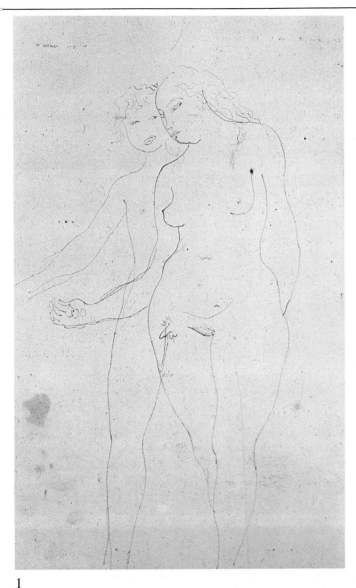

1

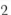

2

*1. Scipione (Luigi Bonchi; 1904-1933):* Adam and Eve, *c. 1930. Pen and ink, 270 × 170 mm. Private collection, Rome.*

*Only the line defines the shape, volume, and weight of each body. It also brings out the vibrations and gesture, expression, and sensuality. A thin, precise line, without corrections, defines the outlines of the figures with utmost sureness, with both strength and delicacy.*

*2. Gibon Sengai:* The Moon. *Rolled paper scroll, 60 × 127 cm. Idemitsu Museum, Tokyo.*

*Oriental culture deeply feels the function of empty spaces in an image. This concept is most effectively confirmed in the extraordinarily simple open line of the moon's silhouette and in the surrounding white. The silver disk of the moon and the infinite space of the sky are contained in the line and in the blankness.*

be rare, we frequently see lines that employ thickness, vibrations, repetitions, overlappings to interpret character, light, atmosphere, and finally color.

What is the ideal model?

Among the many possible subjects, let's examine how you can draw a tree. The aim is to have your lines express the poetry of the tree. Use any method you wish. You can even place several sheets of translucent paper on top of one another to guide you in creating a drawing that becomes more and more a synthesis and interpretation.

• A line can either envelop the form or merely delineate an outline, depending on whether we want to wrap the subject in a thread that be-comes a key line for seeking form as well as volume—or whether we can merely wish to draw the abstract shape of a silhouette or profile.

The following exercise will help you create a descriptive line: Think of the shape of a cat or a bunch of flowers in a vase, or even your face. Look not only for the form, but also the character, the expression, of your subject.

A linear drawing must be animated by a special poetry, the poetry created by your sensitivity.

The final drawing may seem beautiful or ugly, it may or may not resemble the subject, it may or may not depict your "idea." However, the most fascinating aspect is the mystery of the line, its expressive possibilities, its capacity to transform and interpret.

"Illusion is hard to describe or analyze, since, even if we are intellectually aware of the fact that every given experience *must* be an illusion, we cannot rigorously observe ourselves in the act of yielding to an illusion. If the reader finds this statement a bit disconcerting, he can always test it by means of a very convenient instrument of illusion: the bathroom mirror. I specify bathroom, because the experiment that I am recommending to the reader works better if the mirror is slightly veiled with steam. It is an interesting exercise in illusionistic representation to draw one's own head on the surface of the mirror and then wipe the shape enclosed in the outline thus obtained. Only after doing this do we realize how small the image is that gives us the illusion of seeing ourselves "face to face." More precisely, this has to be half of our head. Since the mirror will always be halfway between me and my reflection, the size of the image on its surface will always be half of what it seems. In spite of all geometry, I too

*The duck/rabbit figure was used by the psychologist Joseph Jastrow as an example of ambiguous images, which can be read by focusing on either the left side or the right.*

*This illustration,* My Wife and My Mother-in-Law, *by the cartoonist W. E. Hill, can be read as the foreshortened three-quarter back view of a young woman or as the profile of an old crone.*

## Ambiguous Figures

In the ambiguous figure, characterized by the inversion of the figure and the background, the most interesting element is the fact that a line can suggest either of two forms, depending on what we focus on.

A line drawing has to be easily identified with the depicted object. Hence, the visual system codifies objects first in terms of their profiles. When the outline is not specified by any other internal element and is filled in with one color (black) against a background of another color (white), we tend to read one part of the image as a figure and the other part as a background. If a composition is divided into two distinct parts, the smaller part is generally perceived as a figure and the larger part as the background.

Other amusing ambivalent compositions are those in which we can see either of two familiar objects. For example, we all know of the figure that shows either a rabbit or a duck, depending on whether we gaze at the right side or the left side of the head. Or the figure that shows either the bust of a young woman or the face of an old crone, depending on whether we focus on the young woman's face or the old woman's nose. The element common to both the rabbit and the duck is the eye. In the second figure, the common element is the hair, which is either over the young woman's ear or over the old woman's eye.

In these figures, we can establish the mechanism that enables us to establish one meaning rather than another: If we identify one element, the eye, we immediately identify the continuous line from the nose to the mouth and the chin, and then we grasp all the other details as elements of the face. On the other hand, if the first element we identify is the foreshortened face, then every other line helps to confirm the image of a young woman.

Sometimes, when viewing an ambiguous figure, we fail to see one of the images, even though we

will continue to state that I have really seen my face in its natural size. It is not possible to yield to an illusion and at the same time observe it from outside." (Ernst H. Gombrich: *Art and Illusion,* 1960)

may stare at it for a very long time. But usually the second image eventually appears.

Aside from these ambiguous two-figure examples, there are also examples where a figure can be separated from its background. This can be done even with an object that is not ambiguous, that is, with one whose background does not offer any meaning as a figure. I have suggested this exercise several times, so that we might shake off our habitual image of a subject. The form of the background becomes a new form, which we see as such beyond any significance or prototype.

*This drawing can be interpreted as a stairway seen from above (so that the steps are to our left) or seen from below (so that the steps are to our right).*

*The pattern of colored rhombuses suggests a drawing of cubes: the red rhombuses seem to be, alternately, the upper and lower surfaces, and thus the corners can appear outside or inside.*

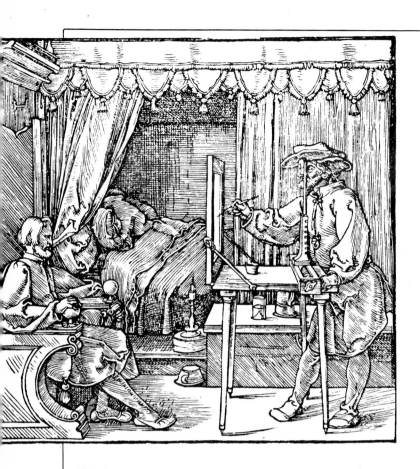

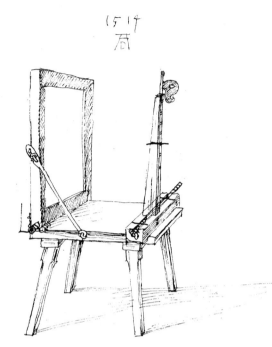

*Albrecht Dürer:* Man Drawing a Seated Man. *Engraving from* Instructions for Measuring, *Nuremberg, 1525. Kupferstichkabinett, Berlin.*

*Albrecht Dürer:* Perspective Device, *1514. Preparatory drawing for the engravings in* Instructions for Measuring, *Nuremberg, 1525. Kupferstichkabinett, Berlin.*

## Instruments for Defining Outline

In the chapter on *Form and Chiaroscuro,* we spoke about the basic notion of drawing as the projection of an object onto a vertical plane cutting through the cone of vision. We illustrated this concept with a famous print by Dürer, *Man Drawing a Reclining Woman.*

As we have said, the outline or contour line is the imaginary line enveloping and defining an object. To clarify what this means, let us look at three more drawings by Dürer: they illustrate the concept of the outline as well as various approaches to drawing. All the procedures Dürer depicted were based on the method of projection; that is, on cutting through the cone of vision. The instruments he depicted were real; they were available or at least constructable (recall Leon Battista Alberti's *velo,* grid) by the artist. By employing such tools, Renaissance artists were able to put their aesthetic theories into practice.

Remember the crossframe or viewfinder described at the beginning of the book? This is a frame on which the horizontal and vertical axes of the inner rectangular area are indicated. The viewfinder enables us to select a define a framework in which to draw. This extraordinarily practical tool is the simplest of these artistic instruments. It was used for many years by all artists in order to facilitate and speed up the process of defining a shape, especially for a portrait. The Dutch painters needed it because of their great love for details.

Let us now look at Dürer's three engravings, which complete the array of mechanical procedures for defining objects with the precise and immediate specification of their outline.

• In *Man Drawing a Seated Man,* the technique has advanced once again. The instrument for drawing in perspective (the *velo*) has become a portable trestle or easel. On a small table, a hinged frame can be pushed up into a vertical position. Through this frame, the artist can sight the figure, the object, and the background. A grooved shaft with a viewing device allows the artist to change and fix the position of the eye.

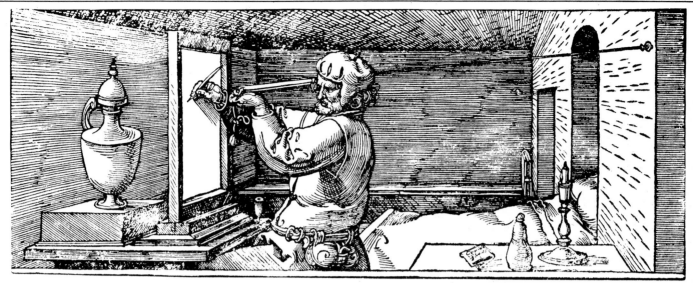

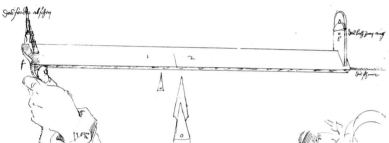

*Albrecht Dürer:* Perspective Device, *c. 1525. Preparatory drawing for the engravings in* Instructions for Measuring, *Nuremberg, 1538. Kupferstichkabinett, Berlin.*

*Albrecht Dürer:* Man Drawing an Amphora. *Engraving from* Instructions for Measuring, *Nuremberg, 1538. Kupferstichkabinett, Berlin.*

- In *Man Drawing an Amphora,* the instrument for focusing the viewpoint is a sort of viewfinder attached to the wall by a string. Through this device, the artist looks at the amphora, which stands on the other side of the transparent plane, and he draws on this plane.
- In *Man Drawing a Lute,* Dürer illustrates a further method for drawing the shape of a projection. This method, which is actually more complicated, requires the help of an assistant.

In a frame provided with a shutter, the artist passes a grooved cord in a ring. The ring is attached to the wall, and the end of the cord touches the main points of the lute (the cord is virtually the materialization of the visual cone).

The assistant then locates the position of each point on the frame, which produces the depiction. He does this by placing a thin shaft next to the cord and a pencil at the intersection. With the pencil he draws the image of the given point on the surface of the shutter, which is closed on the frame. He repeats this for every point of the lute.

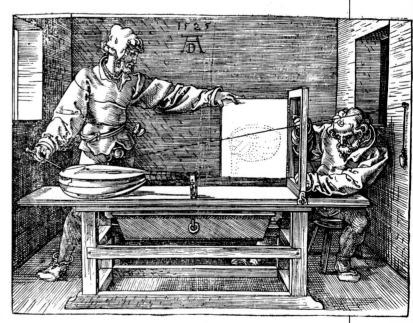

*Albrecht Dürer:* Man Drawing a Lute. *Engraving from* Instructions for Measuring, *Nuremberg, 1525. Kupferstichkabinett, Berlin.*

*Giacomo Balla (1874-1958):* Study for the painting "Girl Running on Balcony," 1912. *Pencil and ink, 230 × 270 mm.*

## The Language of Lines

The Futurist photographer Anton Giulio Bragaglia described Balla's compositions as examples of "theories," one of which is "movementism," which the Bragaglia brothers defined with photographs of motion. This research is expressed in *Movementism of a Dog on a Leash* and then in *Girl Running with a Hoop.*

For the Futurists, drawing constituted a possibility of rendering the "duration" of movement, for which they would superimpose and stagger successive images of a moving figure. The influence of stroboscopic photography is obvious—as is the graphic and painterly sensibility of an artist like Balla, who could express himself in lines alone.

Giacometti declared that he "lived only in order to see and draw, and drew in order to see better." He added: "When it comes to painting or sculpture, all that counts is their roots, the drawing. You have to grab drawing, nothing else. If you can just barely master drawing, then everything else is possible."

Giacometti's sketch *Landscape, View of Maloja* is a very clear example of what can be done with a simple line. A subject with no particular poetry is drawn with a few strokes of the pen; we see a landscape with houses in the foreground, a hilly setting, a mountain background.

*Alberto Giacometti (1901-1966):*
Landscape, View of Maloja,
*1930. Pen and India ink, 215 ×
265 mm. Kunsthaus, A. Giacometti
Donation, Zurich.*

*Renato Guttuso:* Morning, *1969. Pen
and India ink and brush, 510 × 365
mm. Artist's collection (photo: Oscar
Savio).*

If we analyze the composition, we see that the
background occupies the top half of the drawing
with sky. The strip of foreground fills the bottom
fourth of the surface; and the strip of hills con-
verging at the center occupies another fourth.

In *Craft of Painting,* Renato Guttuso writes:
"What has always counted more than anything for
me is my relationship with things. Finding—or
believing I have found—this relationship (which,
of course, is neither stable nor fixed) has meant,
somehow attempting to communicate this rela-
tionship. There is no such thing as art without an
audience. Everyone certainly has his standards,
depending on experience; and this is the impond-
erable mode in which a certain cosmic force

establishes itself in form.

"Not even the taboo of preconstituted language
and method can suppress this impulse in a true
artist. And because this impulse is human in its
roots and ramifications, it is the only impulse that
counts."

In every work, Guttuso seems to be looking for
this relationship. In his drawing *Morning,* the
expressive strength of the line is formidable. The
figures, caught in a split second, are virtually
enveloped in the folds of the sheet. They are
sketched in light, sinuous, exaggerated lines,
which suggest and create volume, color, light, and
shade out of nothing, or rather, with black strokes
alone.

"This book [*Jazz*] was conceived in the same spirit. The *papier découpé* [paper cutout] enables me to draw in color. I find this to be simpler. Instead of drawing the outline and inserting the color (one modifying the other), I draw directly in color, which is all the more calibrated in that it is not transposed. This simplification guarantees precision in the union of two devices, which become one. There is no break between my old paintings and my cutouts. I have merely achieved more surely and more abstractly a form concentrated to its essence; and as for the object, which I previously presented in the complexity of its space, I have preserved the line that is sufficient and necessary for making it exist in its proper form and for the totality in which I have conceived it. In the *papiers découpés,* the material (the paper) has to be disciplined, I have to make it live and grow.

"For me, this is a need for knowledge. The scissors can bring a sensitivity to the drawing, more than pencil or

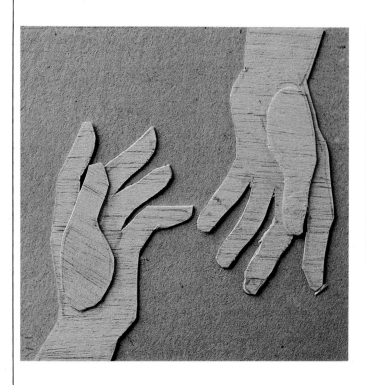

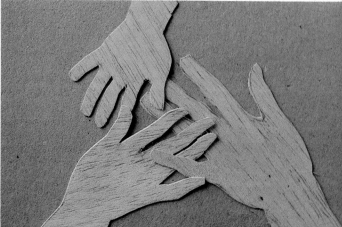

*The reproductions on these pages illustrate "drawings of forms" for compositions in balsa. The silhouettes of hands have been cut out and then freely arranged.*

## Silhouettes in Balsa Wood

For Leonardo, "the first painting was nothing but a line surrounding a man's shadow, created by the sun on a wall."

So for us, the simplest and most immediate exercise for defining the form, say, of a hand, is to place the object on a sheet of paper and draw the outline with a pencil. Even better, instead of paper, use a thin piece of balsa, a wood that can be notched easily. Cut out the silhouette and then paste it on some surface (white or colored). The more you practice this, the more complex and entertaining the experience will be.

You can cut out the outline of your hand simply as a shape, with the palm and the fingers more or less open. Or, you can use a lamp to project the shadow of your hand on the balsa, holding the latter sufficiently close, and then hold your hand in various positions and draw it. You can even add another hand or two, your own or a friend's, or even a child's hand, and you can also superimpose them, one on the other. In this way, you can create any number of different silhouettes.

Don't just stop with the *shape* of the hand. You can give it more relief and make it more expressive if you present a foreshortened image of the inside of your palm and superimpose the outline of the thumb on it.

Our theme is the hand, but obviously we can use any other subject, so long as it can be characterized by its silhouette.

This brings us to the second exercise, which we can regard as developing from the first.

Leaf through your books on art history or through the pages of this course and scrutinize the various drawings. Select one that you feel lends itself to a silhouette in balsa. Even better, pick a drawing on whose silhouette you can place other cutouts to accentuate its characteristics and suggest its volume.

If you thus superimpose several silhouettes, your contour drawing will actually become a composition. The interplay of superimposed planes,

charcoal. Look at this large composition: leaves, fruits, birds—a garden. The white in between is determined by the arabesque of colored paper silhouettes, which gives the surrounding white a rare and impalpable quality. This quality is that of contrast. I was inspired to do the *papier découpé* in order to unite color

and drawing in a single movement."
(Matisse: *Writings on Art*)

1

the alternating of wood veinings (some in one direction, some in another), and the contrast with the white or colored background will help make your work decorative and imaginative. It will be a modern interpretation of a technique that was masterfully used by such painters as Matisse, Braque, and even Picasso.

2

3

*1. Kathsuishika Hokusai (1760-1849):* Sparrows in Flight. *Ink and brown tint on paper, Madame Janette Ostier, Paris.*

*2,3. In these illustrations, Hokusai's drawing has supplied the outlines of birds caught in successive moments of their flight. The silhouettes were cut out in balsa and then arranged as in the original composition, reconstructing its rhythm.*

### A Drawing a Day: Landscape or Cityscape—
### The Profile of the Horizon

Sometimes, when we leave a city and look around at the view of the outskirts or the remote landscape of the surrounding countryside, we are struck by the silhouette of the horizon, the skyline. The hills stand out against the blue sky, and we see the outline of a village on the mountainside, the flat, relaxing line of the meadows, the profiles of the mountains, which look like a stage set and the image of the city itself, which we have left behind us and which now seems so far away.

Stop for a moment and take out your sketchpad and draw. Capture your feeling, the view, the contours. Don't try to draw everything. Half close your eyes and read the skyline of the city, the country, the hills, the mountains, the trees. Since you are seeing this form for the first time, you might try to read it, follow its line, first with your eyes, then with your pencil. Otherwise, instead of looking at the shape of the village or of the hills silhouetted against the sky, concentrate on the shape of the sky as cut out by the hills or the village.

A few strokes will be enough to indicate what you see between yourself and the skyline. A precise, continuous line will mark the outline of the faraway village, which is in the lower part of the paper. The remaining space will suggest the sky.

You may not succeed immediately in creating the overall synthesis of what you see. Refer to the drawings on this page:

- The form of the church dome and the bell tower silhouetted against the sky.
- The form of the whole village, ignoring the details of volume of individual houses.
- The shape of the island of San Giorgio with the outline of the church, filtered through the fog of the lagoon.

We can make our own synthesis by half closing our eyes and deliberately ignoring the individual details. Instead, just look at the scene as a whole and at the line that defines it.

*The black diagrams indicate the outlines of the views.*

*The church of Santa Maria di Montesanto, Rome.*

*View of the village of Sperlonga.*

*The island of San Giorgio, Venice.*

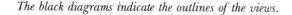

—164—

# Ratios, Relationships, and Symmetry

We have already spoken about proportions and hidden geometry, especially in regard to the problem of the ideal proportion as achieved by means of a "module" in accordance with classical teachings.

On the one hand, as we have seen, artists have always been interested in finding a special "relationship" for the correct proportions of, say, the human figure. If we establish a 1:9 ratio between the length of the head and the overall height, we can draw the human body more easily and with fewer mistakes. This rule can help us either in devising a figure without a model or in drawing one from life.

But when we have to draw another subject, then no rule will be as useful as our knowing and defining the relationships between its various parts. For example, in regard to a rectangular shape, the simplest and most immediate relationship is that between height and width. Next comes the connection between the various elements in a continuous chain of relationships. We can also find the relationships between the diverse elements of a more complex subject: a scene or a landscape. When we use our crossframe or viewfinder to frame the elements we have chosen, we can easily relate them by comparing them to each other and to the broad framework of the drawing.

These relationships are found not necessarily in a geometrical or regular structure or construction, but in a network of references that can and should be free and personal, varying with each individual drawing.

Imagine, for instance, that you are going to

*Bonifacio Bembo (c. 1420-active until 1477): Tristan and Lancelot Playing Chess,*
*from* The History of Lancelot of the Lake. *Cod. Pal. 556, f. 105. Pen and ink, silverpoint lines on parchment,*
*275 × 200 mm. Biblioteca Nazionale, Florence.*
*The Diagram illustrates the reversal and insertion of the left-hand figures in the right half of the drawing. As we can see, the similarity of the symmetrically positioned figures is almost perfect.*

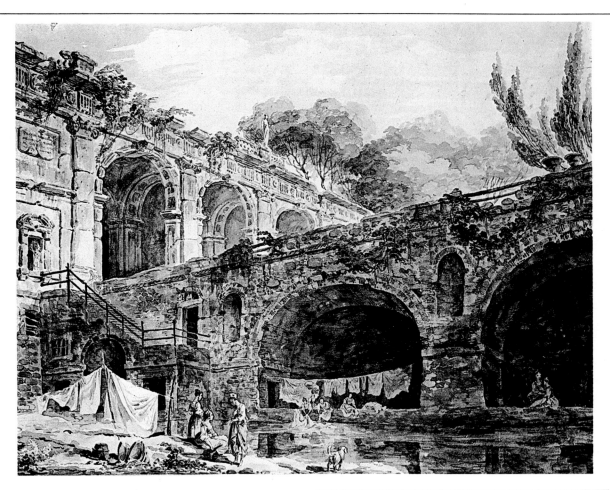

draw the scene depicted here by the French painter and engraver Hubert Robert, *Villa Madama*. The first thing you would have to pinpoint is the directions of the three principle lines: the angle of inclination of the archway in the middleground, the angle of the edge of the wall in the foreground, and the angle of its base. To do this, establish the perspective line of the arcades and its angle by relating it to the vertical and horizontal axes of the crossframe or by holding a pencil against the scene, in a vertical or horizontal position. You will now see the following:

- This perspective line meets the line of the upper edge of the wall in the foreground, roughly at one third of its length.
- The wall is joined to the walls of the arcades at a place that is one-third of the overall height of these walls.
- The first arch opens within the wall after a space that is as wide as the arch itself.
- The impost of the arch in the foreground wall corresponds to the end of the second arch.
- The connection to the right side of the wall is at a spot two-thirds the height of the drawing.
- The line of the base of the foreground wall is almost horizontal.

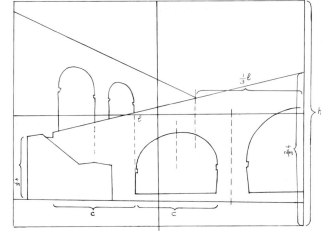

*Hubert Robert (1733-1808):* Villa Madama, *1760. Pen (sepia) and watercolor on pastel sketch, 345 × 455 mm. Graphische Sammlung Albertina, Vienna.*

Using a similar method, we can now find the relationships among the various elements in a drawing by the Dutch painter Willem Buytewech:

- By drawing a horizontal line across the heads of the female figures, we can see that the right-hand figure is only a bit higher than the other.
- Dividing the scene in half vertically, we can see that the two figures are within the first half.

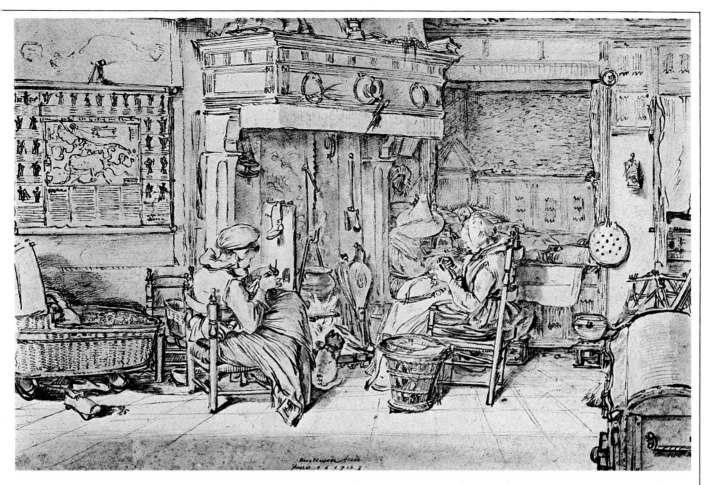

- The fireplace is roughly at the center of the space above the line of the heads.
- The line of the plane of the chairs exists at a midpoint on the height of the figures.

Against the imaginary grid this information creates, we can easily locate the position of each object: the cradle and picture are in the first quarter, the fireplace ends halfway into the third quarter, and other objects such as the pot and the trunk.

You can use these and similar drawings to practice on in setting up your own personal relationships and reference points.

When we speak of symmetry today, we generally mean bilateral symmetry; that is, the mirrorlike correspondence between the two parts with respect to an axis or center. This notion is linked to the concept of "classicism," especially in architecture. Classical constructions are characterized by axes of symmetry, which are found in every building in which the architect wanted to establish order, geometry, and monumentality.

In drawing, symmetry acts as a guide, by setting up invisible axes, as in certain portraits and figures in which the artist tries to communicate a sense of staticness by means of the composition, the ratios, and the even proportions.

*Willem Buytewech (1591-1624):* Interior with Family at Fireplace, *1617. Pen, brush (India ink), and bistre wash, 188 × 290 mm. Kunsthalle, Hamburg.*

Most important, symmetry—which is based not only on a vertical median axis, but also on diagonals and other lines—becomes an element capable of expressing the compositions of scenes and figures "in space." In general, however, the term *symmetry* indicates a system of correlation rather than a repetition or parallelism of parts. In this sense, symmetry has a profound aesthetic meaning rather than a strictly mathematical one.

"The complete dimensions of a body—if we may phrase it thus—are connected at a ratio of three to three as the basis of specific numeral relationships, which are naturally 'harmonious' or else conceived according to exact and precise criteria of various origins, as follows. The concept of harmony includes those numbers whose ratios reproduce the proportions of musical harmonies: for instance, the double, the triple, the quadruple. Two can be gotten from one by increasing the latter by one-and-one-half, just as it can be increased by one-and-one-third, as in the following example. The minor number two can be assigned to the ratio of two; from this we get in the proportion of one-and-one-half, three; from this, in the proportion of one-and-one-third, four: and this number is the double of two."
(Leon Battista Alberti *De re aedificatoria*)

*Double (diapason 1:2)*

*Sesquialtera (diapente 2:3)*

*Sesquitertia (diatessaron 3:4)*

*Double diapente (4:6:9)*

*Diapason diapente 1:3 (3:6:9)*

*Diapason diatessaron 3:8 (3:6:8)*

## The Musical Proportions of a Drawing

Tone, chiaroscuro, proportion, harmony.... These terms refer not only to the study and practice of drawing—but to music as well. This is no coincidence. The relationship between music and the visual arts goes back to ancient times. Without traveling too far back, let us spend a moment or two in the Renaissance and listen to the words of Leon Battista Alberti: "We apply the word *harmony* to a concordance of notes agreeable to the ear." Alberti wrote this statement in his treatise on architecture. In both music and architecture, mathematical order is expressed respectively in sounds or in measurements and spaces; thus, music can be invaluable in describing both subjects. Alberti goes on: "Notes can be either deep or high. The deeper a note, the longer the string that producees it; the higher the note, the shorter the string. Varying these diverse notes produces different harmonies, which were classified by the ancients according to specific numbers reflecting the relationships between the strings."

There we have the whole theory of harmonies

1

"Music is nothing but the sister of painting because it composes harmony with the conjunction of its proportional parts." (Leonardo da Vinci: *Treatise on Painting*)

"The reasons for this harmony in music are those of coloring; their terms are low and high, and the terms for painting are light and dark." (Pietro Testa, 1611-1650: *Treatise on Painting*)

The pleasure given to us by Painting, viewed as a mute art, seems to be the same as is given to us by Music; its beautiful forms and its arrangements are pleasing to the eyes as the notes and harmonies are to the ears: both fill us with joy, they make us realize the ability of the artist, as we are capable of judging it." (Jonathan Richardson, English portraitist, c. 1665-1745)

and intervals, founded on the relationship between the lengths of the strings and the sounds they emit. These numerical ratios refer to the relationship between string lengths. For people interested in drawing, these relationships refer to the lengths of the sides or to the values of length and height specified by the various elements in the scene.

Applying Leon Battista Alberti's theory to measurements in a drawing, we can establish the following major relationships:

- *Diapason* or double; an interval of eight notes, an octave; produced when the ratio between the lengths of the sides is 1:2, that is, when one side is twice as long as the other.
- *Diapente* or sesquialtera (one and one-half): an interval of five notes or a fifth; produced when the ratio between the two lengths is 2:3, that is, one side is one and one-half times as long as the other.
- *Diatessaron* or sesquitertia (one and one-third): an interval of four notes or a fourth; produced when the ratio between the lengths is 3:4, that is, one side is one and one-third times as long as the other.
- *Diapason-diapente* or triple (a whole against its third), an interval of twelve notes or a twelfth; produced when the ratio between the lengths is 1:3, that is, when one side is three times the length of the other.

Aside from these relationships, there are more complex ones, such as the double diapente (double sesquialtera, 4:6:9); the double diatessaron (double sesquitertia, 9:12:16); or the union of the diapason and the diatessaron with a ratio of 3:8 (3:6:8).

The Renaissance artists took Alberti's text literally and used the relationships that Alberti offered as examples to proportion their paintings and to determine the positions of the chief figures in a scene. Some of the most frequent ratios were 1:2, 4:6:9, and 9:12:16. Their goal was to find a rhythm that would bring musical harmony to the surface of a drawing.

2

*1. Raphael:* The School of Athens *(detail). Fresco, 1590-1514. Vatican Palace, Stanza della Segnatura, Rome.*

*We see the diagram of the musical consonances with the Greek indications: tone, diatessaron, diapente, diapason, with their respective ratios: 6:8 and 9:12, 5:9 and 8:12, 6:12.*

*2. Albrecht Altdorfer (before 1480-1538):* Deposition, *1513. Black ink, white lead highlights on reddish paper, 215 × 155 mm. Uffizi, Gabinetto dei Disegni e delle Stampe, Florence.*

*The composition based on the musical rhythm of 1 to 2,4,6 (as shown in the diagram of the verticals), confirms the balance of the scene, which is perfectly constructed on the diagonal (an ascending line enclosing the figures of the pious women around Christ) and on the vertical line of the thief's cross, which closes off the scene at the left.*

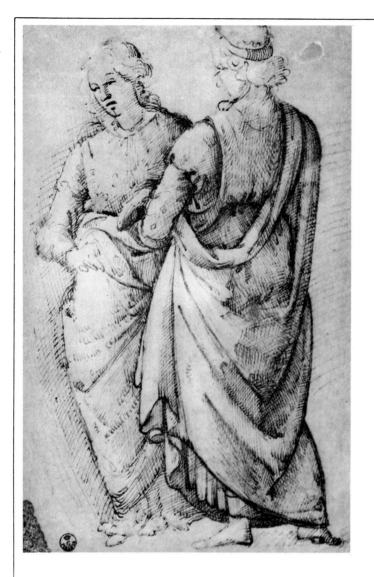

## The Symmetry of the Contrapposto (Contrast or Counterpoint)

Let us study this drawing by Ghirlandaio. An imaginary circle unites the bases (the feet) of the two figures, who are facing one another almost as if mirroring each other in a rotating movement. The figure with his back to the viewer balances the figure we see from the front. The two figures almost seem to be conversing, but they are actually one and the same figure seen from both the front and the back. The artist has simply drawn them from two different and successive viewpoints.

The device that Ghirlandaio has achieved in his drawing is the so-called *contrapposto,* one of the most fascinating secrets or, rather, inventions of the Italian Renaissance. Contrapposto was expanded by such artists as Peter Paul Rubens, especially within a circular composition, and Eugène Delacroix, a master of the S-shaped composition. This invention makes the viewer think he is

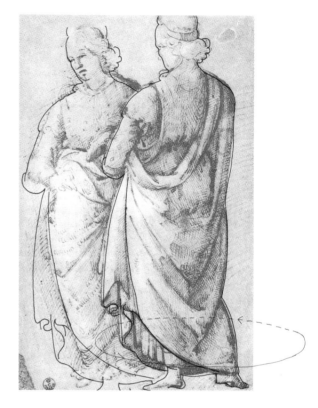

*Domenico Ghirlandaio (1449-1494):* Two Female Figures for the Frescoes of Santa Maria Novella. *Pen and ink. Uffizi, Gabinetto dei Disegni e delle Stampe, Florence.*

*In the red diagram superimposed on the drawing, we see that the outline of the right-hand figure coincides almost perfectly with that of the left-hand figure, like a mirror reflection. By preserving the illusion that the two figures are in conversation, the drawing manages to render the spatiality of the figures more imaginatively and more subtly.*

seeing the figures spatially, in their entirety, when they are really depicted from either side in a sort of mirroring. This is not only a quest for compositional symmetry, it also expresses a desire for total depiction in order to attain what the Italian Renaissance called a *paragone* (a paragon or model).

During the Renaissance, the *paragone* arose because of the confrontation between sculpture and painting. A competition was set up between artists to establish which of these two arts was more capable of rendering the full volume, the com-

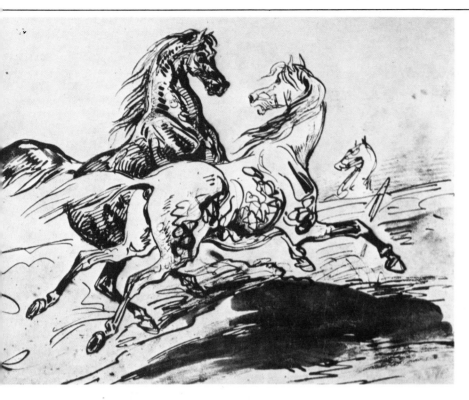

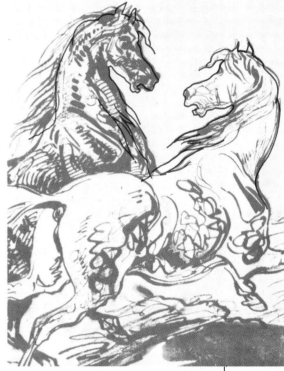

*Eugène Delacroix:* Stallion and Mare. *Pen and ink and wash. Private collection.*

*The diagram of the head and neck of the right-hand horse, reversed and superimposed on the head and neck of the left-hand horse, coincide perfectly. The similarity may seem unintentional, but there is nothing acidental about the contrapposto of the two horses, seen from behind and in front, with their heads virtually reflecting one another.*

plete spatiality of a figure. This debate involved the best artists of the era, and was mentioned by Vasari in the *Proem* of his compilation of artist's lives. There he defined the *paragone* as "a dispute created and nourished by many but to no purpose."

At the funeral of Michelangelo, the controversy became harsher and even more violent. The great artist died inRome in 1564, and when his remains were brought to Florence, solemn tributes were arranged at the Basilica of St. Laurence. The organizing committee was made up of two painters and two sculptors. They decided to place four statues, symbolizing Painting, Sculpture, Architecture, and Poetry, on the catafalque: Painting at the right and Sculpture at the left. Since the right-hand side was the traditional place of honor, Cellini, one of the two sculptors on the committee took this as a personal insult. He gave a speech, claiming once again the preeminence of sculpture over painting, which he called the "shadow of

sculpture," a "falsehood." The question remains: which of these two arts is superior and capable of expressing depth and volume?

Sculpture would seem to be the immediate and logical answer. Sculpture can depict three dimensions, while painting can use only the surface of the two-dimensional picture plane. On the other hand, painters would see painting as the superior art. While sculpture can render volume and spatiality only by forcing the viewer to move around a given work, painting can transmit depth and volume by means of perspective. Above all, it can show the various faces of the object in a series of positions, successive moments of a movement (as in Ghirlandaio's figures or Delacroix's horses), which enable the spectator to "move" around the figure and see it from various sides without budging.

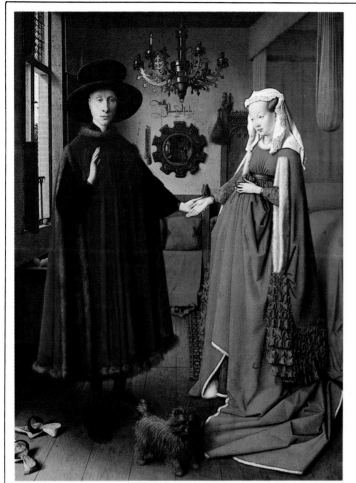

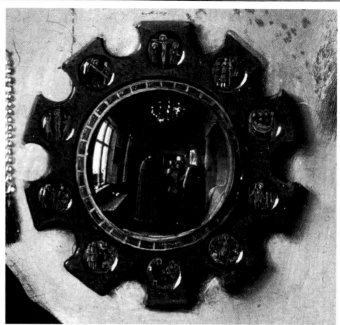

1

2

*1,2. Jan van Eyck (c. 1390-1441):* Arnolfini and His Wife *(and a detail of the mirror), 1434. Painting. National Gallery, London (by courtesy of the Trustees).*

*Edouard Manet (1832-1883):* Bar at the Folies-Bergère, *c. 1881-82. Painting. Courtauld Institute Galleries, London.*

*The mirror reflecting the crowd not only constitutes a device for rendering the observer as a figure in the picture, it also serves to emphasize the contrast between the festivity of the throng and the melancholy of the young girl.*

*Mary Cassatt (1845-1926):* Study for "Dressing", *1891. Black pastel and pencil, 393 × 277 mm. National Gallery, Rosenwald Collection, Washington, D.C.*

*In Mary Cassatt's sketch, the composition includes the reflection of the figure at the dressing table, seen from the back and also (in the mirror) from the front.*

39

*Henri Matisse:* The Artist's Studio: Nude in front of a Mirror, *1937. Pen and ink. Private collection, Paris.*

*In Matisse's drawing, this quest for the overall volume, the front and back view, and the simultaneous view from two viewpoints without an overlapping, is made possible by the presence of the mirror. The mirror reflects not only the painter himself (at the left) who thereby "signs" his work, but also the young model kneeling or sitting in front of the mirror. The reflection shows us the other side, the hidden side, which there is no other way of seeing.*

## The Mirror

In Jan van Eyck's famous painting, *Arnolfini and His Wife,* a circular convex mirror reflects the entire room, including the door in the front wall, where we can see the artist himself entering. With the help of the reflecting surface of the mirror, the viewer can also see the backs of the figures.

Mirrors also play an important role in other paintings. In Manet's *Bar at the Folies-Bergère,* a girl stares at the spectator, and her profound melancholy contrasts with the carefree throng of people milling before her and reflected in the mirror behind her. Furthermore, anyone in this festive crowd of many figures barely rendered by the impressionistic brushstrokes can easily find his own image and be transported through the magic of the mirror.

The surface reflecting the subject we draw thus becomes a means of spatial representation, a way of completing the image in its various aspects. In both drawing and painting, the mirror is sometimes the element that, by reflecting the depicted figure, allows us to see its hidden part. We virtually circle the figure, capturing it in its various aspects. The mirror is an artifice, granted—but it is one that allows the artist the pleasure and possibility of depicting the entire figure from both sides. It enables the viewer to feel as if he were participating in the space surrounding the figure, as if he were entering the picture itself, seeing the scene from inside and outside and observing the figures from front and back. This is exemplified in these two works by Matisse and Mary Cassatt.

However, the mirror is not only a reflective surface; it is also an instrument for testing and correcting a drawing. Thus we can use the mirror to compare the reflected image of reality with the image drawn or painted from life to help us correct any mistakes. Such an approach is already discussed in the writings of Leon Battista Alberti and Leonardo da Vinci. Alberti advises using a mirror in order to demonstrate the precision of the painted image. On the other hand, da Vinci suggests using a mirror in order to check the "likeness" of the depiction by comparing the "real thing" reflected in a mirror with the drawing. And da Vinci goes even further, seeing analogies between the mirror plane and the picture plane: specifically, the possibility, inherent in both, of "demonstrating things that appear to be in relief," the impalpable nature of images.

Using a mirror to check as well as to facilitate drawing, was common among artists until the 18th century. It is easy to make a mistake if you always look at your model in the same way; by dwelling on your drawing, you fail to notice its defects. But by analyzing the reflected figures reflected in the mirror, we see them in a new light. We can examine them without prejudice and discern our mistakes more easily. Thus the mirror is a valuable aid.

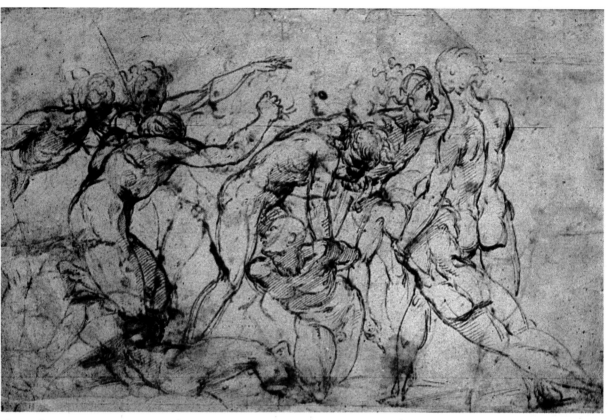

*Raphael:* Battle Scene with Prisoners Being Chained. *Pen and ink on black pencil, 268 × 417 mm. Ashmolean Museum, Oxford.*

*The diagram illustrates the ratios and the rhythm of the composition. The figures are clustered in three groups: a first group, at the left of three men with extended arms; a center group of three men, one kneeling, one leaning, one howling in profile;*

*the third group is made up of a man standing with his back to the spectator, the only really upright figure, who holds up an abandoned body.*

*The directional curves of the first two groups tend toward the vertical line of the last figure with an extraordinary dramatic force and a remarkable sense of movement.*

*The rhythm is scanned in a double ratio of 1:2 and then 3:4.*

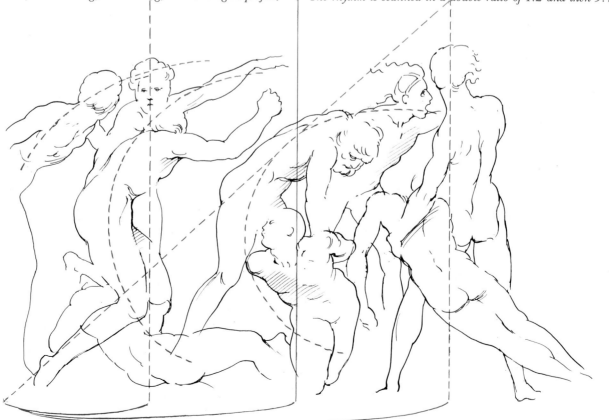

*Hans Holbein the Younger:* Battle. *Pen and ink and gray watercolor, 284 × 434 mm. Kunstmuseum, Basel.*

*The composition is based entirely on straight lines at various angles. These lines add movement and drama to the composition: the lines of the lances and spears dominate the mob of warriors and the lines of the axes of the foreground figures. The soldiers are arranged on a sort of stage marked off by the lances on the ground; the wedge shape accentuates the violence and depth of the scene.*

## Paper Game (and Elementary Symmetry)

There is a very simple and well-known children's game that seems to offer many analogies to our study of the proportions among parts. This game was an aide-mémoire or a demonstration-example in the hands of the old master builders.

You construct a figure by folding up a sheet of paper. Not only does this figure then have its own structure and proportions, but it also suggests various connections and developments in defining the module of symmetry. For example, the basic ratio of the figure is 1:1; the square at a 45 degree angle is the basic outline. The starting module could be segment *a*, the side of the triangle that, in turn, constitutes the module of the surface. Now break down the figure into three parts: 1, 2, and 3. These parts are simply adjacent, but parts one and two are the true connections of ratios, while part three is merely a simple proportional triangle. The whole thing is an elementary example illustrating the proportional method of symmetry, seen as a proportioning of the various parts in terms of a given module.

The concept of symmetry as a proportion could be summed up as follows:

- An initial module (or else, at times, a set of modules);
- An equality of ratios, leading to proportion;
- A logical succession of ratios (symmetry) in a geometric whole: the origin of rhythm;
- A connection and *succession* of ratios in the figuration of a composition: the creation of rhythm;
- The logic of the conception in a spiritual compositional order: eurhythmics.

*These diagrams illustrate the successive stages in folding a sheet of paper in order to construct forms.*

—176—

# The Psychology of Form

In the conclusion of the chapters on form, we observed that, basically, what we see is not really as we see it.

We examined a series of phenomena such as perspective vision, the relationship between the figure and its background, chromatic experience (with the appreciation of colors changing according to their arrangement), the reading of form in motion, and finally, the quest for the dimension of time (Cubism).

These and other phenomena are determined by certain norms that can be summed up in the following laws worked out by the German psychologist David Katz (1884–1935):

• *The Law of Vicinity:* The parts of a perceived whole are grasped in units according to the smaller distances. For example, in figure 1 (page 178), the lines and dots separated by smaller spaces tend to cluster in homogeneous groups: in the area of the lines, stripes separated by larger intervals form, just as in the sector of the dots, there are obvious rows of dots, separated by larger intervals.

*Max Ernst (1891-1976):* Katharina Undulating, *1920. Gouache and pencil, pasted paper, 300 × 248 mm. Collection Sir Roland Penrose, London.*

*For reading a drawing like this one by Max Ernst, with its many male and female symbols in a fantastic landscape (we see Mount Fuji, the constellation of Cancer, and a sort of swastika-shaped automaton), we have to study the psychological components.*

1. The Law of Vicinity.

- *The Law of Equality:* In a set of diverse elements, there is a tendency to perceive similar elements in groups. For instance, in figure 2, the equally thick lines on one side and the empty circles or filled-in circles on the other side tend to unite respectively. Such a tendency to unite may be due to the shapes of the elements, their configuration, their color, or to their natural or man-made characteristics.

2. The Law of Equality.

- *The Law of the "Closed Shape":* The lines that outline a surface are perceived as a unit more readily than those that are not closed. For instance, in figure 3, the linear elements 1 and 2, 3 and 4, 5 and 6, 7 and 8 appear as stripes, while in figure 3a, lines 2 and 3, 4 and 5, 6 and 7 constitute units.

  The law of closed forms plays an important part in reading and interpreting images and, hence, in drawing and painting. It enables us to pick out and complete not only familiar geometric forms, but also invented or merely suggested lines and shapes.

3. 3a. The Law of the Closed Form.

- *The Law of the "Good Curve" or the "Common Destiny":* Elements forming a "good curve" or having a "common destiny" (that is, one characterized by their autonomous configuration) form units more readily than others. For example, in figure 4 we see a straight line as continuous even though it is interrupted by superimposed stripes; and in figure 4a, we recognize a hexagon and a circle.

- *The Law of Common Motion:* The elements of a whole that move simultaneously and similarly or that move in contrast with non-moving elements constitute a unit.

- *The Law of Experience:* A familiar whole is recognizable even with the help of only a few elements, because of our experience with the perceptual organization of objects.

4. 4a. The Law of the Good Curve.

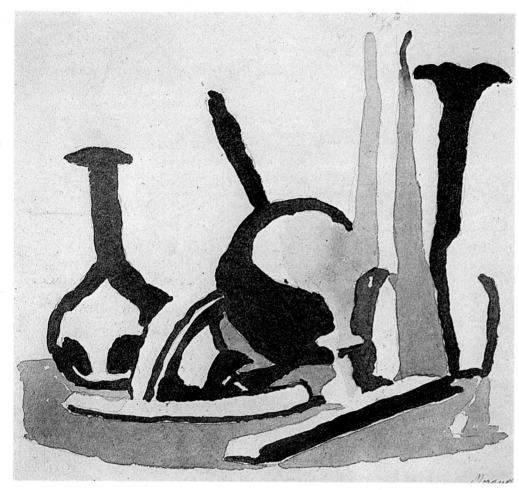

*Giorgio Morandi:*
Still Life, *1936.*
*Pencil and watercolors,*
*325 × 240 mm.*
*Private collection,*
*Milan.*

*The artist suggests just enough to identify the objects and make them recognizable. Thanks to our knowledge of these items, we manage to find them in our memories and experiences.*

For example, in figure 5, even though the lines are separated, anyone who knows the Latin alphabet will easily recognize the outline of a capital H or rather the shadows of a letter in relief. However, the lines must be presented in the correct direction. If we rotate them by 90 degrees (figure 5a), we will see three separate lines instead of an H.

Beyond the cases and examples illustrated here, the psychology of forms and shapes (Gestalt psychology) studies and helps us to understand our behavior with respect to the mechanism, illusions, mystery of vision, and, above all, the interpretation of images.

5    5a    5. 5a. The Law of Experience.

# Optical Illusions

"In regard to perspective, I would like to tell you an anecdote about my father. When I was in high school, I had a drawing manual. One of the examples was the drawing of a rectangular box depicted in its proper perspective. When my father saw it, he said: 'What is this? What is depicted here? This box certainly isn't rectangular, it looks

Because of optical illusions, we see objects and figures differently from what they are in reality. The knowledge of these "illusions" enables us to correct the shapes of objects and figures in our drawing, so that they appear as we want them to look and not as they really are. As we know, the ancient Greeks corrected the warped illusion of a curve created by the horizontal lines of their temples (e.g., the entablatures and the bases of columns) by using lines that curved up slightly, thereby correcting the visual effect.

- One of the most famous illusions is the "arrow illusion." Two schematized arrows are placed next to another, one with its ends open in obtuse angles, the other with acute angles. Although both arrows are of the same length, the first seems longer than the second.

- Another, equally famous, illusion is the "illusion of binaries": equal parallel lines are placed between two converging lines of equal length. The higher parallel line seems longer than the lower one, even though they are actually of the same length.

- In the "fan illusion," we have two parallel vertical lines on which two sets of converging lines are superimposed. The oblique lines make the straight lines look curved.

- An analogous illusion results from placing a square or circle on a field either of concentric circles or of lines radiating from a circumference. The square and circle looks distorted against such backgrounds.

All these illusions can be placed in two main groups: those produced by the background (the fan illusion), and those produced directly by the

1

2

3

1. The arrow illusion.
2. The illusion of binaries.
3,4: The fan illusion.
5,6: The illusion of the square and the circles on circles.

7. 8. 9. Other optical illusions: the line interrupted by a bundle of rays no longer seems straight; the two circles within the angle no longer seem equal; the balls, arranged in various ways in the circles, do not seem aligned.

irregular.' Many years later, while leafing through the same manual, he called me over and said: 'Strange....I always thought that this box looked irregular. But now I realize that it's exactly right.'

"This example demonstrates that if someone doesn't know the laws of nature, then even something that is perfectly correct in its rendering, may seem completely wrong. That is why I recommend a scientific apprenticeship, even if it is boring. In this way, an artist does not have to count purely on his own common sense and experience, which are insufficient and often hazardous."

(from *Childhood Memories* by the Japanese artist Yoshio Markino, 1912)

geometric figure (the arrow illusion).

The explanation for these optical illusions is based on viewing these figures as flat projections of three-dimensional visions. If we examine these illusory figures, we see that each one can be interpreted as the flat projection of a three-dimensional figure: like a perspective drawing done according to the rule that "the parts of the illusory figures depicting distant objects are enlarged, while those depicting nearby objects are made smaller."

This phenomenon of "perception reversal" is clear in the "arrow illusion." Here, the segment delimited by two obtuse angles recalls the image of the inner corner of a room; while the other segment, limited by the two acute angles, recalls the outer corner of a building. Thus, as in the "illusion of binaries," the converging straight lines, evoking a perspective convergence and hence depth, make the upper segment look further away and therefore larger than the lower segment.

As we can see, the observer's experience plays a fundamental role in the illusion and interpretation of an image. Thus, when we look at a portrait, we instinctively take it to be the likeness of a living model. And if we see a black-and-white drawing, we imagine it to be in color. It is our knowledge and assumptions that enable us to interpret and bring to life the images of reality reproduced in a drawing or painting.

The observer also enjoys exercising his "faculty for imitation," his imagination, in order to participate in the artist's creative adventure. And the pleasure is all the greater, the less easy and automatic transformation. We could say that this is the secret of contemporary art, starting with Cubism, when the codified illusion of perspective was replaced by the interpretation of the images in a painting.

5

6

7

8

9

## Impossible Figures

Impossible figures, an amusing game invented by illustrators, are figures that flout the laws of vision and perspective, as we can see in figure 1. By means of this reversal, they transmit a strange feeling of uneasiness, constantly contradicting themselves every time we think we have found their meaning and direction.

Here are three examples of impossible figures. Try to draw similar ones:

1. Two frames, interlaced normally in the first illustration and absurdly in the second. As you can see, we have modified the representation of the superimposition of the elements of the second frame with respect to the first.
2. A cube, drawn first purely in outline, then with the thickness of the sides, and finally in a view "contorted" with the impossible superimposition of the horizontal side on the back vertical side.
3. A pyramid, drawn purely in outline, then with the thickness of the sides, and finally "contorted" in the perspective superimposition of the posterior side of the base upon the anterior side of the pyramid.

1

# Escher's Universe

*M. C. Escher (1898-1972):* Other World, *1947. Woodcut in three colors, 317 × 260 mm. Geneentemuseum, The Hague.*

The Dutch engraver Maurits Cornelis Escher was born in Leeuwarden, Holland in 1898 and died in Laren in 1972. His drawings are based on the obvious conviction that nothing is truly as it seems; everything is ruled by the superior laws of logic and the laws of mathematics, which unite the universe and its elements in a mysterious harmony.

Escher seems to enjoy ambiguity, contradictions, the possibilities of drawing things that do not exist. From here, it is only a short step to depicting pure figments of the imagination. In Escher's most famous drawings, the outlines do not perform their normal function of delineating a figure against the background. Instead, they delineate a figure in two directions, the right and the left. Different figures have an outline in comon, and that links them in an infinite repetition. Or else, by means of a gradual mutation of the outline, Escher's figures are modified and become entirely different.

Let us pinpoint the characteristic features of

"Don't ever copy nature, and don't ever imitate it, let the imagined objects take on the semblance of reality. You don't use painting in order to achieve nature; you have to go from nature to painting. There are painters who transform the sun into a yellow splotch, but there are others who, with their skill and intelligence, transform a yellow splotch into the sun.

"The elements taken from nature are used for variety in a painting. And that is how we approach the ideal of the great masters, who, guided by their own conception, depicted the natural appearances of such things.

"I believe that all painting is based on an objectively organized vision or an inspired illumination.... I place no importance on the subject, but I do insist greatly on the object.

"Respect the object!

"Don't confuse the aspect or order of your innermost thoughts.

"Today, we know that art is not truth. Art is a lie that permits us to approach

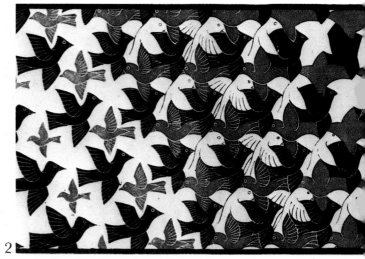

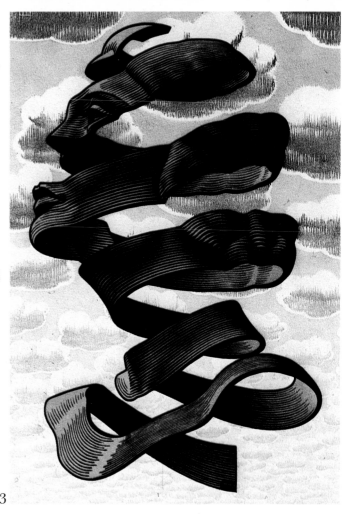

Escher's works, which are very close to, among other things, Gestalt psychology:

- Simultaneous perception and composition of different and often contrasting aspects of reality (for example, views of one scene from different viewpoints) and of the imagination (for example, the transformation of objects into animate figures).

- Mirror-like effects based not only on the normal reflecting surface of a mirror, but more often on the top of a sphere with a concentration of the

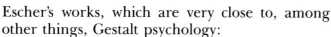

truth, or at least conceivable truth. The painter must find a way of persuading the audience that his lie is truth....

"Often the painting expresses a lot more than the artist wanted to depict. The artist gazes stupefied at the unexecpted results, which he did not foresee. The creation of a painting seems like an unforeseeable spontaneous generation. People talk about naturalism as the opposite of modern art.

"Yet have you ever seen a 'natural' work of art? Nature and art are two absolutely similar phenomena. Art offers us the possibility of expressing our conception and our intelligence of what nature never gives us in an absolute form."

(From a statement by Pablo Picasso and Marius de Zayas, published in *The Arts*, New York, 1923).

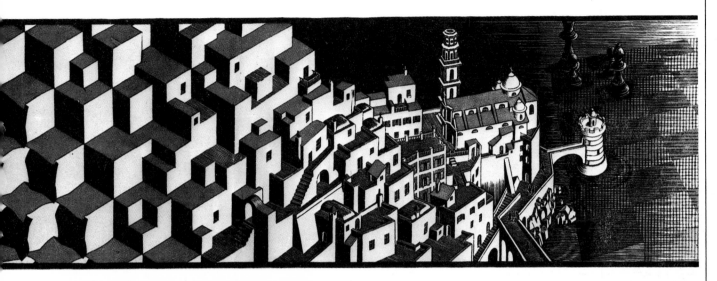

4

*Maurits Cornelis Escher:*

*1. Belvedere, 1858. Lithograph, 462 × 295 mm.*

*2. Metamorphosis II (detail), 1939-40. Woodcut in three colors, 195. × 400 cm.*

*3. Bark, 1955. Woodcut in four colors, 345 × 235 mm.*

*4. Eight Heads, 1922. Woodcut, 325 × 340 mm.*

*(1–4: Hague, Gemeentemuseum)*

image and a deformation (accentuating the dream-like sensation).

• Animation of abstract figures in a contiguous repetitious motif that follow a process of transformation; that is, simple geometric figures (for example, triangles) that produce and develop the drawing of an animate figure which then, by means of a new process of geometrization, returns to the abstract structure, thus recommencing the cycle. This movement can go in two directions: from the margins to the center or from the center to the margins.

• Depiction of impossible figures as well as impossible environments, in which the same figures and the same architecture are seen from above, below, and from the side. Disconcerting effects result because each plane is seen from three different viewpoints, and each surface is both the floor, the walls, and the ceiling simultaneously.

• Experimentation with the expressive possibilities of black and white, gradations of tones, gradual transitions, and sharp contrasts. All this shows a remarkable technical ability.

In all of this, Escher's work seems to express many features of our own era.

**A Drawing a Day: Escher's Stars**

The constructions of Escher's stars are meant to develop the models that Escher found in 18th century prints. The suggested procedure is as follows:

1. Practice drawing the geometric and spatial shapes that are to be assembled into the compositions of the stars: that is, the pyramids with triangular and square bases, and the cubes.

2. Draw a cube in space with a precise continuous line. After repeating the drawing several times, you will achieve a good result—that is, the image of a cube viewed spatially.

3. On the visible faces of the cube, draw the axes of the surfaces and the diagonals, thereby ob-

taining the necessary points for the successive constructions and superimpositions of the other solids.

4. Detach a perpendicular segment of any length, from the surface to the center of the cube. This will constitute the height of the pyramid.

5. Draw the sides of the pyramids with the help of the points specified by the axes and the diago-nals. It is harder to draw the interlacing of the two pyramids with triangular bases and the two cubes, one seen in the position of the first drawing, the other inserted into the first in such a way as to have a common vertex, with the sides cutting into the corresponding sides, at the central point.

## Without Limits

In practicing the suggestions made on this page (based on Escher's study for a lithograph), we propose the following:

1. Take a sheet of graph paper and cut out a square shape.

2. On this square piece, draw a square whose side is the same length as half the sheet of paper.

3. Next, extend each side of the square by a segment equal to half the initial side. We will now have the original square, plus five squares (their sides equal to half the first square) arranged two on the right, two below, and one along the diagonal.

4. Next, extend the sides of the smaller squares by a segment equal to half the second square. We will thus obtain thirteen squares (their sides equal to half the side of the second square).

5. Continuing in this way, construct smaller and smaller squares to the limits of visibility.

# INDEX

**DATE DUE**

BENEDUM CIVIC CENTER LIBRARY

*1230035590*